The Trouble & Strife Reader

The Trouble & Strife Reader

Edited by
Deborah Cameron & Joan Scanlon

BLOOMSBURY ACADEMIC

First published in 2010 by:

Bloomsbury Academic

An imprint of Bloomsbury Publishing plc
36 Soho Square, London W1D 3QY, UK
and
175 Fifth Avenue, New York, NY 10010, USA

CIP records for this book are available from the British Library and the Library of
Congress

ISBN 978-1-84966-002-0 (Paperback)
ISBN 978-1-84966-012-9 (eBook)

This book is produced using paper that is made from wood grown in
managed, sustainable forests. It is natural, renewable and recyclable.
The logging and manufacturing processes conform to the
environmental regulations of the country of origin.

Printed and bound in Great Britain by the MPG Books Group

www.bloomsburyacademic.com

contents

List of illustrations

Acknowledgements

We would like to express our gratitude, not only to the women who have permitted us to reprint their work in this collection, but to all those who contributed to *Trouble & Strife* magazine as authors, editors and illustrators. We are especially grateful to the other members of the last *T&S* editorial collective, Dianne Butterworth, Liz Kelly and Stevi Jackson: the original idea for this book was formulated in the course of our collective discussions, and their continuing support for the project has helped us bring it to fruition. Dianne deserves particular thanks for her technical assistance in the preparation of the text; we are also indebted to former collective members Sophie Laws and Diana Leonard for their help tracking down some of the contributors. Finally, for their support, enthusiasm and efficiency (and for pioneering a new kind of academic publishing), we thank Frances Pinter, Caroline Wintersgill and their colleagues at Bloomsbury Academic.

DC & JS
2009

introduction

TROUBLE

THE RADICAL

FEMINIST MAGAZINE

& STRIFE

Trouble & Strife Magazine, 1983–2002

Debbie Cameron & Joan Scanlon

This volume contains a selection of articles originally published in *Trouble & Strife*, an independent radical feminist magazine which appeared regularly in Britain over a period of 20 years, beginning in 1983 and ending in 2002. Our own involvement with *T&S* spans the whole of that period: we read it from the beginning, contributed to it on occasion, and served for a decade as members of its editorial collective. The magazine was an important part of our political and intellectual lives; it also made a unique contribution to the life of feminism in Britain.

What made *T&S* stand out from other feminist publications of the time was partly its distinctive political stance, and partly the fact that it did not fit straightforwardly into the usual generic categories. Though it had some of the characteristics of each, it was not a theory journal for academics, nor a campaign newsletter for activists, nor a general publication aimed at anyone interested in women's issues. And it definitely was not a 'little magazine' devoted to creative writing (the notice stipulating that unsolicited contributions were welcome made clear that it did not publish poetry or fiction: nevertheless there was always, for some reason, a steady trickle of unsolicited verse). Its founding editors described what they were aiming for in their first editorial statement (see ch.1): 'a widely available, easily readable magazine, exploring in depth issues which are of direct and current relevance to the Women's Liberation Movement in Britain'. With that in mind, the pieces *T&S* published were shorter and more accessibly written than most academic articles, and the magazine was deliberately designed to look like a magazine rather than a scholarly journal. A lot of thought and care went into visual aesthetics generally: the format and logo were the work of professional designers, and some accomplished feminist illustrators contributed on a regular basis (this collection includes some examples of their work).

Those who wrote for the magazine were a varied group. Very few were professional writers (though some, like Patricia Duncker and Denise Mina, are now successful writers of fiction). A significant number were academics, but the magazine also had regular contributors working in law, government and politics, social and community work, information technology, publishing and the media. A commitment to radical

feminism does not make for an easy or uncritical relationship with mainstream institutions, but it is evident from the Notes on Contributors at the end of this book that many of the women who wrote for *T&S* have had an impact within the mainstream: they now hold senior positions in a range of organizations, especially in the public and voluntary sectors. Others have preferred to stay — or to move — outside the mainstream, whether by setting up their own businesses or turning away from conventional careers to use their energies in various kinds of activism. Either way, in most cases the work they do has some relationship to their feminist politics; the choice they made to write for *T&S* was an expression of the same commitment.

Today, the purposes *T&S* served for a particular feminist community — acting as a focus for shared political commitments, and providing a forum for the exchange of ideas — are most often pursued via the worldwide web. But in the 1980s and for much of the 1990s, feminists around the world expressed themselves first and foremost through the medium of print, creating an international network of feminist periodicals. These publications often exchanged advertisements, and a glance at the ads that appeared in *T&S* reminds us how many titles flourished during this time: there were 'national' feminist news magazines such as *Broadsheet* (New Zealand), *Kinesis* (Canada), *off our backs* (US) and *Women's News* (Ireland); there were also more specialist publications like *Sinister Wisdom* ('a journal for the lesbian imagination') and *Trivia* (which published 'interviews, theory and experimental prose'). *T&S* sometimes reprinted material from magazines in the first category. However, its strongest link outside the UK was with the French journal *Nouvelles questions féministes.* Though *NQF* was more academic, the two publications were very close politically, and there were also personal links between the two groups of editors.

In the UK, the feminist publications with which *T&S* coexisted at various points in its history included the radical women's newspaper *Bad Attitude, Catcall* (which described itself as 'a non-sectarian discussion forum by and for women'), the Scottish feminist magazine *Harpies & Quines*, the lesbian feminist *Outwrite*, the young women's magazine *Shocking Pink*, and what is still probably the best-known of all British feminist periodicals, the WLM monthly *Spare Rib*. Launched in 1972, *Spare Rib* helped *T&S* to establish itself by giving practical assistance with production and design. However, the two publications occupied different niches: *T&S* appeared less frequently, had a less news-based agenda, and did not aim to address or represent the same broad-based feminist constituency (*Spare Rib* at its peak had something like 100,000 readers).

Like *Spare Rib, T&S* remained in circulation for approximately 20 years, outlasting numerous other publications which were often better resourced and less politically

outspoken. *The Guardian* newspaper once said of *T&S* that it was 'not for the faint-hearted feminist' (this was a reference to Jill Tweedie's *Guardian Women* column 'Confessions of a faint-hearted feminist'—and yes, we took it as a compliment). But magazines designed to appeal to faint-hearted feminists (like the blandly-titled *Everywoman*, which was launched in the 1980s) proved not to have the staying power of their fiercer, more uncompromising sisters. *T&S* received no funding, was almost entirely dependent on unpaid volunteer labour (it paid only its typesetter, printer and distributor) and accepted no commercial advertising. Its survival over two decades is a tribute to both the commitment of the women who collectively produced it and the loyalty of its core feminist audience.

When *T&S* originally emerged in the early 1980s, there was a significant audience for feminist analysis and political debate. Organized feminism had existed in Britain for over a decade, and had made some important political gains (such as the equal pay and anti-discrimination laws which were passed in the mid-1970s). But by 1983 the climate was changing, both at the national level and in the WLM itself. The Conservatives, led by Margaret Thatcher, were embarking on a second term in government. Thatcherism was inimical to feminist aspirations, both ideologically (it championed 'family values' while maintaining there was 'no such thing as society') and materially (since one consequence of Thatcherite economic policies was cuts in the public funding many practical feminist initiatives depended on). An article by Miriam David in the first issue of *T&S* reflected the perceived need for feminist analysis of and resistance to these ongoing developments in British politics, declaring that 'Thatcherism *is* antifeminism'.

Meanwhile, the WLM was addressing its own internal political divisions. By the early 1980s there were tensions on a number of issues, including race and class differences, motherhood, the women's peace movement (then at the height of its public visibility thanks to the camp women had established at USAF Greenham Common), sexuality and sexual practice (this was to be the decade of the so-called 'sex wars', pitting feminists who styled themselves 'pro-pleasure' against those they disparaged as 'anti-sex'). Against this background, *T&S* sought to give a voice to a distinctive current in British feminism which was, the original editors suggested, 'central to movement practice [but] too often silent in print': *radical* feminism.

Radical feminism: what it was and what it wasn't

Radical feminism is a much-used term in writing about the WLM, but also one which is frequently misunderstood. This can be related to radical feminism's 'silence in print'. On both sides of the Atlantic, the most prominent historians of and

commentators on second-wave (post-1968) feminism have tended to be socialist or Marxist feminists; consequently, the most influential accounts of radical feminism are not the accounts of radical feminists themselves. Produced by outsiders, these accounts are often confused or lacking in nuance, and sometimes they are also coloured by the writer's explicit opposition to radical feminism, so that the result is less a description than a sustained political attack.

One account which illustrates these tendencies is given by the British socialist feminist Lynne Segal in a 1987 book called *Is the Future Female? Troubled Thoughts on Contemporary Feminism*. Segal is by no means the only writer who tells this particular story—since the late 1980s it has been repeated many times—but we will focus on her because of what she shares with *T&S*, namely her cultural and political location in the UK. Segal is troubled by what she alleges is the hijacking of the WLM by a kind of feminism which calls itself 'radical' but is in truth entirely reactionary. It is essentialist (based on the axiomatic belief that women are innately virtuous while men are naturally evil); apolitical (instead of organizing to bring about social change, radical feminists want women to retreat into a separate female culture); and morbidly obsessed with sex and violence (in the radical feminist worldview, all men are rapists and all women victims).

The problem we have with this account, and others like it (such as Alice Echols's 1989 history of American radical feminism, *Daring to be Bad*), is not simply that it is *critical* of radical feminism. The problem is rather that in order to make its criticisms, it represents radical feminism in a way we find unrecognizable. The political beliefs Segal ascribes to radical feminism bear no resemblance to our own beliefs, and the radical feminist she conjures into being bears no resemblance to anyone we have ever met. Like the mythical chimera, this figure appears to have been put together using parts from two completely different creatures—on one hand the dour, man-hating, dungaree-wearing political lesbian, and on the other the goddess-worshipping cultural separatist who spells 'women' as 'wombyn' and has named herself 'Tree'.

We will not dwell on the fact that both these stereotypes come straight from the misogynist repertoire of the tabloid press and *Private Eye*'s 'Wimmin' column (where they are directed against all feminists, not just the ones Lynne Segal criticizes).[1] We will even grant that some actually-existing feminists may have something in common with either the dungaree-wearer or the goddess-worshipper. But what we find wholly implausible is the idea that any feminist, or type of feminism, personifies both at once. The same confusion/conflation is apparent in Segal's suggestion that radical feminism as a political philosophy is based on the writings of three iconic

figures: Andrea Dworkin, Mary Daly and Dale Spender. One problem with this claim is that it projects onto radical feminists a kind of reverence for theoretical authority-figures which is probably commoner among socialists. But the main objection to it is that, like the dungaree-wearer and the goddess-worshipper, the three writers Segal mentions do not represent the same perspective on feminism or appeal to the same kinds of feminists. Distilling a coherent political philosophy from their collective wisdom would be a singularly challenging task—which may be why no one that we know of has ever tried.

The radical feminism represented by *Trouble & Strife* was remote from the 'radical feminism' of some critics' imagination. A succinct summary of the magazine's political position can be found in the brief legend which appeared on the masthead:

Trouble and Strife is cockney rhyming slang for wife. We chose this name because it acknowledges the reality of conflict in relations between women and men. As radical feminists, our politics come directly from this tension between men's power and women's resistance.

Far from speaking the language of 'victim feminism' or apolitical cultural separatism, *T&S* with its emphasis on 'conflict', 'power' and 'resistance' seems closer to the language of traditional Marxism. But its feminist politics were not Marxist or socialist, as is clear from the editorial with which the first issue opened:

We believe that men as a group benefit from the oppression and exploitation of women as a group. We do not see women's oppression as secondary in importance to class or any other oppression; nor do we see it as produced by or maintained because of class or any other oppression. Although we recognize that women experience additional oppressions, particularly through race, ethnic origin, age, disability, class, and that these...may benefit and be contributed to by women who do not share them, *all* women are oppressed *as women*.

Socialist feminism is not, however, the only kind from which the editorial distinguishes *T&S*'s radical feminism. The next paragraph begins:

Men oppress women, but not because of their (or our) biology—not because men are physically stronger, nor because...women may bear children and breast-feed, nor because men are innately more aggressive. We consider men oppress women because they benefit from doing so.

This makes clear that *T&S*'s radical feminism was not essentialist. Rather it was *materialist*. Although it did not draw the same conclusions as Marxist feminists about the causes of women's oppression, it used a similar conceptual apparatus to theorize them, focusing on the benefits one group (men) derived from the exploitation and subordination of the other (women). In this *T&S* was influenced less by the 'holy trinity' of Dworkin, Daly and Spender than by the ideas of Christine Delphy and other feminists associated with the French journal *NQF.*

Because of its commitment to materialism, *T&S* consistently and emphatically rejected analyses based on the idea of a 'natural' difference between men and women. Among the articles that appeared in its first few issues were a critical piece by Ruth Wallsgrove about the Greenham Common peace camp (the criticism being that Greenham represented women's commitment to peace as the consequence of their instinctive concern for future generations), and an article by Lynette Mitchell whose self-explanatory title was 'Against cultural separatism'. Several chapters of this book demonstrate *T&S*'s explicitly critical attitude to 'maternal thinking', matriarchalist myth-making and assorted varieties of spiritual mysticism (see e.g. Christine Delphy, ch. 6, Dena Attar, ch.10, Rachel Hasted, ch. 20, and Sigrid Rausing, ch. 26). Undoubtedly there were feminists to whom those things appealed, but most of those who wrote for *T&S* had no time for them at all.

The editorial goes on to state: 'While we criticize the institution of heterosexuality, we do not think that only lesbians can be feminists or that all feminists should be lesbians'. In the context of 1980s British feminism this can be read as an attempt to distinguish *T&S*'s radical feminism from the current known as 'revolutionary feminism'. In 1979 Leeds Revolutionary Feminist Group had written a pamphlet entitled 'Love your enemy?' which argued that a committed feminist could not have sexual relationships with men. *T&S* never accepted that view. Its founding collective described themselves as 'heterosexual and lesbian', and subsequent collectives also fitted that description. No one questioned prospective editors or contributors about their sexuality: what mattered was their politics.

It did, however, matter that they were women: though *T&S* opposed the cultural variety, it was committed to *political* separatism—to the principle that women must liberate themselves through their own collective action rather than working in mixed-sex organizations where they would inevitably come under pressure to cede control to men. No man ever contributed to *T&S* as an editor, writer, designer, typesetter or illustrator; the only men it dealt with were those it paid to print and distribute the magazine.

Differences among women, though acknowledged and discussed, were less central to *T&S*'s thinking. The magazine was generally critical of the rise of feminist

'identity politics', where the socio-demographic category a woman belonged to or identified with—Black or white, working class or middle class, straight or lesbian, with or without disabilities, etc.—was assumed to determine both her political priorities and her position on any given issue. Committed to the view that 'all women are oppressed as women' (and that the main beneficiaries were men rather than other women), *T&S* saw identity politics as over-emphasizing differences among women at the cost of obscuring their common oppression and fragmenting their collective resistance (see Purna Sen, ch. 11).

One of the concerns expressed by the founding collective in their inaugural editorial—that few Black women saw themselves as radical feminists, and that consequently the magazine under-represented the voices and concerns of non-white women—became less marked over time. More accurately, perhaps, developments in British society and politics made the existence of a radical strand in Black feminism more visible, and *T&S* reflected that. Though the editorial collective did remain, with few exceptions, white, the magazine strongly supported and frequently publicized the work and the political views of groups such as Southall Black Sisters (SBS) and Women Against Fundamentalism (see Dena Attar, ch.10). These were (and are) organizations whose support for minority ethnic women combined a strong anti-racist element (e.g. opposition to racist immigration laws, whose impact on women they insisted other feminists must take on board) with a refusal to gloss over the oppression of women by men within their own communities, or to entertain the kind of liberal multiculturalism which condones oppressive practices by proposing they should be respected as expressions of differing values and cultural traditions. If this defence of women's interests in opposition to fundamentalism on one hand and liberalism on the other ever seemed less than central to the politics of radical feminism, it most certainly does not seem so now.

The criticisms made by groups like SBS of liberal cultural relativism fed into *T&S*'s more general concern with distinguishing its position from liberal varieties of feminism. This point is often neglected in discussions which concentrate on the 'great divide' between radicals and socialists, presumably because it is something which does not divide the two currents. Both reject what Lynn Alderson once dubbed 'the sensible agenda', meaning the kind of moderate, liberal approach which talks about women's 'disadvantage' rather than their oppression, locates the problem in individual attitudes rather than social structures, and couches its demands (if that is not too strong a word) in a language of 'choice', 'empowerment' and 'equal opportunities' (the radical feminist equivalents would be 'power', 'power' and 'power').

Radical (and socialist) feminists do not of course dissent from such basic liberal principles as women's right to political representation, reproductive freedom or equality before the law. Their objection to liberalism is that it cannot in practice deliver the rights it promises, because it refuses to acknowledge the deeper structural causes of inequality. On many issues of concern to radical feminists, perhaps most notably pornography and prostitution, it is also evident that there are conflicts which cannot be resolved within a liberal framework of individual rights and freedoms. Upholding the rights of men may entail negating those of women; his 'freedom of choice' may depend on her servitude (see Debbie Cameron and Liz Frazer, ch. 17).

This reference to pornography and prostitution brings us to the one respect in which T&S's radical feminism did resemble, at least partially, the otherwise unrecognizable caricature discussed earlier. Male violence—domestic abuse, rape and sexual assault, the sexual abuse of children both inside and outside the family, prostitution, trafficking and the production and consumption of pornography—were indeed key issues for radical feminists, and they were frequently discussed in T&S. This discussion did not, however, portray men as natural predators and women as eternal victims: its aim was rather to analyse the structures that sustained the abuse of women and children, and to support organized efforts to change those structures. Contributors explicitly criticized the kind of analysis which either treated male violence as 'natural' or used a quasi-medical language to define it as a form of individual pathology (see e.g. Liz Kelly, ch. 7). What they refused to do, however, was gloss over the extent of the problem or minimize the damage done to women and children by it.

Critical discussions of this aspect of radical feminism often dwell on its 'conservative' position in the feminist 'sex wars' of the 1980s and early 1990s. The sex wars, however, were not primarily about male violence or male sexuality: they focused more on female (especially lesbian) sexuality, with feminists who described themselves as 'pro-sex' or 'pro-pleasure' arguing that practices like using pornography or engaging in S/M sex were both erotically pleasurable and politically empowering. T&S did enter into this debate, since it was clearly 'an issue of current relevance', and it did so from a perspective that was critical of sexual libertarianism (see e.g. Julia Parnaby, ch. 13, Susanne Kappeler, ch. 14, and Stevi Jackson, ch. 15). One of the criticisms radical and revolutionary feminists levelled at mainstream heterosexual culture was that power differences between the sexes were routinely eroticized; this not only reflected but also contributed to the maintenance of unequal gender relations. T&S writers saw nothing daring, let alone empowering, about importing this heterosexual cliché into sexual encounters between women.

However, *T&S* did not give debates on lesbian sadomasochism anything like the same emphasis it gave to, for instance, the continuing struggle to get justice for women who had been raped. The topic did not even feature in most articles about lesbian sexual practice itself (one such piece was advertised on the cover of the issue in which it appeared with the words 'Sexuality – NOT the sadomasochism debate'). Some *T&S* writers took a sceptical view of the argument made by revolutionary feminist Sheila Jeffreys in her books *Anticlimax* and *The Lesbian Heresy*, that sexual libertarians were destroying the women's movement: as one commented, this was reminiscent of the socialist feminist complaint that radical feminists were destroying the movement. Someone or other was always being accused of destroying the movement, but somehow the movement always survived.

One reason why it survived was that in the real political world there were few spaces in which any variety of feminism could exist in a pure and undiluted form. As Liz Kelly (then based in Manchester) remarked, reviewing *Is the Future Female?*, the way the book drew up the battle-lines between socialist and radical feminism could be seen as reflecting a metropolitan bias:

> For those of us in the provinces, political differences have seldom had the same hostility and divisiveness. Our communities are not large enough, our resources too limited for us *not* to find ways of working together (p.24).

Although we have focused here on what distinguished *T&S*'s radical feminism from other feminist currents, we hope we have also made the point that these differences were not in reality as stark as some accounts imply. Liz Kelly reminds us, not only that feminist politics has always involved coalitions, but also that what feminists have in common, like what women have in common, is more fundamental than what divides them.

Unlike feminism itself, *T&S* has not survived, but the reasons for its demise were economic rather than political. Like many other small independent publications, by 2000 the magazine was having difficulty dealing with a combination of rising production costs and increased competition from other media; in the summer of 2001 it was forced to cease publication. Later that year, however, the events of 9/11 prompted ex-collective member Sophie Laws to suggest producing a special issue. With the help of external funding, she and Helen Lowe guest-edited 'Piecing it together: feminist perspectives after September 11', which appeared in 2002. This 43rd issue of *T&S* turned out to be its last. But in the belief that the magazine deserves not only to be remembered, but also to be made available to a wider

audience than it could reach in its original form, in this volume we reprint some of its most memorable contributions to the feminist debates of the eighties, nineties and early noughties.

Content and organization

To maximize the quantity and range of material we could include, most of the pieces reprinted in this collection have been re-edited to shorten them. We have also added occasional notes, to clarify references made obscure by the passing of time. The chapters are grouped thematically in six sections.

The opening section, 'Manifestos', reproduces the two editorial statements in which *T&S* collective members defined the magazine's purpose and its political stance. The first appeared in the inaugural issue, while the second was produced to mark the magazine's tenth anniversary.

The second section is devoted to 'Controversies': this is also the largest section, reflecting the important function *T&S* fulfilled as a forum for internal feminist debate. The editorial which appeared in the first issue explicitly stated: 'we will publish material which we do not necessarily agree with in every detail, and certainly from women who do not call themselves radical feminists'. Though some views would not have been given house-room, contributors (who included a number of revolutionary feminists and even the occasional socialist) were not required to follow a strict editorial line. For one thing, there were often differences of opinion within the editorial collective. Even women who did call themselves radical feminists did not hold the same views on every issue; on some questions there were passionate disagreements. Publishing articles written from conflicting viewpoints (with the letters page often continuing the debate) did not necessarily settle these arguments, but it did help to clarify what was at stake in them.

The 'Controversies' section begins with a series of contributions on an issue which has often divided feminists (and indeed, women more generally): motherhood. Contributors discuss questions of reproductive choice, childcare, the rights of mothers and those of children. Since these were matters of controversy among radical feminists themselves, these pieces refer or directly respond to one another, producing a sustained (though finally unresolved) exchange of views. The remaining chapters take up other issues on which there was disagreement among feminists: child sexual abuse, prostitution, abuse perpetrated by women, and the perennially difficult subject of ethnic, cultural and religious differences among women. (Our two pieces on this last theme, written in 1990 and 1999, now look highly prescient: they show that radical feminists were developing critical analyses of both religious

fundamentalism and some kinds of anti-racist or 'multiculturalist' discourse long before the events of 9/11 put these issues on the mainstream political agenda.)

The pieces in the next section, 'Sexuality', also focus on issues that were matters of disagreement and controversy among feminists. We have chosen to give them a section of their own, however, because as we noted above, debates on sexuality and sexual practice took on a particular significance in the 1980s and 1990s. The radical feminist position in those debates has been repeatedly characterized as essentialist, puritanical and hostile to heterosexual women. But the chapters in this section, dealing with the HIV-AIDS epidemic, the emergence of Queer politics, the status of the body in feminist theory and the relationship between feminism and heterosexuality, show that this description is misleading: more importantly, they show what *T&S*'s position actually was. The writers of these four pieces are not disputing the importance of sexual freedom for women (nor suggesting that heterosexuality is in principle and forever incompatible with it). Rather they are taking issue with facile libertarian notions of what *constitutes* sexual freedom— for instance, the idea that if conservative moralists disapprove of something (like pornography or sadomasochism) then feminists should axiomatically embrace it as politically subversive and 'liberating'. Radical feminists argue, by contrast, for an approach to sexual desires and practices which is based on an analysis of their relationship to power and inequality in the wider social world.

Although *T&S* was not an academic journal, its contributors and readers included both academics and students, and it regularly published articles which engaged with academic feminist theory—or Theory, with a capital T. This engagement can be seen in some of the 'Sexuality' pieces, and the fourth section, 'Theory', contains a selection of contributions in which it was the central point. Writers set out both to explain particular approaches—psychoanalysis, liberal political theory, postmodernism and neo-Darwinism—and to offer a critical, radical feminist assessment of them.

As well as showing what *T&S* writers made of some of the intellectual fashions of the day, this section illustrates their more general attitude to theory itself. The early WLM had been a culture in which abstract or theoretical writing was often regarded with suspicion (see ch.2). *T&S* was never 'anti-theory' in that sense—on the contrary, in fact, its founders wanted to create a space where radical feminists could reflect on and develop ideas (though in their inaugural editorial statement they did feel the need to reassure readers that they were not suggesting 'intellectual activity is more important than practical campaigns'). The magazine was always, however, critical of the kind of feminist theory which is totally disconnected from

women's experience and from feminist politics; and it was resolutely opposed to the kind which is so arcane conceptually and linguistically as to exclude the uninitiated (see Stevi Jackson, ch.16). Its commitment to inclusiveness was made explicit in the founding editorial statement: 'Sharing knowledge supportively, not using it to impress or mystify, is an important part of radical feminist practice. It is to this that *Trouble & Strife* is devoted'. The magazine did, arguably, become more 'academic' (or perhaps, less self-consciously *un*-academic) in its style and tone over time; but it never lost sight of its original goal of demystifying knowledge and making ideas accessible.

From its inception *T&S* had a strong interest in women's and feminist history. It often included articles based on research by feminist historians; the fifth, 'History' section begins with two such pieces. Rachel Hasted's reassessment of the figure of the witch raises questions about the political uses of historical source material, while Rosemary Auchmuty's account of early 20th century schoolgirl fiction shows how it reflected, and was affected by, changing attitudes to intimate friendships between women.

T&S also published pieces dealing with the more recent history of the feminist movement itself. Beginning in the very first issue, a regular feature called 'Writing our own history' interviewed women about their experiences of feminist activism. Introducing the first of these interviews, the editors remarked: 'we hope that this… will go some way towards countering the attempt to write us out of existence'. This was not only a reference to the general tendency of mainstream historians to leave women and feminists out of the record, but also to the tendency discussed above, for historians of the WLM to concentrate on the liberal and socialist varieties of feminism while ignoring or misrepresenting the radical current *T&S* belonged to. In this volume we reprint one example of the 'Writing our own history' feature, in which Lilian Mohin recalls a campaign against the Wimpy Bar restaurant chain (a sort of pale British imitation of McDonald's) for its policy of refusing to serve unaccompanied women late at night. That such a policy ever existed will doubtless astonish younger readers, but even those who were around when such things were commonplace may well be unaware that feminists took direct action in opposition to them.

The other two pieces in the History section contain first-hand testimony from feminists who had been directly involved in significant recent historical events. Monica McWilliams describes the setting up of the Northern Ireland Women's Coalition and the part it played in negotiating the Good Friday agreement which paved the way for peace in Northern Ireland, and Sarah Maguire offers her observations, as a lawyer and activist working in the former Yugoslavia, on attempts to bring war

criminals to justice in the aftermath of the Balkan wars. While the events discussed here are certainly acknowledged as historic, they are rarely portrayed in mainstream accounts as events in which feminists either had a particular stake or played an active political role. These feminist accounts, which are both personal and analytical, thus represent another way in which *T&S* sought to counter the tendency for feminism to be erased from the historical record.

The final section, 'Culture', contains a selection of pieces in which radical feminists addressed such topics as the rise of self-help and the recovery movement, the emergence of a New Age 'masculinist' movement, the success of women's literary publishing, the increasing sexualization of girls' magazines, the strange return of the housewife as a cultural icon, and the extraordinary popularity of reality TV. These are all fundamentally critical pieces, which may leave some readers wondering if *T&S* ever commented positively on an aspect of popular culture or celebrated a new social trend. The answer is yes: among the developments contributors applauded were the rise of feminist detective writing and science fiction, women's participation in activities like windsurfing and drumming, and young girls' enthusiasm for the Spice Girls (though writers were less keen on body-building and new-age spirituality: an article on the latter was tersely entitled 'Crystal Balls'). *T&S* also gave positive reviews to various books, films and plays, and celebrated the lives and achievements of numerous inspirational women. But these pieces were often reviews, interviews with an artist or writer, or reports of a specific event; they were very much 'of the moment', and are therefore less satisfying to re-read now than the more critical and analytical contributions.

Because we have concentrated on reprinting the analytical pieces which we believe are *T&S*'s most significant legacy, some themes and some types of articles which regularly appeared in the magazine are under-represented in or absent from this volume. Our selection excludes news reports about political events and campaigns; it excludes most interviews (the exception being the feminist history pieces already mentioned) and 'straight' book and film reviews (though a few pieces do belong to the genre of the 'classic' or 'discussion' review in which an influential book provides the author's starting point). It also excludes the round-table discussions in which groups of women mused on subjects ranging from vegetarianism to cleaning, and the short opinion pieces which appeared in a slot called 'Barking Back'. While pieces in these categories were often entertaining, their 'off-the-cuff' quality combined with the ephemeral nature of some of the topics they tackled made us feel they should not take precedence over more considered contributions.

Our selection also excludes most of the magazine's global coverage. Though *T&S* did not set out to be an internationalist publication—it concentrated largely

on British concerns, with north America and France as its other main reference points—it did regularly feature pieces on feminism in other parts of the world, which were usually either articles by, or interviews with, local activists. But most of these pieces were designed to inform readers about the current state of feminist politics in a particular locality, and consequently they are now very outdated. Others cannot be included here because they were not originally written for *T&S*, but reprinted from other feminist periodicals with which it had exchange arrangements.

But although this collection cannot give the full flavour of *T&S* as a regular subscriber would have experienced it, we hope it will enable readers unfamiliar with the magazine to understand what it was about, and what kind of feminism it stood for. We hope it will convey a sense of the strengths that kept this small independent publication alive and self-supporting for two decades: its understanding of what its readers cared about (and its willingness on occasion to challenge them); its ability to render complex arguments accessible and make connections between theory and activism; and, not least, its commitment to readable prose and lively visual illustration. Finally, we hope that by compiling *The Trouble & Strife Reader,* we will be helping to achieve one of the magazine's original aims—to put a particular current of feminism (back) into the historical record and ensure that its ideas cannot be 'written out of existence'.

Note

1. *Private Eye* is a British satirical weekly magazine, which for some time ran a column titled 'Wimmin' lampooning the supposed absurdities of feminism.

References

Alderson, Lynn (1993) 'The failure of the sensible agenda', *T&S* 27.

David, Miriam (1983) 'Thatcherism *is* anti-feminism', *T&S* 1.

Delphy, Christine (1984) *Close to Home: A Materialist Analysis of Women's Oppression,* London: Hutchinson.

Echols, Alice (1989) *Daring to be Bad: Radical Feminism in America 1967–1975,* Minneapolis: University of Minnesota Press.

Jeffreys, Sheila (1990) *Anticlimax,* London: Women's Press.

Jeffreys, Sheila (1994) *The Lesbian Heresy,* London: Women's Press.

Kelly, Liz (1987) 'The new defeatism', *T&S* 11.

Leeds Revolutionary Feminist Group (1979) 'Love your enemy?' London: Onlywomen.

Mitchell, Lynette (1984) 'Against cultural separatism', *T&S* 4.

Segal, Lynne (1987) *Is the Future Female? Troubled Thoughts on Contemporary Feminism,* London: Virago.

Wallsgrove, Ruth (1983) 'Greenham Common women's peace camp—so why am I still ambivalent? *T&S* 1.

manifestos

1. Editorial Statement (1983)

The Trouble & Strife Collective[1]

We hope that this magazine will provide a new forum for what has been known, since the start of the current wave of feminism, as radical feminism.

We want *Trouble and Strife* to be a widely available, easily readable magazine, exploring in depth issues which are of direct and current relevance to the Women's Liberation Movement in Britain. We will publish material we do not necessarily agree with in every detail, and certainly from women who do not call themselves radical feminists. But we want to encourage writing from, and make visible the activities of, a particular strand within feminism. Radical feminism, though central to movement practice, is too often silent in print.

Within this strand, some call themselves simply 'feminists', because they see labels as restricting and divisive, and they want an evolving, broad and united Women's Liberation Movement. However, there are today important differences within the movement and many strands use a qualifying adjective. The following paragraphs, therefore, outline what we in the collective see as the shared basis of our radical feminism.

We believe that men as a group benefit from the oppression and exploitation of women as a group. We do not see women's oppression as secondary in importance to class or any other oppression; nor do we see it as produced by, or maintained because of, class or any other oppression. Although we recognise that women experience additional oppressions, particularly through race, ethnic origin, age, disability, class, and that these additional oppressions may benefit and be contributed to by women who do not share them, all women are oppressed *as women*.

Men oppress women, but not because of their (or our) biology, not because men are physically stronger, nor because men have phalluses and women may bear children and breast feed, nor because men are innately more aggressive. We consider men oppress women because they benefit from doing so. All men, even those at the very bottom of male hierarchies, have advantages which flow from belonging to the category male. Even the men most sympathetic to women's liberation benefit from women's subordination. The social structure has been developed so as to ensure that the collective and individual actions of men support

and maintain them in power. We believe change can come about only through women's collective action, and convincing men of the need for feminism is therefore not a priority for us in our struggle against male supremacy.

We seek a movement of *all* women to overthrow male supremacy. While we criticise the institution of heterosexuality, we do not think that only lesbians can be feminist or that all feminists should be lesbians.

We hope that *Trouble and Strife* will encourage feminists to communicate with each other about what they are doing and thinking. We hope it will enable ideas and practices to be clarified and developed. We see ideas as emerging from personal experience and practical struggles which then feed back into our work within the Women's Liberation Movement. Although we are producing a magazine we are not doing so because we think intellectual activity is more important than practical campaigns. Sharing knowledge supportively, not using it to impress and mystify, is an important part of radical feminist practice, and it is to this that *Trouble and Strife* is devoted.

The idea for a magazine came from several of us who had connections with a French radical feminist journal, *Nouvelles questions féministes*. We had discussed the possibility of an English language sister publication with them over a number of years. Others of us have been involved in various kinds of radical feminist publishing. Last year we formed a group to produce this magazine.

We come from various backgrounds within the Women's Liberation Movement but have a shared commitment to radical feminism and the project of getting this new publication established. We do not want it narrowly to reflect the opinions of the collective, but rather to be a forum for debate open to and used by all who fall within a broad definition of radical feminism. An important part of our commitment to open debate is to develop links with radical feminist publications in other countries world-wide, in order that our readers can be informed about and contribute to radical feminism internationally.

We are aware that our collective by no means represents all the lines of division between women. We are all white women, and we recognise that few Black women see themselves as radical feminists. We are heterosexual and lesbian, working and middle class, with and without children, and we vary in age from mid 20s to mid 50s and in kinds of Women's Liberation Movement experience. We are united by our differences and our similarities.

Note

1. The members of the 1983 collective were Lynn Alderson, Jalna Hanmer, Sophie Laws, Diana Leonard, Sheila Saunders and Ruth Wallsgrove.

2. Editorial Statement (1993)

The Trouble & Strife Collective[1]

n the first *Trouble & Strife* editorial, in 1983, the collective gave a definition of women's oppression which foregrounded the benefits men get from the oppression and exploitation of women, and which suggested that the existence of 'men' and 'women' as social categories must be seen in relation to this: 'all women are oppressed *as women*' and 'all men have advantages that flow from belonging to the category male ..'. Whilst recognising that women experience other oppressions, the collective argued that women's oppression should not be seen as secondary to other oppressions, nor as being derived from, or produced by other oppressions.

Multiple oppressions

Some ten years later, developments in radical feminist analysis have changed this understanding of women's oppression in some very important respects. Although the central insight — that women are oppressed as women and this is not secondary to any other oppression — still holds, the analysis of other oppressions and the relationship of these to women's oppression is now seen as flawed.

Specifically, the idea that oppressions such as class, race and disability are somehow 'added on' to women's oppression (making you working class and a woman, or Black and a woman, etc) has been challenged. That approach implicitly assumed that these oppressions were somehow ungendered or gender neutral, and that gender is class and race neutral. But this is not the case.

Capitalism, for instance has been exposed as a gendered system. Being able 'freely' to exchange one's labour power for wages (to be a proletarian in Marx's class analysis), is not a universal, but rather a male 'privilege'. Women are simply not as 'free' as men to sell their labour to an employer. Women *do* work for wages, of course, but under different and worse terms and conditions than men. And this is integral to the capitalist labour process.

This increasing recognition that oppressions of race and class are in fact also, in and of themselves, patriarchal; and conversely that gender is classed and raced, has led to an increasingly more sophisticated analysis of women's oppression.

The institution of heterosexuality

Ten years ago the *T&S* collective also insisted that radical feminism is not, and should not be, a lesbian-only movement. This, we would argue, is still central: it is still a defining feature of radical feminism that we see heterosexual and lesbian oppression as two sides of the same coin. But here too there is not only continuity but also change. Radical (and other sorts of) feminists now have a much more developed analysis of the central significance of heterosexuality in all manner of social phenomena — in the creation of nations and nationalism, in economic development, in religious movements, and so on.

Activism

Ten years ago the *T&S* collective commented that radical feminism was central to the women's movement's practice and that change can only come about through women's collective action. While we would agree that radical feminism is still central to movement practice, *the movement itself* has obviously changed enormously. Some have claimed it has disappeared altogether; and this apparent disappearance of an organized women's movement has been seen as either signalling the dawning of a post-feminist age, or as indicating a decline: a loss of power and a lack of interest in activism among women.

However, this not only ignores the existence of a whole range of feminist organisations — including some new ones (such as the Campaign Against Pornography and Women Against Fundamentalism) and women's concern to understand their own situations, as evidenced by the growth in Women's Studies; it also, and more importantly, ignores the way in which social conditions have changed.

Quite rapid social change — in particular changes in the nature of employment and unemployment — have made it more difficult for women to participate in social movements and to organise politically. Many now work much longer or more irregular hours; they are more likely to be the only employed member of the households in which they live; and they are more likely to have increased obligations to care for children and elderly or sick relatives who are now 'out in the community'.

It is not that feminism is no longer required, nor that women no longer want it and are not interested in activism. Rather, the decline of the highly visible women's movement is a question of feminist political activity being differently constituted in the 1990s.

The death of many forms of collective political activity, including consciousness raising, is often lamented by radical feminists — not simply nostalgically, but because they see it as the only form of 'authentic' feminist political activity. As a

consequence, women who are new to feminism, and who have never taken part in such forms of collective action, find their feminism put in doubt by the 'old guard'.

Many women discover feminism today individually (rather than by joining a local CR group or specific campaign) by, for example, reading books or by doing a women-only course, but we need not interpret this as a sign of a failing movement. Rather it may be a shift in the points at which politicisation can take place, connected to broader social changes.

Given that there appears to be a revitalised interest in radical feminism amongst young women — many of whom would have been too young to have taken part in the collective activities of the 1970s, or not born at all — surely what we need (and this piece is a very small contribution to answering the need) is an analysis of the social conditions in the 1990s which form women's relationship to feminism.

Different not dead

If we recognise that the old forms of political practice were possible because of the particular social conditions of ten and twenty years ago (and not just because of the particular qualities of the people who were present), and that these conditions have changed, we can see that there is perhaps not so much a demise of the women's movement, as a change in its form or expression.

However, if, as we have argued here, points of politicisation have shifted and many forms of collective activity have dwindled, we are going to have to rethink the claim made in *T&S* ten years ago 'that change can come about only through mass women's collective action.'

If social conditions have changed and if, in particular, it is increasingly difficult to organise collectively — then our strategies will also need to change. We need new forms of activism — ones that don't necessarily depend on hundreds or thousands of women taking part in one particular event or being organised around one particular issue and which use new possibilities. Lesbians abseiling into the House of Lords comes to mind — one action by a few women which was seen by millions on TV in Britain.[2]

This is not to argue for ad hoc pieces of action which are disconnected from radical feminist analysis — far from it. But it needs to be recognised that huge marches, protests or conferences may not be possible in the way they were ten or twenty years ago, and also that they may not be as effective as tools of change today.

In some ways there have already been changes in feminist organisation. Whilst it may be increasingly difficult to organise nationally, we have many more international contacts than ten years ago, and we think much more globally.

Why we still need a journal

Another issue which stands out in the original editorial statement is its apologia for writing, and for providing a journal. A similar sentiment was also expressed in other radical feminist publications set up around the same time. In the French journal *NQF* which started in 1977, for instance, there was a long justificatory note on why the founders believed writing was an important part of radical feminist activism, which now seems extremely outdated.

Ten years ago, whilst radical feminism had a strong oral culture, very little was written down — and there was suspicion of those who did write. They often got accused of trying to take personal credit for collective 'movement' ideas, or (paradoxically) of giving their personal view instead of everybody's (differing) views. This antagonism has had some unfortunate consequences. There are, for instance, very few (no?) histories of radical feminism available; and grievous omissions and misrepresentations in the 'general' (mostly socialist feminist) histories which do exist.

We no longer feel the need to apologise for writing or to justify its significance, perhaps because the benefits of radical feminist writing are now far clearer, and perhaps also because of the kinds of social change discussed earlier. Since we don't have the conferences, the campaigns and the oral culture that we used to have, we can't rely simply on hearing about what's going on. This also has the advantage of making radical feminist ideas more accessible to 'outsiders'. However, just as it was ten years ago, it is central to *Trouble & Strife*'s position that radical feminism retains a commitment to written ideas being simply expressed and accessible to all women.

Notes

1. The members of the *T&S* collective in 1993 were Lisa Adkins, Dianne Butterworth, Debbie Cameron, Marian Foley, Liz Kelly, Sophie Laws, Diana Leonard, Joan Scanlon and Sara Scott.
2. The reference is to a protest against Clause 28 of the Local Government Bill (1988) which prohibited local authorities from 'intentionally promoting homosexuality' or condoning any teaching at a state maintained school which promoted 'the acceptability of homosexuality as a pretended family relationship'. The bill became law, and the clause was not repealed in the whole of the UK until 2003 [Eds].

controversies

3. Thicker than water?
Mothering and Childcare (1985)

Ruth Wallsgrove

Though I've never wanted to give birth myself, I've always liked children, and believed I could work out some sort of relationship with them outside of motherhood. At one point I would say, if anyone asked, that I wanted to be an aunt. Beyond that I didn't think particularly theoretically, just assumed we should work out alternative ways of bringing up children, and that my part in this would be to commit myself to children who weren't 'mine'.

When I began to meet feminist mothers of small children, I kept my eye out for possible ways to become involved—a search for compatible children and (more tricky) compatible mothers. I'd be the first to admit that I was young and foolish, not offering much more than babysitting, but everyone was happy enough with that.

When challenged some years later to make more of a commitment, to do more real sharing, I was actually thrilled. Over time I'd come to appreciate what children require and began to adjust my life. The box of toys, the changes of clothes, the potty and nappies, the routine procedures of feeding and cleaning, the regularity of time—all those things I acquired. I ended up deciding, in a crisis, to take on two children full-time, when their mother felt she couldn't cope with them any more.

I have ended up losing altogether those children, the two human beings I cared most about in the world. My situation is not, in fact, very unusual: it has happened to several other working-class mothers and middle-class non-mothers in the women's movement that I know of. The circumstances that made life so difficult for the mother in the first place, probably forcing her to seek other carers for her children—her poverty as an extremely oppressed working-class woman—was precisely the issue that blew up in both our faces. I can't feel blameless in or oppressed by that situation, however angry and hurt I was.

What made me much more cynical politically was the attitude of other, middle-class feminist mothers. Some of them knew instantly who to support when I lost access to the two I'd lived with—and it wasn't me. Whatever my experiences or commitment, I was a Non-Mother, on the other side from them.

It's not that I think non-mothers have done everything right. I do realise that those of us who get involved with children in ways other than giving birth to them have the

freedom to be irresponsible, to leave, to cause trouble by going on about the right-onness of sharing and of mothers giving up certain things without understanding that lectures do not instantly alter feelings, and that the mother only has our word that we'll keep our side of the bargain. I've seen all that happen. I can get lost whenever I choose. And that's one reason I'm not a mother. I don't really want sole responsibility for a child every day. But I don't get lost. I don't interfere, in the name of some higher political good, between the children I look after and their mothers. I do try to make the mothers' lives a little more pleasant, because helping lift the burden of work and exhaustion off mothers is a large part of the point for me.

But I do take it very personally every time a feminist mother complains about how non-mothers are oppressive, giving no support to mothers, and how children aren't taken seriously as an issue. You could say they don't mean me, really, but I don't know any more. The fact that the mothers whose children I have looked after didn't want me being any closer than I was doesn't prove there aren't others who'd appreciate sharing more. But I almost feel that the extent of my commitment is precisely what most feminist mothers don't want. They want support, on their terms, but they don't want to share.

Does that sound horrible? I don't think it is—or it is only if we all believe that shared childcare, to the point where the boundaries between being a mother and not being a mother become blurred, is the feminist way forward. But who now wants that? Not those who are choosing to be mothers, obviously. I know there is the line that no-one really chooses to have children; I suppose in many senses none of us choose to do anything. But if we don't accept that women, in certain privileged circumstances (such as being in the women's liberation movement) can make a choice to have children, aren't we claiming we're entirely passive, entirely without control of our lives? That women who do think very hard before they get pregnant are entirely misled in believing they are making a positive choice?

The argument that women don't choose, while intended to silence liberal nonsense about how women who have children should have to suffer the consequences of society's poor treatment of them, can end up sounding suspiciously mystical, as if there's something about giving birth, about making a baby with some bits of the same genetic material as yourself, that is so different as to make any comparisons between 'before' and 'after' meaningless (and conversation between mothers and non-mothers impossible). Or as if women don't choose, it's something spiritual moving in us ... Excuse me, I've heard this one before somewhere.

Insisting that women don't 'choose' can sound like an insistence on a definite boundary - a statement not so much that women can't make sensible choices, but

that motherhood is in itself qualitatively and intrinsically quite different from any other way of being involved with children. Perhaps that's what we all believe.

I'm going to take it that some of the women around me are making an informed choice to become mothers. What is it that they are choosing? Some of them, I know are choosing to become mothers because shared childcare didn't work out for them: they were never given enough time or say with children that didn't 'belong' to them, and sometimes even lost them, as I did. They have come to feel the only way to make sure of a secure relationship with a child is to have one of their own. Of course I understand that. I felt, for the only time in my life, that I wanted a child just after I'd lost all access to the two I'd been parenting. I couldn't do it, mostly because I knew no child of my own would ever substitute for them. But other women feeling they have to have their own child are accepting the division between mothers and non-mothers. A division, ultimately, of control?

Women I know—feminists, mostly lesbians—who are choosing to have babies want to be *mothers*, not non-biologically-determined parents. They want to *have* a baby, not access to someone else's. They want it to know they are its mother, to be identified as mothers socially, even to be the one who *has* to get up in the middle of the night. If that sounds crazy to some non-mothers, it doesn't to me. I know something about what you get back for doing that; and part of what I know is that you get a sense of power. Not just over the child, but also in relation to other adults. Mothers are oppressed by male-dominated society in so many ways. But I think many feminists who are now choosing to have children want to have some area of life, childcare, where they'll have the last word, where the importance of their position as the one and only 'Mum' is assured.

They know, of course, that they'll have to struggle for control with schools and other institutions, particularly if they are Black, Jewish, working class, lesbian, and/or disabled. But they can choose, by using self-insemination, not to set up any struggle for control with individuals, either fathers or female non-mothers.

Women are coming more and more to want to have their children without interference from other adults. Many mothers around me, non-feminist as well as feminist, aren't looking for ways to offload the caring, but positively appreciating being the adult who's in control. What they do want, and need, is more money, better housing, more and better childcare facilities - nurseries with parental control, schools with more parental say. And creches at conferences and childcare for meetings and socials, as a matter of course. All that has to be a priority for the Women's Liberation Movement.

And yet, if I've stopped being angry at feminist mothers, individually and collectively, I think I'm going to remain a little sad—I suppose, at the passing of my youthful idealism about new ways of bringing up children, which break down society's divide-and-rule into mothers (Real Women, but ignored) and non-mothers (who don't even count as adults). Is the only way to survive such a woman-hating, child-excluding culture to take the small power and status the label 'mother' gives us in return for the isolation? And if so, how can we prevent endless tensions between mothers who feel unsupported, and non-mothers who feel betrayed?

4. The Demand that Time Forgot (1992)

Dena Attar

On the corners of streets near where I live you can often see groups of women hanging around, toddlers in tow, after they've taken their children to school in the morning. They stand talking for up to half an hour whatever the weather, because there isn't anywhere else to meet and it's better than being alone. Then they go and there is no more sign of the mothers and children shut away behind doors somewhere, isolated. It is easy to forget, with all the current emphasis on mothers returning to work, how many women's lives are still like this.

At the first WLM conference I went to we agreed to have four demands, for equal pay, equal opportunities in work and education, free contraception and abortion on demand, and twenty-four hour nurseries. From then on I was active in all sorts of groups and campaigns — consciousness-raising, women's centres, women's aid, free pregnancy testing, reclaim the night, rape crisis. We made up more demands, then stopped having demands. We won the arguments about equal pay and opportunities but realised there was a lot still holding us back. We found new issues all the time. There was more and more to do but then I had children and started cracking up and stopped going to lots of meetings and being in several groups at once. Now I have to figure out very carefully where the time's coming from.

We were always a bit embarrassed about that demand anyway, even when it was first adopted. We had to keep explaining that we didn't mean that babies and children should be left in the twenty-four hour nurseries all the time. It was just that mothers needed provision to work the hours their jobs required, day or night, and to go to meetings, go out, whatever. Nothing less would really do if we wanted to free mothers to participate as equals in the adult world. The embarrassment was resolved simply enough — we kept it as a demand but left it at that, without groups or campaigns or anything much at all.

I have other embarrassing memories and some that make me very angry. I remember a group meeting where we discussed motherhood, and had decided to interrogate each of the mothers present (they were in the minority) about their reasons

for having had children. They all said it had not been consciously or deliberately chosen. That let them off the hook then. They obviously had the rest of us figured out — that version of events gave them some lever to demand support, whereas any woman confessing she'd deliberately opted to have a child could expect to be left to get on with it. An even more shameful memory is of early experience in free pregnancy testing groups, where we just assumed that every positive result was a disaster. I heard later of one woman wanting a baby who sneaked in alone and used the kit herself so she wouldn't have to face us. We learned eventually and mended our ways.

I first realised how much of a minority mothers were in the WLM at a meeting where a majority vote decided to charge women for using the creche at a new women's centre. Looking around the room I could see exactly why the vote was lost. In fact, most women are mothers. In meetings like that one, most women weren't. Most of them missed the point that their decision meant charging women with children for using a centre which childless women, who are usually more affluent, could use for free. Few mothers had any say in the matter, because few of us were able to be at the meeting.

A couple of years later I went to an open meeting at another women's centre where I knew no-one but hoped to start getting involved. It was a daytime meeting and I had three-year old twins with me. The creche wasn't open. Nobody spoke to me when I arrived. I struggled to keep the children quiet and non-disruptive while the other women got on with the agenda — they spent a long time on details about one worker's maternity leave and replacement. Eventually the effort became too much and as I couldn't follow or take part in the discussion I decided to leave. Nobody spoke to me when I left either — I didn't go back for a long time and I'm still angry.

Strip away the anecdotal detail and this is the picture — feminists have failed to campaign for childcare because mothers, who need it, don't have enough of it to find the time for campaigning, and others, who don't think they need it, don't have the motivation — some are even hostile. The situation I'm describing also coincides with a historical period where the marketplace, not the community or the state, is supposed to provide. Instead of a collective response to the needs of working mothers, there's been a privatised response. The waiting lists for nursery places are still huge while domestic service is once again becoming a significant sector of employment for young women working as nannies, in a reversal that takes us back to the 1930s.

There has been a National Childcare Campaign but it was never an autonomous, feminist campaign. It was a mixed rather than a women's organisation which for a

while lived up to its name and did some campaigning. In the mid-80s the government offered it, amongst other organisations, what seemed a large sum of money to administer for childcare projects outside London. There was a debate; the amount was really tiny in comparison with the need, enough to fund some office expansion and new workers and a few new nursery places around the country. In the end the NCC took the money, the organisation grew (amidst splits and quarrels), and increasingly devoted itself to topics like the pay and conditions of nursery workers (but most of us still didn't have nurseries), the management and running of nurseries it was involved in (but most of us still didn't have nurseries), and virtually stopped campaigning (but most of us still didn't have nurseries). Its offshoots survive, and there is still some piecemeal campaigning for moderate demands, but without much visibility or grassroots support. Of course feminism has attended to the concerns of mothers and children, but what I want to address in the rest of this article is the gaps and silences, the biases.

In her article 'Feminism and motherhood' Ann Oakley critically examines the predominantly negative evaluation of motherhood which was presented by feminists up to the late 1970s. She speculates that the shift in emphasis was connected with whether or not feminists theorising about motherhood were writing from experience, noting that those who were (such as Adrienne Rich) were more positive than those who were not (Shulamith Firestone, Germaine Greer, Juliet Mitchell and Kate Millett). She may be right, but I think there were also other shifts for which we need wider explanations.

Shulamith Firestone was unequivocal about the centrality of motherhood, as a role, in the oppression of women when she wrote in *The Dialectic of Sex* (1970) 'The heart of woman's oppression is her child-bearing and child-rearing role'. In some ways the revolutionary and radical feminists of the 1970s and 80s took this statement and turned it around, in arguing that we needed a politics of reproduction, the point being that men oppressed women in order to control reproduction, rather than that the way for men to oppress women (for whatever reasons) was through reproduction and motherhood. But other issues took over anyway: the cornerstone of women's oppression was next said to be heterosexuality, or pornography, or violence. I guess there are four corners to my house.

Firestone didn't argue for twenty-four hour nurseries but much more radically against a society which excluded both mothers and children, against the institutions of both motherhood and childhood. *The Dialectic of Sex* is a brilliant book, funny, passionate and very much of its time — the era of anti-Vietnam protests, student uprisings, dropping out. It isn't really about sex or dialectics so much as it's about freedom. The sections on children and mothers are still widely remembered and referred to, although often in a distorted way (notoriously the suggestion that child-bearing could be taken over by technology). The most unusual feature of her analysis is the stress on children's rights — she has considerably more empathy with children than with mothers, although she doesn't distinguish between girls and boys, nor always even between mothers and fathers. Her views on the freedom of ghetto life — kids bringing themselves up — now seem startlingly naive, but at least she did recognise that children too were oppressed, and didn't simply equate their needs with those of adult women.

Firestone influenced my generation of radical feminists far more than I realised at the time. Since there wasn't a handy technological fix, there seemed only two choices. The first was not to have children at all, but the problem with that was if creating the feminist revolution meant not having children, it wasn't clear to some of us why a feminist revolution was in our interests. The second was to construct the complete alternative society within which to raise them. The realisation that we didn't quite have time for this before our own childbearing days ran out started hitting lots of feminists in the 1980s — and then there was trouble.

I have been painfully re-reading articles and letters to get the flavour of those times. Ruth Wallsgrove's 'Thicker than water: mothering and childcare' (ch. 3, this volume) spoke of betrayal — that is, the betrayal of a feminist ideal, or of other feminists, by women who decided to have children and have them now when we hadn't yet achieved the revolution and were going to have to raise them in the

same old ways. These confrontations happened in real life, as well as on paper. Oddly enough, in wanting to know why exactly mothers thought they had to have a different relationship to children from that which other adults could have, feminists kept on forgetting about breastfeeding — or remembered, but set limits so that it wouldn't interfere with a co-parent's equal rights and responsibilities. There were also the feminist voices claiming you really did have to choose — you not only couldn't be a revolutionary, you couldn't be a creative artist and a mother. Alice Walker conceded you could write and be a mother if you only had one child.

Exploring the whole issue of choice was important, and still is; I do not minimise the impact of negative attitudes towards women without children (which to some extent those of us with children have also experienced for part of our adult lives). Taken to extremes, the wholesale querying of biological motherhood as a reasonable choice led to some distinctly anti-woman attitudes, covert or outright hostility towards mothers and children alike. It also served to push aside other questions about choice. Whether or not to have children and the right to choose is not as urgent a question to mothers who already have them, who generally have less money, less time and fewer choices than other women. (The income gap between men and women, for example, is really a gap between men/some women, and mothers).

Meanwhile socialist feminists, less troubled by the personal politics of it all, were analysing reproduction and childcare in relation to production and capitalism. Many were working within trades unions and local government to put childcare on the agenda, trying for what was possible (and therefore not very radical). Liberal feminist mothers worried about conditioning and wrote about how you needed to set up a thoroughly illiberal regime in your own home, censoring children's TV, toys, books and access to the world outside. Radical feminism grew more interested in less mainstream issues: new reproductive technologies, child sexual abuse, lesbian custody cases. From a radical feminist perspective it was always clear that extreme cases grew out of a general situation, but also served to patrol the edges of the mainstream — they kept mothers in line, but also happened because mothers were kept in line. Yet the effect of concentrating on minority experience in this way can also be that mainstream experience ceases to be seen as problematic, and is reconstructed as normal.

The point is not to blame individual women, let alone feminists — there is certainly no point at all in simply leaning on other women to take the personal responsibility for childcare which they may have deliberately decided against for themselves, nor do many of us want our children cared for on that basis. It is much more important to look at the politics of childcare and the politics of motherhood which we have

collectively developed. Most mainstream current discussion is extremely narrow, focused on working mothers, childcare provision for the under-fives and a few allied concerns. It is not only twenty-four hour nurseries which have fallen off the agenda. We've stopped even discussing what we might want, and meanwhile the agenda could just as easily move backwards as forwards. There's always a possibility of a backlash against working mothers, not only in this country, even though for most mothers there is never anything but an illusion of choice. In middle-class sectors of employment, things are supposedly getting easier for working mothers all the time. Meanwhile there are right-wing arguments that better maternity leave will make it too expensive for international capital to employ women here, forcing it to seek out cheaper labour elsewhere in the world where women don't have such costly rights.

A radical agenda for discussion ought to include more than how to get our children taken off our hands — which isn't always what we want. It has to include poverty. It ought to include how mothers are constantly policed, how we have responsibility without social power, but also frighteningly real power. Who do we want to have caring for children when mothers aren't doing it — the state? Men? Other women? We need more honest discussion of choices or alternatives without having to pretend it's all fine.

References

Firestone, Shulamith (1970), *The Dialectic of Sex*, London: Paladin.

Oakley, Ann (1986) 'Feminism and motherhood', in Martin Richards and Paul Light (eds.), *Children of Social Worlds*, Cambridge: Polity Press.

5. Baby Talk (1992)

Diana Leonard

am writing in response to Dena Attar's article on motherhood, childcare and women's liberation.[1]

Since I was active around childcare, trying to get a nursery at the university where I was a research student and creches at conferences when I had kids, I guess I've become one of the feminists she mentions. I fail to campaign for childcare anymore because I personally don't need it and don't have the motivation; and I may even appear hostile since nowadays I won't organise a creche at conferences I'm involved with.

But this isn't just indifference. My gut response is that I veer away from work on childcare because it feels like a bottomless pit — witness Dena's account of how little was achieved with the seemingly large sum of money given to the National Childcare Campaign in the mid-80s. And the reason I will no longer organise creches for conferences is because I know from bitter experience that (a) it triples the work and the cost; (b) women say they need one — and then don't come/don't bring the child, so one is left with a pissed off nursery worker who has given up a Saturday for nothing; and (c) kids don't like them.

But this is obviously not the whole story, and musing on this, and on Dena's account of being ignored when she visited a women's centre with her children, together with her remarks on early 80s feminist arguments that having children was a betrayal (of a feminist ideal or other women), leads me to some questions. These all relate to aspects of motherhood which I think mothers have to change if feminism is to progress.

In the women's centre, why did none of the other women help look after her kids? Dena suggests the reason she could not participate in a meeting was because she had her children with her, because the creche was shut. Either there is a creche or the mother is responsible for keeping the children amused/quiet—certain people care for children (mothers, creche workers, fathers) and the rest of the world doesn't and shouldn't have to. If all those present at the meeting had kept an eye on and entertained the children and tolerated their activities and chatter, there'd have been no need for a creche.

But as Ruth Wallsgrove (ch. 3) makes clear, although many mothers want other women to help with childcare and say they welcome support from others, they

never want to lose control of 'their' children. We can actually be very 'hands-offish' if other people try to help, let alone to establish a close relationship with a child. Mothers *own* — and intend to continue to own — their children. The trend in feminism seems to be towards an intensification of this 'mother right' (Christine Delphy, ch. 6).

Why don't children like conference creches? Or to put it another way, why is the childcare which kids routinely get (and expect) so difficult to reproduce elsewhere? Dena's article takes as given the very high quality of childcare provided (in most cases) in the UK today. Children (and husbands) expect to be comfortable in their own homes with their own toys and food, looked after by an adult on a one to two or three basis. It is incredibly expensive to substitute for this — and anyway, the location and the personalised nature of the servicing is absolutely integral to the job.

This is why socialist feminists' suggestions that 'socialised' (state or commercial) services (restaurants, laundries — and nurseries) could substitute for women's domestic work have always been so way off-beam. They have never recognised what husbands/fathers get personally from women. It is also why the early WLM demand for twenty-four hour nurseries was embarrassing. Childcare and other domestic work is not as 'good' when done elsewhere. It has to be done for children and men in their own homes, at exactly the times and in the form they want. To get something approaching the same quality universally provided by the state, or to buy it, would be prohibitively expensive — so it is exploited, taken free, from women. We shall not get out of this impasse unless and until feminists/mothers are prepared to problematise the content of childcare: to stop taking what are in fact middle class, western, late twentieth century standards of childcare as a given or as desirable.

Why are some women/feminists hostile to mothers? While I sympathise with a lot of what is in Dena's article, and don't (as she would say) minimise the pleasures of motherhood, I think we do have to go on 'querying biological motherhood as a reasonable choice'. I have never tolerated a women's movement which required women not to be mothers (or indeed not to be heterosexuals); but I have more sympathy with non-mothers than Dena.

Women without children are heavily policed, and where else except in the women's movement do they get any support for their choice? To me, the oppression of mothers and non-mothers are two sides of one coin.

There is not only heterosexual privilege, but also maternal privilege. Women do get praised for being so clever and normal as to have managed to get pregnant; and some of us, even feminists, put down childless women. Mothers do say to me

'You'll understand because you're a mother too', or 'You have to be a mother to understand what it (equalling virtually the whole of life) is all about'.

Motherhood divides women, and hard as a mother's lot may be (at times), mothers are the socially acceptable group — and often very unreflexive on our own situation and motivation. We need to think hard before appearing to attack other women.

Note

1. This piece originally appeared on the letters page.

6. Mothers' Union? (1992)

Christine Delphy

What I want to discuss is an intellectual tendency to be found to a varying degree in various parts of the women's movement, and to varying degrees in many individuals. It is an inclination to think in a particular way which exists more or less strongly, more or less manifestly, and more or less consciously in all of us. This inclination is not something which is explicitly formulated, but an element in writing on different subjects and in diverse campaigns and actions which together form a whole I call the 'maternal demand'.

This is defined by three aspects:

■ it tends to base women's rights — claims for liberation — *on women's specificity* (and not on their universality, on being members of the human species);
■ it tends to base this specificity on women's particular function in reproduction;
■ it tends to demand special rights over another category of human beings: *children.*

This clearly shows the central problem posed by all ideologies of difference, whether they apply to women or to other groups. Specificity allows a group to demand exorbitant rights — rights which are not accorded to other groups. But the other side of the coin is that this same specificity requires the group to renounce other rights, rights to common treatment. The motherliness which marks out women is the basis on which some feminists currently claim exclusive ownership of children; and the individuals and groups concerned unquestionably set great store on acquiring this right. But whether they are aware of it or not, their approach is certainly not *objectively* compatible with other feminist demands based on universalism; and in making this demand they are implicitly renouncing full membership of the human species. In addition, there is the equally important problem that they are demanding ownership, not of goods, nor of their own bodies, but of other human beings.

The reason why I looked through various texts for indications of this position was because in the last few years my attention had been drawn to it by untheorised

attitudes amongst most of my feminist friends: by their 'spontaneous' reactions which all went in one direction. To them it seemed to be 'obvious' that when a couple separated it was a victory *for feminism* if the woman got custody of the children, and a defeat if her husband got them. After a while I started to ask myself why; and then I asked other people. But all I got was a look of astonishment. How could I even ask the question? In addition, various 'feminist' political actions seemed also to be inspired by the same implicit sentiment: that it is both 'good' (for women) and 'the right' of women to own children. Here I will take just three examples of the very diverse concerns within feminism which show evidence of elements of the maternal demand.

New reproductive technologies

Many feminists are currently studying the new reproductive technologies, and with few exceptions their attitudes towards them range from fairly negative to apocalyptic. Now, some disquiet about reproductive technology is certainly legitimate. Research suggests those who seek to have their eggs removed by laparoscopy and then re-implanted in their uteruses may not be making a fully informed choice. They may not know the risks involved in the operation nor realise the very low success rate. But is this something specific to surgical interventions to remedy infertility or doesn't it also apply to the majority of medical interventions? If so, what is at issue is just another instance of a more general problem — the retention of information and abuse of power by the medical profession.

Another line of criticism argues that surrogate motherhood will lead to poor women being exploited for the benefit of rich women, and suggests we should not accept surrogate motherhood in principle, since it involves selling one's biological processes. However, if the issue is the exploitation of poor women's bodies, then surrogacy is not the most striking instance. Every day hundreds of thousands of prostitutes, three-quarters of whom were captured or sold by a relative and held in conditions of slavery and torture, sell their bodies — often with no profit to themselves. There are a few hundred surrogate mothers and their exploitation lasts nine months; it is voluntary; and they themselves receive money. If feminist critics were really concerned about the exploitation of women's bodies, how can we explain their being more scandalised by surrogate motherhood than by prostitution? Which leads me to think it is not the exploitation of the body which is their real cause for concern.

In addition, those opposed to reproductive technology often paint apocalyptic pictures of a conspiracy by men to replace women by artificial uteruses. The goal

attributed to such men when the spectre of 'gynocide' is evoked, is the elimination of women thanks to artificial wombs. But the snag is that, as yet, not a single artificial womb exists. And even if men could produce such a machine, imagine what it would cost — and even more how much it would cost to produce millions of them! Can we really imagine the construction of enough such machines to replace three billion women?

But leaving aside the feasibility of the operation, to imagine this is the goal of the masculine half of humanity, is to think (a) that men only consider women in so far as we serve them; and (b) that women only serve men through reproduction. Although the first proposition is unfortunately true, the second is not. To say that men only 'use' us for reproduction, is to fall in the trap of accepting men's own ideology. Men do indeed often say 'women are only good for having babies', but this is their way of minimising how useful we are to them. Women also do more than half of all human work, and three-quarters of the work we do is unpaid and benefits men. So why should they want to eliminate us?

The fear that women will be physically eliminated is both unfounded and in the present circumstances (given the wide-ranging exploitation to which women are subjected), absurd. It is hard to believe this is really what preoccupies those who oppose the new reproductive technologies. So what is at stake for them? I think one indication is given by their constantly repeated assertion that women's role in biological reproduction is more important than men's.

In order to pass new laws on assisted reproduction, a single, unique form of descent and kinship, the western married couple and their legitimate children, has been erected as the unchangeable and supposedly natural model. But not only has this always been a model, an ideal which has never been the statistical norm, it is itself in the process of losing its normative status. Things are being asked of people who want to use assisted reproduction — that they be heterosexual and married, etc. — which other people not only do not fulfil, but which are not even asked of them any longer. Some feminists' views on what should be allowed and what forbidden when reproduction is assisted, *also* involve a model based on reference to nature — though theirs is not the same nature as the nature invoked by legislators. In 'feminist' nature:

- the only biological tie in reproduction is the one between a woman and a child. The role of the biological father is minimised (read ignored);
- this biological bond between woman and child is considered to be the basis of kinship, ie of affiliation or descent.

But this supposedly natural matrilineal descent also does not prevail in either norms or fact. So here it is feminists who are demanding of potential 'non-natural' parents (those seeking assisted reproduction) that they conform to so called natural requirements — things they do not require of natural parents.

Such feminists seem to find the debate on reproductive technology an occasion on which to express their views on what descent *should be*. But whatever form descent may take, it is *always* a social convention. Instead of attacking the social convention and demanding that, as a social convention, it could and should be changed, most feminist critiques of reproductive technology simply assert that descent exists already, in nature.

Feminist reconstructions of human evolution

The same assertion is also found in feminist writing on the origins of women's oppression which draws on ancient history, anthropology and prehistory. Books written in the 1970s and 80s interpret knowledge, from frequently disparate scientific universes, in the light of certain assumptions. These are not usually explicit. Sometimes they are totally implicit and sometimes they are produced simply as assertions which require no proof. They speculate about the possible conditions of human existence either in an ahistorical, absolute condition or in a primitive community whose technological level and cultural forms are not specified. So what they are really doing is questioning under what conditions human existence would be possible prior to the emergence of any social formation or organisation.

So far the disciplines of anthropology and sociology are concerned, however, such a question is a contradiction in terms. So despite their use of anthropological material about real human life, these writers in the end attach themselves to a tradition of philosophical thinking which places the individual chronologically prior to society and tries to imagine the emergence of life in society on the basis of the (biological, psychological, etc) 'needs' of these pre-social humans. They therefore postulate a non-social human nature.

I call such accounts 'feminist reconstructions', because the way they operate has the same mythological character as patriarchal reconstructions. Both share the same surreptitious abandoning of the anthropological premise that human beings and culture cannot be dissociated from one another; they also share certain presuppositions about the conditions of existence of the first human beings, who are sometimes seen as a mythical group, and sometimes conceived of on the model of existing hunter gatherers (the population with the lowest known level of technology).

Feminist reconstructions differ from their patriarchal counterpoints, however, in their interpretation of these same premises. Both feminist reconstructions and patriarchal constructions see the reproductive role of women as largely dictating their social role. Both take for granted particularly that

- the woman who gives birth to a baby will necessarily suckle it;
- the woman who nurses a child will necessarily care for all its other day-to-day needs;
- each of these functions will be performed by just one person; and
- all these functions will be performed by the same person, who will be called the mother.

Patriarchal reconstructions distinguish descent — the affiliation of the newborn into society via a given individual or individuals (the 'father', 'mother' or 'family') – from the responsibility for upbringing. Feminists, however, not only see all the roles as intermingled and as deriving from the act of giving birth, but also affiliation or descent as automatic. A baby is deemed to be automatically affiliated to the woman who brought it into the world. Descent is seen to flow naturally from giving birth, with no social mediation and no decisions being made.

The second point of difference from patriarchal reconstructions is that in feminist reconstructions, women, or rather females, are the ones mainly responsible for the survival of primitive society. This is firmly linked to the first point, since the fact of giving birth is seen as itself carrying social responsibility for the young, just as it carries the social attachment of the child to its biological mother. Thus, for instance, according to Maria Mies women were concerned with gathering and later invented agriculture, so as to feed themselves and 'their children'. Note that they were the women's children — with no question asked or explanations sought. In these feminist reconstructions, women's specific role in reproduction entails responsibility for — or ownership of — 'their' children, without further formalities.

In patriarchal reconstructions, the domination of women by men is not a problem. It is inscribed in the unchangeable nature of the human species: in women's reproductive role and everything (giving birth, breastfeeding, and caring for children) which is thought to be part of this reproductive role. Women's subordination does not have to be explained or to have an origin. It was always there. It has simply continued.

In feminist reconstructions, however, women are the motor of progress, and they are this not despite but because of motherhood. Therefore the overthrow of

mother right is for these feminists *the overturning of a whole social and cultural structure*, which included as a fundamental trait descent through the female line. This original social organisation was motherly, responsible, and particularly careful of the immediate and future survival of the group. Maternal care induced a culture where the values of peace and co-operation predominated, and where aggression, violence, individualism and egoism were prohibited.

This whole edifice rests on one assumption: that women feel a responsibility towards future generations, and hence to the entire group, because of the way their experience is shaped by being responsible for 'their' children. And this assumption itself rests on another, for this feeling of responsibility is attributed to all women, and denied to all men, for just one reason: women give birth and men do not.

The sacred bond

Such theories are also evident in essays which fall into the category of 'general feminism' and which stress feminine qualities and values, for their authors see such qualities as deriving from an experience specific to women: motherhood. In an analysis of the emergence of conservative and pro-family 'feminism', Judith Stacey notes that its principal advocates draw inspiration from accentuating 'the life giving values associated with motherhood'. Authors from this new current pay only lip service to the problematic of gender. They may affirm at the start of their work that the values and attitudes they are going to talk about are historically constructed, and they deny that they support any form of biological determinism. But having said that, they proceed as if the values and attitudes in question were shared by all women: by all women irrespective of the society in which they are geographically located, by all women who have ever lived within the same geographical area whatever the epoch, and by all women who live in the same country at the same time whatever their social background.

These authors are therefore calling 'feminine values' a collection of very specific values, which correspond more or less to those of western housewives of the last half century; and they are then projecting these values on to all the women of the world across the centuries. In addition, these values correspond only 'more or less' to those of western housewives, since the authors speak more of the norms than of reality. But whether or not the values and attitudes they call feminine are really those of even a particular generation of women, is less important than the fact that they generalise in such a way that their thesis is actually ahistorical.

These writers make modern motherhood into not only a supposedly universal experience, but also an entirely positive one for both women and children. This is

pretty astounding. How can anyone idealise motherhood in a movement where half the activists are in therapy because they are mothers, while the other half are in therapy because they have been children?

Women's liberation or a mothers' union?

This new current tends to see only positive behaviour and values in motherhood, which involves a stupefying misinterpretation of the facts. But what this does, and this is perhaps its purpose, is to make us totally identify the interests of women with those of mothers; and the interests of children with those of mothers. The identity of women is thus once again completely circumscribed by motherhood; and children's dependence continues to be taken for granted.

It is assumed children have at best, or at worst, two parents; and that only a parent can defend a child against its other parent if he is bad. People don't ask why children are dependent on adults, and on just two adults; nor why they are so fragile and so exposed to violence. Abuses of parental powers, are caused by/attributed to the character of the parents, and given it has been shown that women are good and men are wicked, to men's bad nature. People forget that there can only be an abuse of power when power already exists, and that changing the protector does not change the situation of non-power which underlies the need for protection.

A feminist project which does not question all forms of subjection, including those which seem natural (because after all we are well placed to know that our subjection was also, and is still, considered to be natural) no longer deserves to be called a liberation project. And I do not want to witness the transformation of our liberation project into an attempt to defend the immediate interests of *some* women. I fear even more women's interests being identified with acquiring the entire set of rights of parents: with wresting from men what remains of their parental authority.

I view with deep disquiet the feminist movement transforming itself into a fight for the ownership of children. There are many (too many) signs which indicate we are taking this path. Whether it is a question of action around the new reproductive technologies, or the new feminist myths of origin, or the idealisation of motherhood, the same leitmotif is everywhere: 'Children belong to women'. (Phyllis Chesler's book on the 'Baby M' case where a surrogate mother opposed adoptive parents with whom she had made a contract, was entitled *Sacred Bond*.)

Maybe we will end up with full ownership of children; but I don't think this will help children. It won't be much of an improvement for them, even if the new owner proves better than the old one. Nor do I think it will help to liberate women. It may constitute a short-term increase in power for some women within the gender

system as it exists; but it will be at the price of renouncing the objective of having the gender system disappear.

References

Chesler, Phyllis (1980) *The Sacred Bond*, New York: Times Books.

Mies, Maria (1986) *Patriarchy and Accumulation on a World Scale*, London: Zed Books.

Judith Stacey (1986), 'Are feminists afraid to leave home?' in Juliet Mitchell and Ann Oakley (eds.), *What is Feminism*? New York: Pantheon.

7. Weasel Words (1996)

Liz Kelly

Over the last few years I have become increasingly alarmed by the ways in which feminist perspectives on child sexual abuse are being undercut by the acceptance of flawed concepts and ideas. It would be bad enough if this were confined to professional perspectives, but more and more I have encountered women's organisations using the word *paedophile* and subscribing to 'cycle of abuse' theories. The ease with which this language now trips off women's tongues disturbs me greatly; do we too —on one level—want to distance ourselves from the implications of sexual abuse in childhood, confine it to limited contexts, have a group of men who we can justify thinking and talking about as 'other'?

Immediately the word *paedophile* appears we have moved away from recognition of abusers as 'ordinary men'—fathers, brothers, uncles, colleagues—and returned to the more comfortable view of them as a small minority who are fundamentally different from most men. Attention shifts from the centrality of power and control to notions of sexual deviance, obsession and 'addiction'. 'Paedophilia' returns us to the medical and individualised explanations which we have spent so much time and energy attempting to deconstruct and challenge.

The self-serving construction of paedophilia as a specific, and minority, 'sexual orientation' acts as a useful distraction from the widespread sexualisation of children, and girls in particular, in western cultures, and from the prevalence of sexual abuse. In a 1989 US study by Briere and Runtz a significant proportion of male college students reported that they could be sexually interested in children if they were guaranteed that there would be no legal consequences. The representation of the 'ideal' heterosexual partner for men continues to be younger, small, slim, with minimal body hair. Across many cultures sexual access to girls and young women is often the prerogative of powerful men: chiefs, priests and religious leaders. The western echo of this age-old patriarchal tradition can be seen in the pre-requisite young girlfriend (occasionally 'under age') of older rich men. There is an important theme here which links male power, economic power and social status with sexual access to girls and young women.

In much of the clinical literature on sex offenders, 'paedophiles' are separated not only from men in general, but also from other men who sexually abuse. Similarities—in

the forms of abuse, in the strategies abusers use to entrap, control and silence children—are ignored. Fathers, grandfathers, uncles, brothers who abuse are hardly ever suspected of being interested in the consumption, or production, of child pornography, nor are they thought to be involved in child prostitution. This in turn means that investigations of 'familial sexual abuse' seldom search for or ask questions about these forms of abuse. This contrasts with what we know from adult survivors who tell of relatives showing them pornography, expecting them to imitate it and being required to pose for it. Some also tell of being prostituted by relatives. A significant proportion of organised abuse networks are based in families.

Who are the clients of children and young people involved in prostitution? I suspect only a minority would fit clinical definitions of 'paedophiles'—men whose sexual interest is confined to children. Whether intentionally or not, calling a section of abusers 'paedophiles' is accompanied by an emphasis on boys as victims, and the abuse of girls and young women outside the family becomes increasingly invisible. Unlike 'child abuser' or 'child molester' the word 'paedophile' disguises rather than names the issue and focuses our attention on a kind of person rather than kinds of behaviour.

In much of the literature there are inconsistencies in how 'paedophilia' is defined, although the most common element seems to be the assumed 'fact' that it is not just a preference for, but the restriction of sexual arousal to, children. The possibility that the 'paedophile' may also have sexual contact with adults is never explored. Julia O'Connell Davidson's work is documenting the fact that the dividing line between the men who exploit children and women in sex tourism is neither clear nor absolute. The focus on sexual arousal moves us into further difficulties, since the recent feminist emphasis on individual men *choosing* to act or not act, and having to take responsibility for those choices, is much more difficult to sustain where 'deviant' sexual arousal is represented as having a biological basis in individuals.

These confusions have, if not created, at least contributed to a context in which men who seek to justify their wish to abuse have been able to organise politically, and even seek the status of an oppressed 'sexual minority'. They also form the basis for a differential approach in terms of intervention, with responses being proposed in relation to 'paedophiles'—such as life licences, and denial of any contact with children—which would cause outrage if proposed in the case of fathers. The issue here is not whether the responses themselves are appropriate, but the way in which spurious distinctions are being made between 'types' of abusers; these result in abuse by family members being regarded as less 'deviant', and therefore, less serious than abuse by men outside the family.

Cycle of Abuse

Whilst 'cycle' explanations have a long and inglorious history, in the 1990s the 'cycle of abuse' has become the dominant explanation of why sexual abuse happens. The origins of this 'theory' lie in nineteenth century philanthropy and early twentieth century psychiatry. It has proved a popular explanation for all forms of physical and sexual abuse in the family (and in a slightly different guise—'cycles of deprivation' —has been the conservative approach to explaining poverty and Black socio-economic disadvantage). Every cycle model attempts to reduce complex social realities, which have more than a little to do with structural power relations, to simplistic behavioural and individualistic models.

In its simplest and most common form, 'cycle of abuse' proposes that if you are abused as a child you will in turn abuse others. But if we begin with what we know about the gendered distribution of sexual victimisation and offending the proposition begins to fall apart. We know that girls are between three and six times more likely to experience sexual abuse, yet the vast majority of sexual abuse is perpetrated by males. If there is any kind of cycle it is a gendered one, and that in turn requires explanation. Even if arguments that there is a hidden iceberg of female abusers have some validity to them, to reverse the gendered asymmetry would require an iceberg of incredible proportions.

No study has yet demonstrated that there is an obvious 'cycle' even within samples of convicted offenders; the range of those reporting experiences of abuse in childhood varies between 30% and 80%. Few of these studies define abuse in childhood in the same way. Some consider whether the individual was abused in the same way as he has subsequently abused children, whereas others include *any* form of abuse in the individual's childhood whilst focusing on *sexual* offending in adulthood. Yet the psychological mechanisms involved in moving from experiences of physical abuse and neglect to sexual abuse cannot be the same as those where the same form of abuse is involved.

In all studies to date either a majority or significant minority cannot be fitted into the theory. Alongside these glaring problems with the evidence for the proposition, there is seldom any exploration of the precise mechanisms whereby those who have been victimised become victimisers—which is not simple repetition, as many models suggest, but rather a *reversal* of roles.

A rather deft theoretical sleight of hand occurs when proponents of this pernicious idea recognise that women do not proceed in great numbers to abuse. There are two ways in which mothers who have been abused are implicated: experiences of abuse are presumed either to make women less able to protect their children, or to

impel them to choose an abuser as a partner. (The influence of this idea is been so strong that some social services departments consider knowledge of a woman's abuse in childhood sufficient to place her children on the at risk register!)

The first proposition is usually supported through analysis of reported cases, although few of its supporters take seriously what prevalence research tells us: that in any group of women a substantial number will have a history of abuse. Harriet Dempster's Scottish study provides a possible explanation: mothers who have been abused are more likely to report the abuse of their children. If so, the link is precisely the opposite of that which the 'cycle of abuse' theory suggests. These mothers' own experience makes them *more* willing to seek formal intervention to protect their children. Presuming a negative link prevents researchers and practitioners from countenancing an alternative 'positive' one. The tragic irony which some women encounter is that if they reveal their own abuse their report may be accorded less validity.

The second proposition, that women choose abusers as partners, is remarkable. Very few women begin relationships knowing their male partner has abused children—prospective employers have legal rights to information about Schedule 1 offenders, prospective sexual partners do not. If 'choice' is operating here it is made by men. We know that some experienced abusers deliberately target single mothers. If we listened to what women have to say we would also know that some men, when trusted with information about a woman's own abuse or that of her child by another man, use that as 'permission' to act similarly.

Recognising the deliberateness of abusers' behaviour is disturbing; it is much more comfortable to believe that abusers and/or their partners are merely repeating what they learnt in childhood. 'Cycle of abuse' is based on a psychic determinism: experience A leads to behaviour B with minimal choice/agency in between. Apart from offering abusers *carte blanche*, it makes the thousands of survivors who, as result of their own experiences, choose to never treat children in similar ways, invisible. This theory does an outrageous injustice to countless women whose courageous testimony made sexual abuse in childhood a social issue. It also makes a travesty of support for children, since the aim becomes to prevent them 'repeating the cycle' rather than to enable them to cope with having been victimised. By presuming the impacts and meanings of abuse we close off the most important question of all: what makes the difference in how children and adults make sense of, and act in relation to, experiences of childhood victimisation?

It is psychic determinism which connects 'cycle of abuse' to the view that the impacts of sexual abuse are in every respect, and in all cases, devastating: that survivors can only be rescued from an appalling future through intensive therapy.

However, studies which use community samples, rather than adults or children in therapy, discover a wide range of impacts; from those experiencing extreme levels of distress through to many who fit within the 'normal' range.

The negative consequences of the 'cycle of abuse' idea are being most strongly felt by child and adult survivors. It is now commonplace for adults who have been abused in childhood—women and men—to *believe* that they cannot be trusted around children. In my experience when women are asked to explore the issue in more depth none have felt a desire to sexually abuse children. Their conviction that this will be the case comes solely from ideas in the public sphere. So powerful is the idea of a 'cycle', though, that even academics who recognise that most people do not 'repeat the cycle' refer to this as 'breaking' it. We need to ask ourselves why this notion has taken such a hold within public and professional thinking. Most crucially it excludes more challenging explanations—those which question power relations between men and women, adults and children. 'Breaking cycles' is a much easier and safer goal to discuss than changing the structure of social relations.

Some important connections

There are two contexts in which the concept of 'paedophilia' is used. One proclaims difference, as already discussed, in order to protect 'normal' men. The other asserts difference in order to legitimise abusive behaviour.

This 'sexual freedom' model is frequently presented as an alternative and radical approach. It is based upon a belief that all laws on sexual conduct, except where explicit force or violence are used, are an incursion into individual freedom and privacy, and as such a form of coercive social control. This has been argued in relation to children and young people by self-defined paedophile groupings like PIE (Paedophile Information Exchange) in Britain and NAMBLA (North American Man/Boy Love Association) in the USA. The philosophical assumptions which are the basis of this perspective are:

■ that paedophilia is a sexual orientation, and therefore that paedophiles are an oppressed minority, with whom other sexual minorities ought to have a 'natural' affinity;
■ that 'inter-generational' relationships are not just about sex, but are beneficial and based on a form of love that is more honest than most familial relationships;
■ that what is seen as sexually abusive varies culturally, and that in some cultures adult/child sex is acceptable;
■ that children are sexual beings, but this is denied and controlled by adults;
■ that consensual sexual relationships are possible between children and adults.

Critics of this position have raised a number of uncomfortable issues: it is overwhelmingly men who argue for it; it is invariably adults arguing (albeit in disguised forms) for *their* right to be sexual with children, usually boys; sexual activity is prioritised above other rights children lack, such as the right not to be hit, or to sex education. In addition, childhood is not *only* a product of oppressive social relations. Whilst the social construction of childhood does disadvantage children in relation to adults, early childhood involves levels of dependency on others which no amount of social change can remove. This material reality makes the notion of non-coerced consent between children and adults inherently problematic.

Whilst the most eloquent supporters of the sexual freedom position clearly locate themselves within the gay and/or paedophile movements, there are some heterosexual groupings which promote similar arguments, particularly sexualized family relationships. The best known is the Rene Guyon Society based in the US, whose slogan has been 'sex before eight or else it's too late'. In 1990 their membership was estimated as 5,000, and they have publicly promoted 'kid porn'. Evidence has also emerged of a number of the 'new religious movements' (often referred to as 'cults') promoting adult/child sex within the group, and much of what is currently known points to this being primarily heterosexual and following the patriarchal tradition of privileging male leaders' sexual access.

The importance of maintaining our feminist perspective and challenging approaches which refuse to name men and male power was graphically illustrated by the hysterical response in sections of the media to the recent publication of *Splintered Lives*, a report on the sexual exploitation of children. What some male radio and newspaper journalists balked at was not the need to take sexual exploitation seriously, but our temerity in questioning the distinction between 'paedophiles' and other men. Taking note of what resistance to feminist analysis turns on has always been an important guide for me in knowing when we were onto something important. Talk about the 'paedophile' and the 'cycle of abuse' indicates a point of resistance to feminist analysis which needs to be challenged *now*.

References

Briere, John and Marsha Runtz (1989), 'University males' sexual interest in children', *Child Abuse and Neglect* 13.

Davidson, Julia O'Connell (1995), 'British sex tourism in Thailand', in Mary Maynard and June Purvis (eds.), *(Hetero)sexual Politics*, London: Taylor & Francis.

Dempster, Harriet (1989) *The Reactions and Responses of Women to the Abuse of their Children*, M.Sc Dissertation, Stirling University.

Kelly, Liz et al. (1996), *Splintered Lives*, London: Barnardos.

8. All in a day's work? (1997)

Ruth Swirsky and Celia Jenkins

The logic of the position that prostitution is 'sex-work', an occupation comparable to any other, would be to offer jobs in the sex industry to the unemployed. This is exactly what has happened. In 1996, British Job Centres advertised work in massage parlours, escort agencies and strip clubs. Following complaints from the unemployed who feared they might lose their jobseeker's allowance if they turned down these jobs, the Employment Service banned such adverts. Yet this is the logic of constituting prostitution as sex-work, little different from other gendered female occupations.

There are two major feminist approaches to prostitution. The first views prostitution as epitomising the use and abuse of women by men, while the second views it as a legitimate form of labour which is freely chosen by women who earn their living as prostitutes. Those who subscribe to the latter position argue that their starting-point is the experiences and needs of women working as prostitutes, in keeping with the feminist principle of respect for the realities of women's lives. There is, however, no necessary and inevitable progression from seeking to understand the experiences of prostitutes and supporting their needs, to viewing prostitution as a legitimate form of labour.

We want to expose the implications of promoting prostitution as 'sex work', to question whose interests are being served, and to reinstate a definition of prostitution that extends beyond individual women's experiences to challenge the *institution* of prostitution. In short, we are against prostitution and for the rights of women in prostitution.

In defining prostitution as the sexual exploitation of women, we attempt to keep the definition broad and inclusive, while at the same time as recognising different women's experiences of prostitution, in a way that defining prostitution as 'sex work' does not. For example, it may be pragmatic to define child prostitution as abuse, insofar as it allows for harsher legal sanctions against the offender/client. But if child prostitution is defined as abuse, that seems to imply that at some notional age coercion is transformed into free choice. It is this connection between age and choice which has to be severed to promote an effective feminist analysis of prostitution, one which acknowledges the different constituencies of women and children involved, without losing sight of the exploitation prostitution entails.

Prostitution as work

The argument that prostitution is work is exemplified in Mary McIntosh's paper 'Feminist Debates on Prostitution', which suggests that prostitution is 'an activity with its own skills and ways of operating', and that '[prostitutes] are women who are paid for what they do, who earn their living by sex...what they do should be respected as a skilled and effortful activity'. This view is gaining widespread currency: for example, the International Labour Organisation (ILO) recognises prostitution as work. It is suggested that sex work simply entails using different parts of the body from other workers. In the February 1994 issue of *New Internationalist*, which was devoted to prostitution, a prostitute is quoted by Nikki van der Gaag as saying, 'You might sell your brain, you might sell your back, you might sell your fingers for typewriting. Whatever it is that do, you are selling one part of your body... I choose to sell my vagina.' But this side-steps any analysis of the relationship between gender, sexuality and power. Only by denying the potency of sexuality in gendered power relations could one equate physical, mental and sexual activity in this way.

The conceptualisation of prostitution as a form of 'legitimate' work, in some ways comparable to service work, and conditioned by women's general economic disadvantage, depends on a distinction between 'enforced' and 'free-choice' prostitution. Within this framework, enforced prostitution is narrowly defined as trafficking in women and especially child prostitution, while British (and other Western) prostitutes would fall into the 'free choice' category. In support of this position, there is a tendency to draw upon the views expressed by individual prostitutes. For example, a prostitute is quoted by Claire Sanders in *New Statesman and Society* (1990), as saying, 'I want to work with feminists who understand that I have a right to do what I wish with my body'.

Advocates of 'free-choice' prostitution focus mainly on women in the elite forms of prostitution, those working in escort agencies, massage-parlours, hotels and flats. An article by David Watson in the same issue of *New Statesman and Society* suggested a leakage from public sector work into prostitution, with women claiming to prefer prostitution, not only because it paid better but also because of the greater fun, freedom and autonomy they enjoyed. These women said they felt less exploited and more in control than in their former professional work. In particular, ex-nurses pointed out similarities between nursing and sex work, both in terms of physical contact with men's genitals and emotional labour in humouring them.

Decriminalisation of prostitution is favoured (where it is treated as a matter of free choice) for two reasons. First, it is argued that all that differentiates prostitution from other work is the way it is perceived. Robin Gorna contends that the lives of

prostitutes are rendered more complex than other women's *only* (our emphasis) by factors that influence their work as prostitutes (such as drug use, for some) and the stigmatisation they experience from the 'moral' minority and also feminists. Secondly, public resources (including police protection and funding) are less accessible to prostitutes because they are seen as less deserving. Prostitution is not prioritised when it comes to allocating public funds for health projects, except in relation to the perceived threat to male clients of sexually transmitted diseases, in particular HIV. The advantages of treating prostitution as work are stressed by health-care professionals who constantly struggle for funds to support projects with prostitutes. It was primarily for this reason that the Royal College of Nursing voted to decriminalise prostitution at their annual congress in 1995. Experiments in zoning in Holland have been presented as providing a safer environment for prostitution where health services can be offered and the area can be policed — though in fact, it seems that these areas have become no-go areas for the police, and women are harassed entering them. Alternatively, zoning may be seen simply as a measure to keep prostitution away from 'respectable' residential areas, without any concern for the safety of the prostitutes.

The phrase 'commercial sex work' has been promoted by prostitutes' organisations in response to the stigmatisation of prostitutes. Indeed the preferred terms for prostitutes and prostitution in much contemporary sociological literature are 'sex-worker' and 'sex-industry'. Robin Gorna argues that these terms are helpful, not only in focusing on the fact that these activities are work, but also in cutting across moral judgements of the women who work as prostitutes. However, the terms also obscure the exploitative nature of the institution of prostitution and the experiences of prostitutes. We therefore prefer to talk about 'women involved in prostitution' as a means of focusing critical attention on the institution.

Prostitution as exploitation

Although it was a contentious issue, the Beijing conference on women made the distinction between free and forced prostitution, viewing only the latter as a violation of the rights of women. This lends some urgency to the need to re-examine the arguments on prostitution as work. The notion of prostitution as a 'free choice' is hugely problematic in a capitalist economic system characterised by patriarchal institutional and ideological relations. And as Janice Raymond argued at the international conference on Violence, Abuse and Women's Citizenship held in Brighton in 1996, how could force be proved in court and how feasible would it be for women to prosecute pimps and traffickers? Raymond argued that there are

significant dangers in the redefinition of prostitution as commercialised sex work, which implies professionalisation. This dignifies not women but the sex industry, which is controlled by and benefits men.

Prostitution-as-work supporters argue that the worst thing about prostitution is the stigmatisation. Norma Hotaling, an ex-prostitute who addressed the Brighton conference, asked how we are trained not to see the harm done to the women involved in prostitution. In any other work setting, what women in prostitution endure would be described as abuse or harassment. But the exchange of money apparently transforms sexual harassment and sexual violence into work.

Cecilie Høigård and Liv Finstad's study of street prostitution in Norway, *Backstreets*, describes the impoverishment and destruction of the women's emotional lives. The emotional costs involved in being a prostitute are not so much the fear and the experience of physical violence — though that is considerable — as the loss of a sense of self. Women describe the various strategies they employ in attempting to protect themselves against this, strategies which essentially involve maintaining a split between the 'public' and 'private', dissociating themselves from their bodies. This is exemplified by Lisa saying, 'Ugh, the whole thing is sickening. I close my eyes and ears. I cut all my feelings off. It's never, never okay.' But in the longer term, these strategies cannot be wholly effective, as Anna indicates when she says, 'My body isn't mine when I work there. Anyway I'm a dirty slut. When I myself feel so dirty there's nothing okay about having a relationship.' Or when Inga says, 'I'm bitter, I think I've been misused. I'm getting more wasted and worn out.' Høigård and Finstad conclude that 'regaining self-respect and recreating an emotional life is ... as hard as reconstructing a hundred crown note from ashes.'

Prostitution has to be understood within a context of the privileging of heterosexuality premised on an inequality of power between men and women, in a capitalist economic system developed in articulation with patriarchal relations. In the context of the pervasive ideology of hierarchic heterosexuality, when men purchase sexual services from prostitutes for money they transform female sexuality into a commodity. Although far less research has been done on male clients than on prostitutes, a New Zealand project undertaken by Elizabeth Plumridge and her colleagues, in co-operation with the New Zealand Prostitutes' Collective (NZPC), provides fascinating insights into men's self-serving interpretations of how they benefit from patronising prostitutes. These men posit such encounters as emotional relationships, while at the same time asserting that all the obligations associated with relationships are discharged by payment. Payment apparently absolves them from responsibility for the emotional damage to women wrought by prostitution.

Prostitution and marriage

One of the curious features of the new discourse on prostitution as legitimate work is the way it uses the familiar juxtaposition of prostitution and marriage to define sex as a form of currency, on a continuum from marital obligation to commercial sex. Twenty years ago in a different political climate, this same juxtaposition was used by feminists as part of a critique of marriage as an institution. Today in a climate of 'moral indifference', the analogy is used to legitimate prostitution as not much different from other contexts in which women engage in sexual activities—a clear reversal of more familiar feminist analyses.

Becoming either a wife or a prostitute might be seen as part of an economic, social and sexual bargain. It is a familiar argument that in marriage, a man acquires rights to a woman's body and to her labour for open-ended usage, whereas in the prostitution transaction (in Britain, at least) sexual services are generally sold by the piece, in a commercial exchange which involves an explicit agreement to perform a specified and limited service or task. Indeed male clients frequently complain of the cold-bloodedness of the transaction: they would prefer to believe they can buy a brief relationship involving women's emotions and their desire. In a sense, both prostitution and marriage are ways in which women can gain some measure of economic security. But in neither case is security guaranteed. The wife may find herself beaten, raped and thrown out, while the prostitute constantly risks rape and violence, and it certainly isn't a career with security and a pension. And in both marriage and prostitution, it is men who benefit.

The point is not to criticise either group of women — those who marry or those who enter prostitution — but to consider points of continuity between the two institutions. Just as any analysis of marriage must distinguish between the relation of any one particular husband and wife and the structure of the institution of marriage, so the relation of any particular prostitute and client must be distinguished from that of the institution of prostitution.

One of the great achievements of the Women's Liberation Movement in the 1970s was to develop a critique of violence against women and the institution of marriage. Feminists set up refuges for women escaping domestic violence, and campaigned for legal recognition of rape in marriage. In fact, these early critiques of male violence described the experience of battered wives in terms that contemporary research would recognise as consistent with the experience of prostitutes. Some women who sought refuge from the violence they experienced from their husbands and partners later returned to the men they had left. Those women apparently made a 'free' choice. However, that did not invalidate feminist critiques of marriage and

male violence. Similarly, many women who work as prostitutes may have decided pragmatically that this was the best, or least worst, option available to them. That individual women have made that choice does not in itself close the debate.

Campaigning against prostitution as work

The debate about whether prostitution should be seen as sex work or as exploitation has political ramifications for feminist activism. Prostitutes' rights organisations such as the English Collective of Prostitutes (ECP) and the NZPC campaign vigorously to improve the working conditions of prostitutes. Their perspective is informed by prostitution-as-work arguments, which logically lead to support for the decriminal-isation of prostitution. It is clear that historically, the main British laws addressing prostitution serve to punish prostitutes, especially street prostitutes. Even the Sexual Offences Act of 1985, aimed at kerb-crawlers, rarely hits its target. In fact, it causes problems for women working on the streets: they are more likely to get into cars quickly so that clients are not prosecuted, but this reduces the time they have to assess the risk of going with a client. Attempts to decriminalise prostitution need to be carefully scrutinised to find out whose interests are served; but moves to reduce the intrusive controlling strategies directed at women, in conjunction with greater regulation and punishment of male users of prostitutes, would be welcomed by feminists opposing the institution of prostitution too.

Critical analysis of prostitution has been attacked as being inconsistent with the commitment of feminism to reflecting the reality of women's lives and listening to women's own versions of reality. Confrontations between feminists opposed to prostitution and prostitutes' rights organisations are legendary; coupled with accounts from women who claim they are better off in sex work than other professional work available to women, the effect has been to silence feminist critiques. But for every woman who may feel empowered by her experience of prostitution, there are many others for whom it is not empowering — which calls into question which women's accounts are privileged. Feminist activism opposing the institution of prostitution and its legitimisation as work must resolve the contradiction inherent in this position by also finding ways of supporting the rights of women working as prostitutes.

Norma Hotaling, speaking at the Brighton conference as an ex-prostitute, argued that if we promote prostitution, we ultimately endorse trafficking in women. She stresses that male perceptions of women change as a result of using prostitutes and that many men using adult prostitutes eventually go on to pay for sex with children. Hotaling asks whether in supporting prostitutes' rights we aren't supporting pimps and punters' rights to abuse, exploit, damage and kill women. As a survivor,

she emphasises the importance of women in prostitution having access to the same services as other women, as well as support to exit from prostitution, and also argues for a shift in focus onto men's engagement in the abuse of women in prostitution.

One effective US example which focuses on men is the SAGE project (Standing Against Global Exploitation), which contributes to a programme for men prosecuted for using prostitutes; ex-prostitutes (such as Hotaling) give their perspective to counter male fantasies of their own power and women's enjoyment. The project is funded by the fines men pay, and used to assist women to exit from prostitution. Exit strategies include safe houses, alternative training and employment as well as medical, social and emotional support. In the Midlands there has been an example of successful feminist activism by a voluntary organisation, Prostitute Outreach Work (POW). Women in prostitution played a crucial role in developing multi-agency services which more effectively meet their needs, facilitate exit strategies and promote useful, women-centred research and activism to change the laws surrounding prostitution.

Following the Brighton conference, there have been two feminist initiatives in relation to prostitution in 1997: a national conference on violence against women and children in prostitution organised by the Research Centre on Violence, Abuse and Gender Relations (based at Leeds Metropolitan University) and a national network, Women Against the Prostitution of Women (WAPOW), formed to provide a national voice against the institution of prostitution whilst supporting the rights of women in prostitution. Both initiatives attempt to drown out the clamour for prostitution to be seen as a job like any other, whilst trying to bridge divisions between women working as prostitutes and feminist activists. In its first newsletter, WAPOW has identified its general aims as promoting the safety of, and services for, women and children in prostitution; developing exit strategies; opposing legalised brothels; removing the life-long labelling of women as 'common prostitutes'; and campaigning for the prostitution of young people to be treated as a child protection issue.

It is claimed that the advantages of treating prostitution simply as work are that it removes the stigma, decriminalises prostitutes, recognises the skills women bring to their work and attributes them employment status with the attendant rights to welfare services and benefits. However, the disadvantages are greater. In the first place it depends on the distinction between 'free' and 'forced' prostitution. In defending a notion of prostitution as a freely chosen occupation, the burden of proof is shifted onto women working in prostitution to demonstrate that they have been forced into it. The reality is likely to be somewhere between the kind of

force that might be recognised in a court of law and truly free choice. Secondly, the reduction of prostitution to an economic transaction involving women's labour effaces the exploitative and emotionally damaging effects of prostitution. The sale of sex to men by women cannot be understood separately from the wider patriarchal organisation of socio-sexual relationships; the transformation of female sexuality into a commodity necessarily entails exploitation.

References

Gaag, Nikki van der (1994), 'Prostitution: soliciting for change' *New Internationalist* 252, February.

Gorna, Robin (1996) *Vamps, Virgins and Victims. How can women fight AIDS?* London: Cassell.

Høigård, Cecilie and Liv Finstad (1992), *Backstreets: Prostitution, Money and Love,* Cambridge: Polity Press.

McIntosh, Mary (1996), 'Feminist Debates on Prostitution', in Lisa Adkins and Vicky Merchant (eds), *Sexualizing the Social: Power and the Organisation of Sexuality*, London: Macmillan.

Plumridge, Elizabeth et al. (1997), 'Discourses of emotionality in commercial sex: the missing client voice.' *Feminism and Psychology* 7.2.

Sanders, Claire (1990) 'Tis Pity she's no whore', *New Statesman & Society* 9 February.

Watson, David (1990) 'Birmingham is second sex city', *New Statesman & Society* 9 February.

9. Unspeakable Acts (1991)

Liz Kelly

The fact that most lesbians and feminists have been reluctant to discuss violence by and between women has not prevented the issue from reaching the public arena. The 'discovery' of women who have sexually abused children, the current case in the US of the first female serial killer (Aileen Wuornos is a lesbian charged with murdering five men), and the case of Lisa Steinberg (a six year-old whose death resulted from abuse at the hands of her adoptive parents) all made headline news. A new knee-jerk reaction amongst policymakers in local councils, and even some police officers, is to include lesbians and gay men in discussions about domestic violence.

Our caution and irritation at 'women do it too' statements were justified, since the speaker was seldom concerned about the issues, and usually motivated by a desire to dismiss feminist analysis. But today, avoiding the issue of women's use of violence represents as much of a threat as we previously felt talking about it did. If we fail to develop feminist perspectives we are handing over this issue to the professionals and the media. Silence also means that we will continue to fail those women and children who have suffered at the hands of women. We all know that our failure to name and find ways to confront issues of power between women has been the downfall of too many women's groups, projects and campaigns (not to mention friendships and relationships). So what is at stake here is not simply what we stand to lose, but also what we might gain.

Definitions

Before looking at evidence of women's use of violence, it is important to explore how it is defined in lesbian/feminist communities, and consider how non-feminist researchers and practitioners are defining abuse by women. In both these areas, confusions abound.

There is a tendency within lesbian/feminist communities to use words in ways that confuse rather than distinguish between forms of behaviour. In a piece called 'Therapism and the taming of the lesbian community' Joan Ward notes that

Therapism has taught us to find everything equally upsetting. I see lesbians respond to minor disagreements with other women as if they had been raped ... We are so emotionally vulnerable that we cannot distinguish between a philosophical difference and a physical assault.

We will not develop either new ways of dealing with conflict or ways to support women abused by women if we equate all disagreements or misuses of power with sexual or physical assault.

Violence/abuse is the deliberate use of humiliation/threat/coercion/force to enhance personal status/power at someone else's expense, to constrain the behaviour of others, and/or to get one's own needs met at others' expense. While some aspects of behaviour between women, and between women and children, do fit this definition, others do not. Our starting point must be to understand how the many variations of 'power over' are used, responded to and challenged in relationships between women, and to distinguish between forms which do and do not use overt force and violence.

The professional literature also produces overly inclusive definitions, whose hidden agenda is to deny that most physical and sexual violence is committed by men. Many strategies have been used to limit the forms of men's behaviour that count as sexual violence, but in relation to women the reverse process is used, for example, by broadening the definition of 'sexual abuse of children'. One study of sexual abuse of children in the US recorded a much larger percentage of female abusers than previous studies. Careful investigation of the data revealed that women were being defined as 'co-perpetrators' if they were thought by professionals to have known about the abuse and not reported it. Mothers who played no part in the abuse were transformed into female abusers.

A popular strategy is to suggest that women have many opportunities to sexualise interactions with children, particularly babies; that mundane, everyday child care offers the perfect cover for sexual abuse, but there are few reported cases because it is so 'normalised'. Abuse thus defined covers touching a baby's genitals whilst changing their nappy and allowing children to sleep in the same bed. Interestingly, no-one has written impassioned articles about the injustice of making 'innocent' mothers insecure about touching their children. This construction of motherhood as suspect has a long history. Freud was far more comfortable developing a mythology of the maternal seductress than acknowledging the reality of paternal abusers.

Another strategy is to extend the category 'woman'. Several recent studies of reported cases record higher figures for women as abusers. When the statistics

are examined in more detail a large proportion of the female abusers are under 18. 'Women' includes girls, sometimes very young ones. I am not questioning the impact of abusive behaviour on any child, but to call a four, five or six year-old an abuser presumes their understanding is the same as that of an adult.

Theory building

Feminist analysis of men's violence is only fragile if it is underpinned by the essentialist belief that aggression is inherent in men. Masculinity and femininity are culturally and historically variable constructs, which individuals 'fit' more or less comfortably. Taking social construction seriously, including the fact that women do not live outside patriarchal ideologies and practices, means we *can* locate women as abusers within a feminist analysis — but it is complicated.

Placing interpersonal violence on the political agenda, challenging the Right's idealisation of family and heterosexuality and the Left's focus on economics and state social control, has been one of the achievements of this wave of feminism. We demonstrated that the use of explicit force and coercion was a common feature in many heterosexual encounters. Theoretical analysis highlighted that violence is a form of 'power over', whose use tends to follow the contours of social inequality. Sexual violence is an expression of male supremacy; racial violence is an expression of white supremacy. The use of force by dominant groups is often socially legitimated, although both its use and legitimacy may be resisted and challenged.

This structural analysis provides us with ways of exploring women's access to, and use of, violence. Following its logic, the most likely targets for violence by women are children, the only group over which women have socially legitimated power. Since the sexual is currently constructed as a potential arena of power for men, however, women are less likely to sexually abuse children. The next potential target for violence by women is other women — physical fights between girls and young women are not that uncommon. The least likely target is men. Where women do use violence intending to harm adult men — for example when abused women kill their husbands — they tend to use weapons to 'equalise' the power dynamics.

Blaming women

Women using violence or abuse seem to be acting outside and against constructions of femininity and motherhood. This is in contrast to men, for whom using violence is consistent with traditional masculinity. This acting against femininity is especially marked when the abuse is sexual. It is the 'unwomanliness' of female aggression which partly accounts for the outrage and blame attached to women who do act in this way.

High-profile commentators have recently suggested that the time has come to ask 'why people do it': gender is now irrelevant. But how can it be, when these same professionals make glib statements about how much worse it is to be sexually abused by a woman, especially for boys? One of them told *Women's Hour* last year, 'When the last taboo is broken, the effect is devastating'.

Is it the same interaction when abuse is perpetrated by a woman? Many survivors' accounts suggest not; they talk of additional senses of betrayal — suggesting that as children and adults we expect women to behave in womanly, i.e., not violent, ways. An example is the book *When You're Ready*, a moving account of a woman coming to terms with her mother's physical abuse. By contrast the sexual abuse she experienced from an adult male is referred to in passing, as if it were unremarkable and played no part in her subsequent distress.

Women, children and physical violence

In the majority of cultures throughout the world, the use of threat and violence to control and 'discipline' children is not only acceptable but widespread. While the forms such control takes may vary, suggestions that excessive violence is used only within specific groups — usually working class and Black families — are just another mystification to implicate everyone but the white middle/upper class. Authoritarian (and non-authoritarian) child care practices exist within all social groups. Hitting children remains one of the few forms of interpersonal violence that is not legislated against in the majority of countries.

There are at least four forms of physical violence used by adults against children: the occasional smack; harsh discipline; explosive, unexpected and — to the child — undeserved outbursts; brutal, sadistic treatment which is justifiably named torture. It is the latter two which concern social workers and are covered by the term 'abuse'; as with violence against women, only the extremes provoke state intervention.

Very few studies provide us with information on how many women use these various forms of physical violence. The National Society for the Prevention of Cruelty to Children (NSPCC), who until last year produced the only national figures for reported child abuse, collapse men and women into categories like 'parents'. We know that women use violence somewhat less frequently than men and are less likely to commit the most sadistic assaults. That said, however, the numbers of women and men are much closer than for any other category of violent behaviour (the exception here is female genital mutilation — which is an act of violence done to girls by women). Physical violence towards children cannot, therefore, be so clearly viewed as gender-specific.

Our failure to explore this issue is most evident for me in recalling the work I did for many years in Women's Aid refuges for women escaping domestic violence. We chose the name 'refuge' to represent our vision of a haven, a place of safety. Yet that safety was never truly extended to children. By seeing ourselves in alliance with other women, supporting their struggles to get free of abusive men, we neglected the fact that the needs of children and those of women are not always the same. Our house rules often included 'no violence', but only a minority of groups applied that to women's relationships with children. Like the social workers we were so determined not to imitate, we justified our non-intervention by talk of 'different values'. Reflecting on my part in this hypocrisy, I can see that simply extending house rules to include children is not the answer, although it is an important beginning. The acceptability of physical violence towards children, the fact that many of us may have used it against our own children, demands a more complex approach. Talking honestly and openly is a crucial starting point: about women's relationships to children; about how for many women an impoverished, constrained and oppressive reality determines their experience of motherhood; about the social expectation that we 'control' children and the legacy of belief systems which promote a 'spare the rod, spoil the child' philosophy.

Women and sexual abuse

We have known about, yet chosen not to focus on, women's use of physical violence towards children. Similarly, evidence of women sexually abusing children has produced not only resistance among feminists but also denial. We did not, and do not, want to believe that women act in this way. In working on this piece I went back to books I read some time ago, and noticed how little attention I had paid to the evidence on women as abusers. If we continue this deliberate avoidance we fail survivors who feel that we do not want to hear what they need to say, and leave a huge space in which anti-feminist ideas and practices can develop. It is possible to recognise that some women sexually abuse children without losing sight of the reality that it is mostly men who commit sexual violence. That position opens the way for us to explore the similarities and differences between sexual abuse by women and men, and ask whether the explanations we have developed for men's behaviour also apply to women.

The information we have about women who sexually abuse is extremely limited, in part because they are few in number, and also because we currently lack the rich insight of survivors' accounts. Most published studies suggest that some 3% of adult sexual abusers are women. In *The Secret Trauma*, a study of women's

experience of incest, Diana Russell recorded a 7% figure for women as abusers (one mother, three other adult relatives and six sisters or cousins). Comparing women's abuse with men's, she notes that more of the female abusers were adolescents at the time, and more incidents were single events. She suggests that because female abusers use less force, abuse less frequently and there is less age difference, the abuse is less traumatic. However, these factors do not predict the impact of abuse by men on women. Is this the mirror image of the 'it's worse if women do it' position?

Kathleen Faller, an American social worker, has published the largest and most careful study of female abusers. She reports on 40; 14% of abusers seen in one programme during 1978–87. Her findings reveal a different pattern of offending: three quarters of the women abused alongside men in a 'family sex ring' (18% of male abusers were in this category), 15% were single mothers who were defined as 'merged' with their children, relating to them as a 'surrogate partner', and 10% were defined as 'psychotic'. (The last two categories raise the question of whether we accept such explanations, which we have rejected for male abusers.) The accounts of the children confirmed that in the family sex-ring cases it was usually men who initiated sexual abuse (although in at least two cases it was women); that women's role in the abuse was secondary and they committed fewer and less intrusive acts. A number of the children stated clearly that they knew their mothers were being coerced and did not want to commit the abuse.

A study of sexual abuse in daycare confirms this pattern whereby the majority of adult women who sexually abuse act in concert with male abusers. Finkelhor, Williams and Burns studied 270 cases, involving 382 abusers (220 men and 147 women) and 1639 children. Women were involved in 36% of cases, and in all of those with multiple perpetrators. In 63% of these they were related to at least one of the male abusers who were either male partners or sons. However, there were 27% of women who sexually abused independently.

Evidence of lesbians sexually abusing children is still more rare; limited to one or two case studies. However, I have spoken to two lesbian/feminist social workers who have encountered such cases. The abuse has been either of lesbians' own children or children and young women they have befriended.

I have yet to come across an account of a woman with a 'career' of sexual offending who targets and 'grooms' large numbers of children she does not know in order to sexually abuse them. The only example I can think of is women who recruit into the sex industry. But here the motivation tends not to be personal sexual access to the girl/young woman, but financial gain.

The circumstances in which women sexually abuse do not excuse their behaviour, nor detract from the impact of their abuse on the child, but we do need to explore what these differences mean. Is it appropriate to link the ways in which some children and women are coerced in sex rings? Where women are not coerced, is there the same connection between sex and violence, power and pleasure that we have documented in relation to men? Whilst the numbers of lesbians sexually abusing children may be tiny, what responses are appropriate? There are complex questions too about the levels of responsibility we can or should attribute to women when they too are being abused; when they fail to challenge men's abusive behaviour; and when — as in the case of genital mutilation — they act within cultural belief systems which legitimate violence.

Violence between lesbians

Constructing alternatives to the medical pathological model of lesbianism was, and remains, an important facet of lesbian feminist politics. As our work increasingly highlighted the oppressive nature of heterosexual relationships for women, it was important, personally and politically, to have an alternative vision. One of the successes of feminism over the last 20 years has been to create spaces where women feel able to question heterosexuality, where lesbians can be visible and to some extent affirmed.

But both the external hostility and the positive energy inside lesbian feminism have led to an idealisation of lesbian relationships. Many women who came to lesbianism through the WLM were both unprepared and unwilling to face the fact that some of the behaviour we criticized in heterosexual relationships also occurs between lesbians. Voicing this publicly seems to undercut not only our political analysis of male power and heterosexuality, but also our optimism about lesbian relationships. This collective refusal has been, in part, responsible for the difficulty many lesbians have in naming their experience as abuse or violence, especially if it includes coercive sex.

When some women did courageously talk about their own experiences they, and others, placed their accounts within a heterosexual domestic violence framework. Certainly women's accounts do suggest similarities. When I read *Naming the Violence* the resemblance of the stories lesbians told to those I had heard from women abused by men both alarmed and disturbed me. They described persistent undermining of self-confidence; repeated criticism, often in front of friends; the use of threats and violence to enforce demands and/or reinforce negative interpretations of the woman and her behaviour; isolation — cutting women off from their friends

and potential sources of support and validation; extreme levels of sexual jealousy and possessiveness, sometimes accompanied by coercive sex; and dire warnings about the consequences of telling others.

But do these echoes amount to an explanation? Part of our explanation of men's sexual violence has been the centuries of entitlement they have had in relation to 'their' women and children. There is no such social legitimation of lesbian relationships, let alone a 'right' of one partner to have power and control over the other. For me there remain unanswered questions about violence between lesbians. I want a framework which does more than map heterosexual theory onto lesbian experience.

We also have to consider what practical support and services we should be providing, both to lesbians who are being abused and, more contentiously, to lesbians who abuse. (Some of these issues also apply to women who abuse children.) Can we afford to take the view we have with heterosexual violence, that we will not work with abusers? If we think men should work with abusive men, isn't the logical corollary that lesbians should work with abusive lesbians? What forms of protection can we create which work, which do not involve women having to resort to state agencies and the legal system? Do lesbians need their own refuges? Should we be working with police domestic violence units to develop specific procedures for lesbians?

Other issues

Here I have only looked at the behaviour of adult women. Interactions between girls and young women need a fuller exploration. The fact that a high proportion of female sexual abusers are girls and young women must be addressed. How many of them are doing what used to be called 'acting out' — trying to make sense of their own abuse by re-enacting the experience whilst changing roles? How many act with full knowledge that what they do hurts the other child, but go ahead anyway because it makes them feel good?

We must also look at women who, in the context of their paid work, use violence as a form of control and/or power. The contexts range from women in the prison/police service/armed forces, through to women working in residential institutions caring for children and young people, elderly, sick and disabled people. A different but equally important issue is the circumstances in which women use or endorse the use of violence in the context of political struggle. These phenomena challenge essentialist constructions of women as 'non-violent', and raise questions about the influence of brutalising contexts on behaviour.

In our discussions about abuse by and between women we must begin from an honest admission of the many ways in which women deliberately hurt/betray other women, and of our own failure to explore this. We need to return to small groups to discuss relationships between women and between women and children. This process will enable us to develop a framework within which we can both describe and explain, which in turn will be the spur to action and change.

References

Evert, Kathy and Inie Bijkerk (1987), *When You're Ready*. Walnut Creek, CA: Launch Press.

Faller, Kathleen (1987), 'Women who sexually abuse children', *Violence and Victims* 2.4.

Finkelhor, David, Linda Williams and Nanci Burns (1988), *Nursery Crimes: Sexual Abuse in Day Care* (Thousand Oaks: Sage Publications).

Lobel, Kerry (ed) (1986), *Naming the Violence: Speaking Out About Lesbian Battering*, Berkeley, CA: Seal Press.

Russell, Diana (1984) *The Secret Trauma: Incest in the Lives of Girls and Women,* New York: Basic Books.

Ward, Joan (1990), 'Therapism and the taming of the lesbian community', *Sinister Wisdom*.

10. The Portable Cage: Women and Fundamentalism (1990)

Dena Attar

f you count yourself part of Christendom, this is for you. If you don't, it's also for you — a reminder that Christendom is still where you're living.

There used to be an old joke about a stock response to news of any event: is it good or bad for the Jews? Now we have another one: is it good or bad for women? The events in Eastern Europe since last year have forced both questions on us: the images of strong communist states have fractured, and amid the dust and rubble the power of the Christian church, hidden before or perhaps grown stronger recently, is once more visible.

From a constant stream of such examples, I note four recent news items: the Catholic hierarchy is issuing new edicts reaffirming in the strongest terms its hostility to abortion, contraception, divorce, and all things feminist; the collapsed Israeli government has managed to re-form as a working coalition only with the aid of some extreme right-wingers and ultra-religious elements; the British foreign minister, under pressure, made some political statements about the government's respect for Islam and its moral code; the American president of the international writers' union PEN reported a rising tide of censorship in the USA, particularly of school books, at the behest of the fundamentalist religious Right.

I take all these things personally, as I think all feminists must. Mary Daly's words in *Beyond God the Father*, first published in 1973, now read extraordinarily:

As the women's movement begins to have its effect upon the fabric of society, transforming it from patriarchy into something that never existed before ... it can become the greatest single challenge to the major religions of the world, Western and Eastern. Beliefs and values that have held sway for thousands of years will be questioned as never before.

In the early 1970s it was possible to believe that religion was in retreat, that feminism could make the great challenge without meeting much of a response. Since 1979 — the year of the Iranian revolution, of the ascent of the radical Right in Britain and the start of the Reagan campaign for the US presidency which vowed support

to anti-abortionists — that has no longer been possible. The extent and viciousness of the backlash becomes clearer all the time.

It's also becoming clearer that we are virtually on our own. Daly is right to describe feminism as the greatest challenge, if we treat feminism only as an idea. But historically the greatest challenge has been posed at a theoretical level by Marxism and, in the struggle for real power, by totalitarian states claiming to put Marxism into practice. As the power of those states wanes, the Left everywhere seems to have lost its ability to provide a critical analysis of religion, or to offer an alternative. Now, when millions of women are falling victim to the rise of fundamentalism, have feminists also gone weak on religion? I am desperately afraid that we have. I want to understand why. I want us to talk about how much it matters.

Confusions and contradictions: just a piece of cloth?

The feminist response so far has been so contradictory that it allows for all kinds of confusions: a range of responses, from conservatism to denial and dissociation, are being claimed as 'feminist'. Writing this, I have four other women in mind. They've all been touched by feminism, know how to use its language, and may even call themselves feminists. The first, a Bradford woman, told me she could not discuss the Salman Rushdie affair[1]: as a non-Muslim it was not up to her to have a view. The second, Rana Kabbani, published *Letter to Christendom* in response to the Rushdie affair. The third featured in a TV programme and refused to be filmed praying behind her brother because she did not wish to be used in a stereotyped portrayal of oppressed Muslim womanhood. The fourth, in another interview, dismissed criticisms of the *chador*, saying it was just a piece of cloth.

I shall start with the piece of cloth. I grew up seeing Orthodox Jewish women in a nearby London district wearing the *sheitel*, a wig covering their own hair so that only their husbands might see it. The *sheitel* was easily dismissed as an abhorrent survival of bygone times, worn by women with no interest whatever in feminist debate. They can still be seen, but now I am more used to seeing the varieties of modest head-coverings (*hijab*) worn by Muslim women.

Some defenders of *hijab* now claim that they are the truest feminists, since those claiming to side with freedom are really siding with sexual exploitation, western decadence or, most tellingly, with racism. Rana Kabbani argues that *hijab* has now become a political choice for Muslim women, enabling them to form networks and work together more effectively, and is a symbol of rejection of western values and permissiveness. But this picture of a politically active Muslim sisterhood consisting

mainly of professional women who have freely chosen to wear *hijab*, and who are released by it from family surveillance, the 'trap of western dress' and even class difference (Kabbani argues that 'since all women look the same in it, it is a most effective equaliser') is selective: against it must be set the evidence of feminist researchers, activists and refugees from Muslim countries around the world. There are countries where wearing the veil is still compulsory for women, and others where most women are veiled and presumably have little real choice. The idea that the veil can be appropriated for women's own purposes does not stand up to analysis either. Could women with shorn hair who wear the *sheitel* claim that as a liberating choice? It seems unlikely, yet the rationale behind the *sheitel* is exactly the same: preserving a woman's modesty and keeping her from being seen as a sex object; reserving her charms for her husband, and protecting men from temptation.

Other writers who do not share the view that the veil is a reclaimable neutral symbol (Edward Said described the *chador* as a 'portable cage') argue either that it is expressive of a basic hostility towards female sexuality, or that it serves to mark out all public space as male, to be entered by women only on condition that they effectively become invisible. Whatever the wearer's motives, the message of *hijab* is still that a woman's presence in the world outside home must be in some way justified. Whatever the circumstances which lead to this, we cannot mistake it for feminism or liberation.

It remains true that at certain times, in certain places, many women have seen it as being in their interests to adopt *hijab*. In Iran, for instance, Westernisation under the Shah had undermined cultural self-esteem and also added to women's burdens, so that many felt they had nothing to lose by supporting the fundamentalist revival. As Andrea Dworkin has argued about the American religious Right, conservatism may appeal to women because it offers respectability, protection and male support. Fundamentalists of different religions share an emphasis on traditional roles for women; they promote, for example, the idea that women with children should be able to stay at home and be financially supported by men. Overburdened Iranian women may well have seen this as desirable, although the reality they were then faced with was virtual sexual apartheid, a diminishment of legal rights and status, sanctions against women not wearing the *chador* or who were not supported by men, and no relief, in the end, from overwork and poverty.

Ideologically *hijab* can't be reclaimed for feminism, but feminist support for women's struggles has to include support both for those who refuse to wear it and are persecuted — as in Iran — and those who do wear it, and are also persecuted. We must support the rebellious women and girls in every case. It would

......... The dissent of woman

be dangerous, though, for us to confuse support for the right to rebel, oppose racism, and wear what we want, with support for fundamentalism itself.

Responses to Rushdie

Rana Kabbani wrote her *Letter to Christendom* primarily as a response to the Rushdie affair. A very different response came from Southall Black Sisters, who joined with supporters from various religious backgrounds in May 1989 to set up Women Against Fundamentalism (WAF). I have found it striking that since the beginning of the controversy over *The Satanic Verses* there have been just two groups affirming unwavering and total support for the book's publication, and without any racist taint. One is WAF; the other is made up of organisations like PEN which represent writers internationally, and oppose censorship throughout the world. These groups have been able to see the allegedly anti-racist opposition to the book for what it is: a convenient means for the fundamentalist leadership to assert its power and suppress dissent.

The first activity organised by WAF, their picket of the May 1989 anti-Rushdie demonstration, showed up dramatically the scale of the opposition to feminist dissenters from religious communities. Since then WAF has organised a benefit (jointly with 'Voices for Rushdie') and a public meeting addressing the rise of fundamentalism around the world. These events have all taken place in a climate of threat, which for some women has been real and urgent. The May picket was a frightening experience; at the summer benefit, where the atmosphere was still tense, some of the expected performers felt unable to appear; at the public meeting one woman at risk of being deported to Pakistan and imprisoned there for 'adultery' (the crime of having been abducted and raped) spoke of what had happened to her as a direct result of Pakistan's adoption of religious law.

Speakers reporting on the rise of fundamentalist religious movements in Iran, Ireland, India, Bangladesh and Pakistan, Israel, Africa and Eastern Europe, pointed out a double threat. One is direct—attacks on women's reproductive rights and on the right of women to be educated, to work, to be politically active, to resist unwanted marriage, abuse or mutilation. The other is at least as dangerous: attacks on secular democracy and attempts to increase the power of religious or communal leaders in the political arena, so that the civil law can be usurped by religious laws which inevitably accord women fewer rights.

Several speakers dealt with the problem of how fundamentalism still manages to attract so many women. Part of its attraction is that, like fascism, it mobilises supporters against external enemies, and thus appears to empower women. Religious practice also gives women an alternative source of power, in the sense they can use its authority to balance the power of the men closer to them. This feeling of empowerment encourages women to become involved. Another speaker described the wealth of the American Pentecostal churches which are buying their way into Ghana, and how that draws vast numbers of the women who bear the brunt of the country's economic crisis. There were some positive reports too, of a growing resistance, particularly among disillusioned Iranian women, and in Bangladesh where feminists see the importance of keeping a secular constitution and fighting to resist a clause denoting Islam as the state religion.

There appears to be an emerging consensus that feminists should, as far as possible, seek to use the civil law to defend women against religious laws. In the case of women threatened by anti-adultery laws in their countries of origin, for instance, we should seek to establish their entitlement to refugee status as victims of political persecution. Similarly, French feminists have sought legal protection for women whose male relatives wish to force them into marriage, by defining such actions as kidnap and abduction and seeking to ensure that the French government acts to protect its citizens, even when the woman concerned has been taken overseas.

Working with our own minority communities or in alliance with other feminists, we are bound to meet the charges of colluding with racism or of betraying our own ethnic group or faith. Such accusations rest on the assumption that there is one ready-defined community and that we are not free to challenge its definitions. They are tactics for controlling dissidents, as Southall Black Sisters have had cause to recognise and as other speakers agreed. But they can only succeed if we submit to the judgment that freethinkers or feminists, radicals, atheists, critics of religion, must forfeit their right to belong to their original communities.

Having challenged, often in the name of feminism, the beliefs, practices and allegiances we start off with, we can't just move into a new community ready and waiting to accept us. I often used to hear that I had no choices other than to continue with Orthodox Judaism or be swallowed up into the larger society which was Christian and anti-semitic. It was a false threat in some ways: I haven't continued with Orthodoxy, and I haven't been swallowed up. But in another way the dichotomy is real, since those communities have a more continuous, more tangible existence, than any others which might fit my feminist commitment. Feminism isn't somewhere we can literally get up and go to, but a framework for understanding and changing our current realities. And feminism, as I understand it, has no place for religion, let alone fundamentalism. If it isn't a refuge or a parallel faith, feminism should be, as Mary Daly suggested, the greatest single challenge to the major religions of the world.

Feminism and religion

Since the early 1970s, feminists have adopted one of three different approaches to religion. The first, most conservative approach, dealt with change at a superficial level, without confronting the basic framework of religious law. Women who took this approach sought to rewrite texts avoiding masculine pronouns, applied to enter religious hierarchies, campaigned to alter religious law and tradition as far as interpretations of the laws themselves would allow. Some got to where they wanted and stayed content with that. Others reached the limits of what this approach allowed and were driven beyond it, an experience which could cause acute distress.

The next approach was either deeper or dafter, depending on your sympathies. It denounced the patriarchal character of existing religions and attempted to unearth through historical research a truly woman-centred alternative. Failing that, it simply gave up the historical quest and resorted to making up matriarchalist fantasies. This is open to the criticism that it fails to understand the cultural and political significance of religion in all its multidimensional forms. It is not so easy to dismiss or overtake the accomplishments of millennia of religious thought and practice, and the alternative constructions of this approach have had little to offer so far. No born-again pseudo-witchcraft tree-worshipping cult is going to be able to compete with the achievements of the golden age of Islamic civilisation, for example. The cultural forms evolved by existing religions carry meanings from so many sources that to invent overnight replacements with as much emotional resonance is really an impossible task.

The patriarchal religions to be replaced in this approach are also much more than political movements setting out to enforce patriarchy. With all their faults, they are

also ethical systems, providing a language with which to contest oppression, to set out moral obligations and to establish concepts of human rights. This makes it unnecessary for feminists to begin again in every detail, as if no work had ever been done before us. A more convincing approach to religion would start by evaluating its achievements as well as its crimes.

The last approach to religion is a rational one, capable of analysing religion in relation to patriarchy and to systems such as feudalism and capitalism; one which sees feminism as a political analysis and movement incompatible both with systems of allegedly divinely-given religious law and with systems of irrational thought. This approach asks the nastiest questions about our silliest beliefs and most comfortable allegiances. Because it's the least respectful and least tolerant, however, it's been the quietest tendency of late.

Publicly, feminism seems to have sided more with the conservatives than with the dissidents, but there is now much more to do. WAF is currrently campaigning on reproductive rights and has picketed the Irish embassy to protest at Irish women being refused the right even to information on abortion and contraception. It is also campaigning for state-funded education to become secular: new legislation in Britain makes it compulsory for schools to hold a daily act of collective worship, which has to be mainly Christian unless a dispensation is granted. It makes no sense to pick on a piece of cloth if we only pick on one religion, or if we take on fundamentalism and leave the rest of religion alone. If Christendom is where we live, we have to take that on too.

Note

1. The British writer Salman Rushdie published a novel, *The Satanic Verses*, which was deemed by some religious Muslims to be blasphemous; its author, raised as a Muslim himself, was categorized as an apostate. In some British cities with significant Muslim populations there were demonstrations and book-burnings; in Iran a *fatwa* was issued which gave believers dispensation (amounting to encouragement) to harm or kill Rushdie, so that the British authorities were obliged to provide him with protection. These events exposed deep tensions between the liberal values that were assumed to be mainstream common sense (e.g. religious toleration and opposition to literary censorship) and the views of some minority ethnic/religious communities.

References

Daly, Mary (1986), *Beyond God the Father*, London: Women's Press.

Kabbani, Rana (1989), *Letter to Christendom*, London: Virago.

Rushdie, Salman (1989), *The Satanic Verses*, Harmondsworth: Penguin.

11. Difference is not all that counts (1999)

Purna Sen

have written this piece as a result of increasing frustration and concern at the way in which claims to 'difference' are used to silence women, and to seek support from well-meaning outsiders for women's oppression. Difference can be turned into a tool for separation, isolation and censorship. Here I will argue for the *recognition* of difference, but against the *privileging* of difference. To do this I will draw on my own experience and work, particularly among Asian women in the UK and in the Indian subcontinent.

Feminism in the Indian subcontinent

The trafficking of girls across countries in the Indian sub-continent is rife, with many young girls disappearing from their homes and ending up in areas of prostitution. Sometimes they are intercepted by government officials or they may try to escape the control of their traffickers. In these situations, the girls are either put into government shelters (which are often incredibly unpleasant) or appear in court and are re-claimed by their traffickers, posing as relatives. The girls may go along with this misrepresentation, out of fear of their abusers. Sanlaap is an organisation based in Calcutta which works on this issue and which has successfully lobbied for recognition in the courts. They have also visited the government residential homes in which 'rescued' girls are placed and in which they too often languish. They have now managed to obtain recognition as legitimate carers for these girls, so that they are given custody. They can then house the girls, try to locate their families and provide some education or training too.

In Pakistan, Shirkat Gah has long worked for the promotion of the rights of women, handling cases of domestic violence, rape, forced marriage and other forms of discrimination. During the 1990s there has been an increase in the number of so-called 'honour' killings of women—where women are considered to dishonour or shame their families and are killed (usually by a male family member) to 'cleanse' the dishonour or shame. Suspicion of adultery or of consorting with a male can be enough to precipitate a killing. The women at Shirkat Gah work with these cases and seek to bring the men and their families to account — a difficult

task in a country where public cultural norms increasingly favour misogynist actions.

One woman long associated with this organisation is Asma Jahangir, a lawyer who with her sister Hina Jilani handles cases of women who have been abused by their families. In April 1999 Samia Sarwar, a client who was in the process of divorcing her violent husband, was killed in their office by a gunman, allegedly hired by her mother (a gynaecologist), uncle and father (president of the local Chamber of Commerce). Hina narrowly escaped a bullet. She and Asma have since been harassed and threatened by the family concerned and their supporters, who declared the murder in keeping with tribal laws and declared a fatwa on Asma Jahangir.

The courage and strength of women working for women's rights in such a context is remarkable. Not only do they face not only the difficulties of dealing with cases of violence and abuse, the consequences of their work include explicit threats to their own lives. Despite these dangers these feminists continue to speak with clear and loud voices against cultural practices which harm women.

Migration

It might be thought that the experience of migration and of living in hostile environments radicalises those who live through this process, but this is not necessarily so. I do not think that the immigration experience and that of racism has actually radicalised very many women — because they are caught inside a need to uphold traditional cultural practices as motifs of their identity and community allegiance. Why should women adhere to these practices? It seems to me that if women live in a hostile environment and have to deal with racism, and if the key 'leaders' who do not undermine women's own cultural identity are men who share that identity, but also promote conservative traditions, then women are more easily tempted (or coerced) into upholding the traditional and orthodox models of their own identity and history.

As a result, there are minority ethnic women who subcribe to notions of cultural identity and tradition more orthodox than those experienced by many women in their countries of origin. Those who leave often define their identity through culture and traditional practices shaped by their experiences in the home country before they left. They do this without being involved in the ways in which culture moves on, changes and transforms in response to and in connection with the other changes in society — economic, political and social. For example, in some Indian immigrant groups in the UK there is a strong ideological and practical commitment to older, stricter forms of arranged marriage than are now practised in certain communities in the subcontinent.

I think that there may be a number of different ways of explaining this: a) cultural practices have moved on but those who left have not — occasional visits are not adequate to participate in the dynamic of change, nor perhaps even to recognise it; b) cultural practices have moved on but those who left do not wish to move on — strong adherence to old practices is a central part of their identity, their self-respect in a hostile and still racist western society; c) those who left the subcontinent are from more conservative groups than those who are involved in radical social and political agitation at home. But whatever the explanation in individual cases, it is important to recognise that there are varied tendencies and histories within a culture. Claims to cultural (or other) difference should not be used to silence critical voices, and definitions of culture and tradition should not be treated as absolute or sacrosanct.

Women in India continue the radical and challenging traditions of the anti-colonial struggles, struggles which were inextricably linked to the promotion of women's rights. A quick look at most of the constitutions put in place when ex-colonies won national independence shows that they committed to gender equality and female suffrage relatively promptly. This did not come about by accident: it came about because women fought long and hard to put these issues on the agenda and to push the nationalist leaders — usually men — to make some progress. Fighting battles for national identity and integrity perhaps helped to set favourable terms in the discourse (if not in a lot of practice) for the promotion of other aims which were consistent with such principles. Improving women's social and political position was one such aim.

I do not mean to suggest that all is well for women in India, Pakistan, Bangladesh or Sri Lanka — far from it — nor that feminist struggles and nationalist projects were one and the same. I do suggest, however, that alongside the traditions claimed by diasporic women — traditions of cultural compliance under regimes of male dominance — there are courageous, exciting and inspiring traditions of women's activism, women's struggles and women's solidarity. Unfortunately, amongst migrant communities the selection of which traditions to promote or adhere to does not commonly encompass these other histories of strong, vocal women's activism. It concerns me that women and girls, first and subsequent generations, lose that aspect of their history and are disconnected from feminist activism and ways of thinking.

This shows itself in the foreclosure that operates for some migrant women (or the succeeding generations) against challenging male oppression within their own communities. It is also supported by (some) feminists from other cultures who, unaware of other traditions, accept and even perpetuate (sometimes under the

rubric of respect) conservative constructions of tradition which oppress women. Feminists in the ex-colonies do not share the reluctance of their migrant sisters to name and challenge the patriarchal practices of their communities.

Difference

There is another aspect of the traditionalism of migrant communities which is of concern: the focus on *difference* and the way in which it can sometimes become an overriding preoccupation. The need to recognise difference is clear — without it there is pressure to conform to a dominant culture, and a denial of prejudice and discrimination. But what does concern me is where difference becomes an absolute organising principle, a fundamental tenet of separateness.

The separatist refrain is along the lines of 'How can you work on my needs when my culture / traditions / religion / experience / language are so different from yours?' Of course, at face value this may have some merit — surely it is those who have particular experiences who are best placed to define their needs — and is an argument which many of us have proposed in relation to women naming their own experiences. However, the dynamics and relationships in which we work are more complex than this formulation permits. I think women in various locations are absolutely central in naming their experiences and needs, and in contributing to the understanding of their situations. But how do others hear these voices? We have to hear them through an organising framework that includes the principles of justice and equality.

When a woman says that her husband has every right to chastise her physically for her wrongdoings, or when a woman says that her husband makes her have sex as and when he chooses but it is not rape, a feminist response will likely *engage critically* with such views. Likewise, it is important to engage critically with cultural expressions of the oppression of women. It is only after hearing these that it is possible to move to working together to address needs — something which I do believe is possible across cultural boundaries. In the case of Sirkat Gah discussed above, for instance, it is not necessary to respect cultural difference by saying that so-called 'honour' killings are a cultural expression or practice (which they may well be). Sirkat Gah is operating within a cultural context and *contesting* its norms: feminists from beyond that context must support their struggle.

Highlighting difference can foreclose discussion, and limit the possibilities for joint action. If I cannot know the particular experiences of, say, Sikh or Muslim women because I am not one, then it can be argued that I can neither have meaningful discussions about their needs, nor can I understand their situations, nor can I sensibly

participate in their struggles. So, on the one hand the privileging of difference can result in closure of communication, while on the other it can silence those beyond the boundary of belonging, in terms of culture, race, ethnicity or religion. The results of the difference principle becoming primary is that it can censure, silence, and support separatism — none of which have a place in struggles for justice and feminist principles.

Another tendency I find troubling is the way in which the language of difference has been taken up by those who are not sympathetic, and used against the very groups which proclaim the centrality of difference. In recent cases of which I am aware, it has not been exceptional for police officers to decline to support women suffering domestic violence because, they claim, of the importance of cultural difference. I know of such instances involving Asian women and women from the Horn of Africa; I know also that others who stray from the 'normative referent' — in their sexuality, appearance, disability etc. — are also liable to have their needs downgraded or dismissed in the name of difference. Such dismissals may be thinly disguised forms of prejudice.

While the police or other individuals or agencies reject calls for support from 'different' women, men from these groups may also take separatist positions on difference. Many Asian women know only too well the intense pressure put upon them by men (but also women) not to speak out about difficult intra-community issues, such as domestic violence. Women should not wash their 'dirty linen' in public, nor subject men to harassment or intervention from a racist state. Where these dynamics are successful they impose once again the compulsion to silence, to uphold and acquiesce in the protection of men and male dominance.

Commonality

Women all over the world experience male violence. I have listened to women of different cultures, religions, countries, age groups, classes, social backgrounds... and over and over again they talk of the devastating impacts of the belittling, of the physical injuries, of the emotional destruction, of fearing for the safety of their children, of the shame and embarrassment of speaking to anyone about their experiences and of the fear that violence brings. Again and again women find ways of expressing their intolerance and disavowal of violence: they share the need for support, belief, safety (including shelter), real options, financial means and clear affirmation that their lives can be different.

All women have the right to live free from violence, the right to live without men and the right to protection by the state against violence inside and outside the home.

How these rights can be best delivered, enabled or facilitated must be considered in relation to the considerations which shape our various experiences, such as culture, language and race/ethnicity. However, the fundamental principle must be that all women have shared experiences, shared needs, rights in common and a sound basis from which to talk to each other and struggle together.

Contrary to what the principle of difference founded on ethnicity or race may tempt us to believe, not all black and ethnic minority women have the same view as to whether and how spaces should be created to resist gender inequality and oppression. Here, the points I made earlier about the divergent ways in which migrant women and those in the home country understand themselves, their cultures and religions are relevant. Constructing a monolithic category of 'third world woman' or even a single Asian stereotype is as problematic and unhelpful as are notions of white women as a single category, or of all women based only on the experience of white, heterosexual, able-bodied women.

There *are* significant differences between women, but they come into play most importantly not in terms of women's life experiences — listening to women from an ever-increasing number of countries and contexts underlines what we share, more strongly than what divides us — but in the ways in which women can and do respond to their experiences and contexts. I will highlight two critical aspects of difference here.

One is access: women have differential access to support and to services. In the UK language issues remain critical in this respect; race and ethnicity are still significant factors when contacting service providers (or when deciding not to do so); dis/ability marks a scandalous barrier to access; and there are many others including those structured by the state, such as immigration rules. The second is politics: much more fundamental than tradition, culture, race or religion is the allegiance women have to particular political projects — feminism is one, anti-racism another. Politics not only influences which projects will be significant but also how those projects are shaped — what justice looks like, what feminism can bring and how one should fight racism. These two issues are much more important in our work together than whether we celebrate Christmas or Eid, how we dress or the food we eat.

I wonder if it is possible to shift the separatist and divisive aspects of a focus on difference by using the concept of *diversity* instead? It seems to me that *difference* has become too loaded with tendencies towards closure, silencing and isolation to be useful in political strategies which emphasise working together. Diversity itself is not without problems — it has been used to neutralise the power of anti-

racist action and politics in the USA and now in the UK (witness the many local government authorities which have replaced their anti-racist teams and policies with those 'valuing diversity' — a de-politicised, unchallenging and anodyne term). Despite this I think that it holds more promise than difference because of the way in which difference has so successfully been used to divide us.

Commonality, diversity and women's politics

The more I hear women's voices from various locations — social, cultural, religious, etc. — the more I am certain that our commonality must provide the framework for our work together. This commonality is shaped by many things including our experiences of male oppression and power, of injustice, violence and discrimination and our struggles for other ways of living. So my first suggestion is that commonality provides the framework and it is within this that we have to recognise diversity.

Secondly, there is one issue which I think is of central importance if we are to work successfully across this diversity — a critical self-positioning. A pre-requisite for conversations across diversity is for women to engage critically with their own position, not only the positions of other women; women must name their own oppression. One of the problems associated with earlier claims to sisterhood was the implicit (and sometime explicit) claims to superiority from white/western women in relation to the rest of us. This cannot have a place in shared struggles.

A third way in which diversity can find a place in our work together is through supporting women's choices and giving credence to other expressions of resistance. This means, for example, that western women cannot instruct all subcontinental women to oppose all forms of arranged marriage, or claim that no feminist can ever wear a head-cover; Indian (and other) feminists should not always rush to write off white women wearing lipstick as not being real feminists.

We should not accept cultural definitions of tradition which are monolithic and which clearly oppress women. We must be able to recognise voices of resistance, which may take many forms, and support them. There are always voices of resistance from women, but they sometimes they struggle to be heard.

sexuality

12. Sex and Danger: Feminism and AIDS (1987)

Sara Scott

AIDS is a feminist issue. It is no longer, if it ever was, simply the name of a medically recognised syndrome; it is a social disease. AIDS brings with it an enormous range of politically loaded questions; for the Right it has become a metaphor of corruption, retribution and moral decay. For the media, the government and the medical profession, the questions it raises are divided into the moral and the political, with the former frequently disguised as the latter. Organising media linked AIDS advice lines during the last few months has provided me with plenty of food for feminist thought, but little space for discussing the sexual politics of AIDS. At the very least, such a politics would deny the division between practical and moral questions and could argue for changes in sexual practice which would be in the interests of women.

It strikes me as bizarre that through all the sound and fury of the AIDS debate, feminists have remained so quiet. AIDS has created the biggest public debate on sexuality, sexual practice and sexual morality since the media recovered from the shock of the 1960s; yet it is one to which feminists have yet to make a particular contribution. Our silence seems bizarre because the issues raised by AIDS are very much on our political patch. I believe we ought to be thinking fast about the implications of AIDS as a health issue for women, and the implications for feminism of all the things other people are saying.

Condom-bound solutions

The idea that there might be other reasons for criticising male heterosexual practice, apart from catching or spreading disease, has not entered public debates. Instead, the liberal establishment are seeing the past (their own male youth perhaps) through rose-tinted spectacles, building a myth of a pre-AIDS golden age of sexual liberation. While bemoaning the loss of wilder days, they appear to be uncritically accepting a monogamous, condom-bound solution to the present crisis. Meanwhile, the Right are regarding the whole affair if not as the wrath of god, then certainly as a gift from god in providing an argument 'from nature' in support of their views on 'promiscuity', the sanctity of the family and the evils of homosexuality. The Left has had very little

to say about AIDS except to criticise the government campaign. It certainly cannot be assumed that the male Left have listened to feminist insistence that sexuality is socially constructed any harder than other men.

The ways of curtailing the AIDS crisis pushed by the government, media and medical profession are by no means the ones that feminists would promote, but they still raise interesting contradictions. For example, a government opposed to sex education in schools is now obliged to promote the most explicit sexual information for young people. It is being advocated that women carry condoms — previously the prerogative of prostitutes and men alone. This suggestion is itself full of ambiguities. In accepting uncritically that women are more responsible than men, it fails to challenge male behaviour and puts the burden of changing their acts and attitudes on to individual women within personal relationships. It takes as 'natural' men's resistance to self control, and falls far short of promoting what an earlier generation of feminists referred to as 'male continence'. At the same time, public permission for women to carry condoms urges us to declare an interest in and preparedness for heterosexual penetrative sex, which women have always been supposed to deny. Most women on the pill, for example, have chosen this form of contraception in part for its invisibility. Young women's only approved role in relation to sex has been to be 'overwhelmed', an attitude which fits uncomfortably with having a packet of Fetherlite in their handbags.

There is a major contradiction for those who use AIDS to advocate a return to 'old fashioned' values: the act which is most acceptable to them is, in AIDS terms, the most dangerous. Women's health campaigners have recognised this

HE HAD JUST FAILED CYNTHIA'S ROUTINE BOY TEST

for generations — hence the campaigns for male continence in relation to venereal disease in the early part of the century. Feminists have understood that penetrative sex has never been free of fear for women: the fear of pregnancy, in or out of marriage; fear of contraceptive failure or side-effects, many of which are life threatening; as well as fear of disease. Our solution has been to promote changes in men's sexual practices. We should advocate non-penetrative sex, with all its positive implications for women's sexual pleasure, as the best way of combatting the spread of AIDS. It's too contradictory for men in general and the Right in particular to advocate 'non-normal' sex because of a health crisis — which is why they're trying to get away with condoms as the solution. We shouldn't be letting them.

The male gay line

Because AIDS is such a new problem it is possible to get radical ideas through to places they would never normally reach, but there is no-one pushing feminist ideas through these channels. Gay men active around AIDS have had unprecedented success in encouraging the media and others to talk about high risk practices in relation to AIDS, rather than high risk groups. This has been argued on the basis that not all men who engage in homosexual sex identify as homosexual and they will not therefore 'hear' advice aimed at high risk groups. When some people are identified as 'high risk', it is possible for others to disassociate themselves from the problem as they do from the group. At the same time, this argument is an attempt to use a philosophical idea about the historical construction of sexuality, in a political present tense. Contemporary sexologists have argued that the concept of a homosexual person is an extremely recent one; until fairly late in the 19th century, homosexuality was identified solely in terms of acts not identities. The law encoded only a series of non-procreative sexual acts, in which buggery appeared alongside bestiality.

What are the implications if gay men are successful in using this argument as a health education tack, an argument which also aims to reduce the homophobia which AIDS has been used to stir up? Could this kind of intervention be part of a continued retreat from identity amongst gay men, with the demise of a gender conscious gay liberation movement? In the context of a 'queer bashing' media, the interventions of gay men are a step forward, but we need to be talking about the wider sexual politics.

Women's monogamy

Some parts of the media AIDS campaign have been targeted at women. An AIDS week programme from Thames Television informed women of a commissioned

survey which showed that women are more monogamous than men. The solution proposed for men's non-monogamy and their unwillingness to use condoms was for women to put pressure on them. No attention was paid to the respective difference between men's and women's commitment to monogamy, or to how women are meant to persuade their long-term and supposedly monogamous partners to use condoms as a precaution against AIDS. How many women could admit, even to themselves, that their husbands might visit prostitutes or have affairs? The media made it quite plain during AIDS week on TV that they were not prepared to advocate monogamy for men outright. Instead they landed responsibility on women, saying that women are 'good girls' naturally and can look after the other half of the population.

Just as the 'naturalness' of women's monogamy is assumed, so is the necessity of heterosexual intercourse. I found the nearest to a feminist media statement in the following from a Channel 4 update to its *Well Being* booklet on sexually transmitted diseases:

> Many people have found that sexual pleasure does not have to depend on penetration; mutual masturbation, for instance, is completely without risk and can give great satisfaction to couples who are worried about the risks of infecting each other.

No comment.

Most women's magazines have carried articles on AIDS and their approach is best summed up by the *Good Housekeeping* headline: 'AIDS: is all the hysteria a blessing in disguise?' Emanating from these articles is a sense of relief, a current of 'we told you so' satisfaction presented as the view of middle-aged, middle-class married women. Celebrating the death of the permissive society, they suggest smugly: 'If you tend to "sleep around", be sensible and aim to settle down with one partner over the next few years'.

It's sad that so many women felt conned, exploited or threatened by sexual 'liberation' but never developed a feminist critique of it. The line taken by these magazines is not anti-women, but it takes for granted that women prefer monogamy by nature rather than because of the social options available to them, and it takes a cheerfully moral view of the joys of less sex.

On the implications of AIDS for relationships between the sexes, Philip Hodson in *She* magazine wrote:

Men who don't look bisexual (even though they may be) will stand in greatest demand. Women will dress to attract the masculine male, paradoxically appearing more seductive, alluring and sexy ... while others will become practically celibate, with all the sex appeal of boiler suits and bags ...

In this scenario a return to 'old fashioned' moral standards and earlier marriage is to be accompanied by a return to old fashioned sex-roles and stereotypes.

Why our silence?

The more I hear about AIDS and the new morality, the more puzzled I become about feminist silence on the subject.

I don't think that as feminists we are immune to the attitudes of the population at large. A recent Gallup poll showed that 80% of people interviewed see themselves at no risk from AIDS, and that 48% agreed that 'most people with AIDS have only themselves to blame'. The idea of AIDS as a gay men's problem has been a slow one to die. This, coupled with the immunity many of us have so far felt as lesbians, plus our political criticism of many gay male lifestyles, means we have been slow to regard AIDS as having much personal meaning for us. Certainly Vada Hart's article in *Gossip* was an extreme example of burying one's head in the sand. Her argument that lesbians and gay men have nothing in common, only the media insists on lumping us together, is fair enough. But the directive that we therefore reject anything to do with AIDS seems positively callous in the face of the biggest surge in 'queer bashing' that the streets or the press have ever seen. It is also incredibly shortsighted.

As lesbians we are associated with male homosexuality, like it or not. *We* may not regard homosexuality as a unitary concept — believing that in a society where men have power over women, loving your own sex has completely different meanings depending on which sex you are — but attacks on gay men do not leave us untouched. Attitudes towards homosexuality and the position of women are often closely linked. What distresses me most about the article is that it regards lesbians as unconcerned and unaffected by something of major importance in the lives of other women. I find this hermetically sealed concept of the lesbian community deeply shocking.

Another explanation for feminist silence is that WLM debates about heterosexual practice have been few and far between in recent years. Few public feminist agendas include responsibility for contraception, non-penetrative sex, non-monogamy or

even marriage. In *Marxism Today*, Melissa Benn observes that heterosexual socialist feminists do not talk about sexuality any more:

> If the debate about sexuality has taken place anywhere in the 1980s it has taken place within lesbian feminism. It is almost as if the subject of sexuality has returned to a pre-1970 situation for women on the Left: the unspeakable clothed as the irrelevant, the disruptive dismissed as the merely embarrassing.

For these reasons we were ill-equipped to raise feminist issues in the context of AIDS. If we don't rebuild our critique of heterosexuality and heterosexual practice our position will be defined for us *within* the parameters of the present debate. This is what I feel Lynne Segal in last month's *New Socialist* is already doing. She claims that feminists have failed to distance themselves from the mainstream anti-sex response to AIDS and, even suggests that the anti-sex scare tactics of the popular press, equating casual sex and death, are following the lead set by some feminist positions on sex:

> they convey a message women have been hearing for some years from a small, but vocal, feminist minority. Sex with men is always and inevitably dangerous. 'A woman needs a man like a fish needs a bisexual' they might say today.

If only it were so easy to persuade the popular press to promote feminist messages. Actually, the sex and danger line is a lot older than us and has done very nicely without our help.

Lynne Segal is trying to associate feminist critiques of heterosexuality with right-wing morality, obviously believing that we have a secret attachment to the nuclear family, will do anything to reduce heterosexual sex in the world or we are simply too stupid to see where our criticisms lead. Feminists, she feels, are liable 'to join the chorus condemning the "permissive" sixties and heralding a new confining morality'. In her fear that political lesbians are going to forge alliances with Right wing politicians, Segal fails to recognise that if the formation of the WLM owes anything to the sexual liberation movement, it is as much to feminist criticism of its philosophies as to the opening up of sexual mores it created. This acceptance that the 1960s really did represent sexual liberation—the freeing of sexuality from 'policing and punishment' rather than the construction of new codes for social control—suggests a dangerous forgetfulness of the lessons of the early 1970s in the face of the quite different problems of the mid-1980s.

We have to find a fuller way of discussing sexual liberation and sexual morality. In Melissa Benn's recent article on feminism in the eighties, she dances on the grave of political lesbianism (a little disconcertingly for those of us yet unburied) and the possibility of a feminist sexual 'morality': 'There has been a growth in the refusal of feminism to accept any idea of a 'correct' or 'incorrect' kind of sexual practice'. She claims the lesbian S/M debate was about 'a rejection by some lesbian feminists of a prescriptive public morality about sex'. I do not believe that our views on sex have become so liberal, nor that we are in danger of being embraced by the Right, but I fear we will be allocated to one side or another unless we get our act together.

Getting our act together

Some of Lynne Segal's points are important — for example, that the media campaign has consistently reduced sex to the 'activity of the penis', and that the government campaign has fostered anxiety and guilt about sex in both men and women (witness thousands of helpline calls from people frantic about oral sex— a comparatively low risk practice, but one that is not seen as 'normal'). She argues that given the power imbalance between the sexes, AIDS can only be countered by 'honesty', 'openness' and more 'imaginative' (women-centred?) sexual habits, which necessitates more equal relationships between men and women, ie women's liberation. What concerns me is her lack of criticism of men's sexual exploitation of women in 'normal' heterosexual sex, her association of feminists who voice this criticism with the anti-sex lobby, and her nostalgia for a 'joint sexual politics with men', which she sees as integral to the WLM of the early 1970s.

By contrast, Ros Coward makes a well-argued case for feminist engagement in discussions about AIDS. She states that AIDS is going to create a 'sexual revolution' of one sort or another, so we may as well use the opportunity to push our vision of what that revolution should look like. She suggests that women may have something to gain from the AIDS tragedy:

> men and women have different interests at stake in any possible sexual revolution and the crisis produced by AIDS may well have different implications for men and women ... women have been bearing the brunt of making sex safe for men in the past ... But now, suddenly, it's a matter of life and death to *men* that they abandon their historical privilege of spontaneous sex and assume personal responsibility for their actions ... sexuality could be redefined as something other than male discharge into any kind of receptacle. In this new

context where penetration might literally spell death, there is a chance for a massive relearning about sexuality.

It's a long shot, and condoms are far more likely to catch on, but given the personal terrors and dilemmas many heterosexual women are facing at the moment, we really must be saying something. The explicit discussions of sexual practice which AIDS has caused have got to be welcomed, and the necessity for a new kind of sex education for young people is pressing. Youth workers and feminist teachers around the country are using the AIDS crisis as a way into discussing responsibility and the rights of women to redefine their own sexuality. As a movement we should be making as much public noise as possible in support of them.

Cruel ironies, exploitable contradictions

Friends have bemoaned the fact that no-one has listened to feminists when we've tackled the very issues which AIDS is getting everyone in a spin about. As Ros Coward puts it:

> There are some especially cruel ironies for feminism in the current situation. We have to watch general pressure mounting to transform sexual innuendo in advertising yet feminist campaigns against sexism in advertising have largely failed. Especially cruel is the conclusion of the British Government AIDS leaflet: 'Ultimately defence against the disease depends on all of us taking responsibility for our own actions'. The feminist call for men to do just that has been something of a voice in the wilderness in the past.

Feminists could be exploiting the numerous contradictions in the Right and Left positions. Like how the Right's 'sex is dangerous' position rests incongruously with their advocacy of 'normal' heterosexual practice. Or the Left's espousal of an outdated liberation politics which substituted one form of women's sexual oppression for another. Perhaps the most satisfying exploitable contradiction is that of a government who, within the space of weeks, moved from attempting to ban sex education in schools, to having to promote frank and detailed information about sexual practice for the entire population!

Ironically, AIDS has promoted the open discussion of sexual practice on an unprecedented scale. We should seize the opportunity to get into the debate, proposing alternatives to a penetrative heterosexual morality and placing a radical, feminist analysis of sexuality firmly on the agenda.

References

Benn, Melissa (1987) 'Sisters and Shoguns, *Marxism Today*, April.

Coward, Ros (1987) 'Sex after AIDS', *New Internationalist*, March.

Hart, Vada (1987), 'Lesbians and AIDS', *Gossip* 2.

Lynne Segal (1987), AIDS is a feminist issue', *New Socialist*, April.

13. Queer Straits (1993)

Julia Parnaby

Here is a quote from *Lesbians Talk Queer Notions,* in which Cherry Smyth argues that the new 'radical' Queer movement has brought about a transformation in lesbian politics:

It has been a long haul back to reclaiming the right to call my cunt, my cunt, to celebrating the pleasure in objectifying another body, to fucking women and to admitting that I also love men and need their support. That is what queer is.

Smyth argues that Queer has grown out of AIDS activism in the United States, and from a dissatisfaction with the way lesbians and gay men have previously worked around issues of sexuality and homophobia. Not surprisingly, Queer has been quick to take hold in Britain where the agenda is so often set by what goes on in the US. Queer activism is centred around actions which make gays and (supposedly) lesbians more visible in straight society. Outrage is the most visible of these groups and they have employed a number of 'shocking' tactics, such as staging a mass lesbian and gay wedding, 'Wink-Ins' and 'Kiss-Ins', all of which are designed to highlight the ways in which lesbians and gays are excluded by the British legal system.

Other aspects of Queer activism have been claimed to be somewhat more threatening to both the gay and straight 'mainstream'. Most notable here is the Manchester group Homocult, who have achieved more than an ounce of notoriety through their 'upfront' poster campaigns and sloganeering, including their infamous 'Paki Poof' images. Even the FROCS (Faggots Rooting Out Closeted Sexuality) outing hoax, which turned Queer activism on its head by tempting the homophobic press with its planned revelation of closeted lesbians and gays, only to leave them foaming at the mouth with a statement about homophobia, and none of the promised star names, was hailed as a triumph for Queer tactics.

What becomes clear from reading *Queer Notions*, however, is that the 'In your face radicalism' which is claimed to be its outstanding characteristic, has, in the end, much in common with plain old liberalism. Queer's 'shocking' tactics constitute little more than a plea to be included in straight society, rather than a demand that

we change it. The Queer demand that lesbians and gays should be allowed to get married too, doesn't question the validity of the whole institution. It seems clear that in the wake of the backlash around feminism (and indeed socialism), Queer as a lifestyle has found its audience.

Reclaiming 'Queer'?

So why the term 'Queer'? Queer — that old style homophobic insult — has been 'reclaimed' we are told, as a way to remind ourselves of how we are seen in heterosexual society. Smyth quotes Joan Nestle, proponent of butch-femme, who says,

> I need to remember what it was like to fight for sexual territory in the time of McCarthy... to keep alive the memory that in the 1940s doctors measured the clitorises and nipples of Lesbians to prove our biological strangeness.

Recycling terms of hatred has been a method employed by some feminists in the past for our own purposes, and to help illustrate our arguments. *Trouble & Strife* for example. However, this has not been done in a simplistic belief that in so doing we have the power to redefine the term's meaning in a wider context, or indeed remove from it its misogynist associations. Nor would feminists wish to advocate that men should continue to use such terms. Reclaiming 'Queer' as a name is based on the assumption that merely to do so strips it of its homophobic power, that it turns the world against the queer basher, rather than the bashed. It is a direct consequence of post-structuralist arguments around language which claim that the meanings of words are constantly redefined each time they are used by the individuals who use them, and that we can therefore make words mean what we want them to mean. Clearly such arguments remove language from both its historical and social context. In heterosexist society 'queer' cannot be other than abusive, just as in white supremacist society racist insults are statements of hatred, and words like 'bitch' reflect patriarchy's misogyny.

Mixed movement

'Queer' also is a very specific word. It is not just a term of abuse but also a term of abuse for men. Queer betrays its origins in male politics even as it names itself, and despite Smyth's attempts to claim otherwise, the book fails to convince that Queer ever did or could include women, and address their concerns. Queer, just like other attempts at mixed movements, has been plagued with accusations of sexism. Attempts to form a lesbian wing of Outrage — LABIA (Lesbians Answer

Back in Anger) — failed. Indeed, the few lesbian members left in Outrage have consistently had to shout to make themselves heard, and have also been obliged on several occasions to prove their existence in the gay (sic) press, after reports that, exhausted by the misogyny in Outrage, all the women had left.

Radical feminism has long recognised the contradictions of working in mixed movements. Queer, however, tries to make lesbians believe that it is in their interests to ally with gay men. What this fails to comprehend is the way in which patriarchy functions to oppress lesbians. By falsely assuming that lesbians and gay men have identical interests, Queer aims to provide an arena where women and men work together to fight men's battles. One of the major demands of Outrage, for example, has been a change in the age of consent laws. Clearly this is an issue which does not affect lesbians, yet Queer tries to convince women to join a movement based almost solely on a male agenda. Queer is not an attempt to challenge the very basis of the hetero-patriarchal society we live in, but rather a campaign for liberal reform to increase the 'rights' of the vocal few. For lesbians to be really free from oppression it is crucial that we engage in struggle for much more fundamental change.

An alternative to feminism?

Nonetheless, *Queer Notions* tries hard to present Queer as an attractive alternative to feminism in a post-feminist age. Feminism, with its emphasis on fighting patriarchy and heterosexuality as institutions, has — Smyth argues — failed. It has failed because it has not addressed the fact that some women like dominant/subordinate relationships; some women want to be objectified; and hey — and here she really gets to the point — some women want to objectify other women. What can a woman do, if she wants to call herself a feminist, and yet she wants the right to do sexually to women what men have always done? Where can she go? Cherry has the answer — Queer:

> The attraction of queer for some lesbians is flavoured by a rebellion against a prescriptive feminism that had led them to feel disenfranchised by the lesbian feminist movement.

Lesbian feminism, it seems, has disenfranchised some lesbians through its very analysis of heterosexuality as an institution and men as a class as oppressors of women. What about women who also want to be fucked by men? What about women who want to act like men? Well, Queer provides a place for them too, by

arguing that it is possible to have sexual relationships with men, yet still call yourself a lesbian. The most integral point seems to be naming oneself (in true postmodern fashion):

> ... there are times when queers may choose to call themselves heterosexual, bisexual, lesbian or gay, or none of the above. If queer develops into an anti-straight polemic, it will have betrayed its potential for radical pluralism.

One can be Queer, whatever one does, if that's what one chooses to be known as. The concept actually has very little at all to do with lesbian or gay sexuality. As Smyth clearly shows, Queer is about breaking down the 'strict binary Homo-hetero opposition which still tyrannises notions of sexual orientation.'

One of the most bizarre aspects of Queer politics — and one which enables those disenfranchised lesbians who want to do what men do, without feeling guilty — is its emphasis on the importance of 'gender fuck', a concept most vocally coined by pornographer Della Grace. Gender-fuck means to 'play' with gender, and has resulted in 'lesbian boys' and 'daddy dykes' — a direct imitation by women of gay male sexuality. Thus lesbianism becomes the poor copycat cousin of male homosexuality.

> In the past two years more lesbians have been discussing their erotic responses to gay male pornography and incorporating gay male iconography into their fantasies, sex play and cultural representations.

Here there is no desire for the female, but rather a worship of the penis, second only to that of many gay men. 'Chick with a dick' is the slogan and image most likely to be adored. For Smyth and her ilk, this is the height of Queerness.

> Della Grace's photograph, 'Lesbian Cock', presents two lesbians dressed in leather and biker caps, both sporting moustaches and one holding a life-like dildo protruding from her crotch. *In this delicious parody of phallic power, laced with an envy few feminists feel able to admit,* these women are strong enough to show they're women. [My emphasis]

The theory buys straight into the age old Freudian and homophobic arguments that all women are frantic with penis envy, and that lesbian sexuality cannot possibly exist without a penis substitute. This, of course, is a lie.

Transgression or reversion

Perhaps unsurprisingly, the logical conclusion of Queer politics is a reversion to heterosexuality. The deification of gay men has reached such a peak that the ultimate experience for Queers has been sex between 'lesbians' and 'gay men'. This is yet more gender-fuck, dabbling in what is seen to be naughty and unconventional, but really what could be more boring than men and women sleeping together!

The play around butch-femme and gender roles, however, is not a flippant bit of fun. Smyth attempts to pay dues to her 'feminism' by pointing out that

> when lesbians take on behaviour perceived as macho and beat up their femme or lesbian-boy identified lovers in the name of transgression, then it's plain old reactionary chickenshit.

However, it is not 'reactionary chickenshit', Smyth believes, if the partner 'consents' to this abuse. Consent is one of the major focuses of Queer's position, but there is no understanding of the way such a concept may or may not operate in a hetero-patriarchal society. If a person pressurises her or his partner, then it may well be the case that s/he gives her 'consent'. It may also be the case that an individual is threatened into a situation in which the coercive partner can easily claim that s/he agreed to being tied up or beaten. Smyth cannot say that some scenes of abuse are OK if both partners 'agreed', and that others are abusive. It is clear that all situations of power inequality are oppressive and must be challenged, not celebrated as some part of Queer liberation.

Queer represents a violent and forceful attack on women who have spoken out about abuse and degradation. Here sexuality is explicitly about power games. Whereas lesbian feminists have questioned the notion that sex is necessarily about dominance and subordination, Queer chooses to celebrate and deify such forms of behaviour. It is a reversion to the old argument that what consenting adults do in private life is fine — or rather, it is even better if they do it in public shouting 'Fuck You'. Queer politics is the apotheosis of teen rebellion — it's as naughty as we want to be and you can't stop us.

The widespread hysteria around the so-called tyranny of 'political correctness' is a large part of what Smyth has swallowed. Queer claims to be challenging the alleged rampant feminist censorship of the individual right to do just what one likes, as and when one feels like it. Anyone who has been active in radical feminist politics will be painfully aware that radical feminism has never had a stranglehold over any part of our hetero-patriarchal society; and to claim that we are the powerful majority denying the libertarians their chance to fuck who and how they like is astounding! Queer however is providing a powerful voice for the libertarian community, a voice which says 'we do what we like without your permission; in the 'new' lesbian and gay politics, if you're not Queer then you have no credibility, and you might as well not exist.

Queer is a deeply conservative movement. It says that nothing can change, that we've got to stop believing that it can. We've got to accept the inevitability of our situation, not try to pretend that the world can change. For Smyth, the most we can aspire to is minor Parliamentary reform. For her, the burning issue is:

> With its anti-assimilationist stance, can the queer agenda help to achieve constitutional reform in Britain?

In the Queer world we learn that power exists and that's all there is to it. Individuals should just choose which side of the power divide they are on and then get on with acting it out. This, Queer argues, is what lesbians and gay men have wanted all along, not the idea that fighting heterosexism ought also to mean fighting the way we oppress people in our own lives. The basic feminist tenet that the personal is political is nothing but an oppressive slogan denying people's right to choose how they have sex, and indeed making them feel guilty about their desires.

In choosing its name, 'Queer' gives its politics away. It fails to recognise the reality of the material world we live in and the fact that neither lesbians nor gay men live in a vacuum. 'Queer' remains a term of abuse for an oppressed group, and as such cannot form the basis for political action to end homophobia. What Queer seems to forget is that we know that there has always been hatred and oppression of lesbian and gay men, and we know that this still thrives in the present. We do not need to remind ourselves by using the language of our oppressors. Revolution requires more than this.

Queer and the backlash

Queer has certainly found a niche for itself, and the movement is in the ascendant, but lesbian feminists should be very wary indeed of a system which fails to acknowledge the role that patriarchy plays in oppressing us and which seems to have rejected feminist arguments almost entirely. Queer fails to address seriously the ways in which men oppress women, and as long as it continues to be a male-led movement there will never be any serious consideration of issues relating specifically to women.

Cherry Smyth tries her hardest to show that Queer can appeal to women, but she fails to convince. Queer is far from the revolutionary movement it would like itself to be, it is little more than a liberal/libertarian alliance. It represents the logical conclusion of 'post-ism'. Post-structuralism suggests that there are no longer clear gender categories: girls will be boys and boys will be girls; and post-feminism

means there's no contradiction in 'feminists' working in a male led movement for male defined goals. We know however that this is not the case. Queer offers us nothing. It is yet one more face of the backlash, trying to pass itself off as something new. We will not be fooled!

References

Cherry Smyth (1992), *Lesbians Talk Queer Notions,* London: Sheba.

14. From Sexual Politics to Body Politics (1994)

Susanne Kappeler

Given the extraordinary vagaries of the term 'sexual politics' in recent times, I want to ask how feminism — a politics of women's liberation — is meant simultaneously to participate in an academic discourse centred on pleasure and the body.

The feminism of the 1970s put its emphasis squarely on sexual politics. Kate Millett's renowned book of that title signalled a new clarity about how the social inequality of women is to be analysed and understood. 'The personal is political' — i.e. the sexual/sexuality is where women individually experience collective oppression by men. While the relations of power between men and women are analytically comparable to other systems of oppression, such as class or race, the oppression of women by men is characterised by the fact that individual members of the opposing groups live together intimately, in the way a capitalist and a worker rarely do, and a master and slave only do if the master is a man and the slave is a woman whom he also sexually exploits. Men not only have power over women, they also desire them. Women are the collective sex object of men's collective sexual subjectivity. This says nothing as yet, of course, about the sexual practice and experience of individuals; it is an analysis of the collective relations between the sexes in the system we call patriarchy.

It is significant, therefore, that in the early 1980s, especially in academic practice, the concept of 'sexual politics' was increasingly replaced by the concept of 'sexual difference'. Sexual difference is the conventional term, used in psychoanalysis, medicine and biology, denoting a given biological difference between the sexes. Most of those who speak of sexual difference had never talked of sexual politics, since psychoanalysis, like other dominant discourses, is firmly grounded in patriarchal ideology. What is interesting, however, is that women — who *had* been speaking of sexual politics — took over this analysis of sexual difference, trying to participate in both malestream academicism and feminism by mixing feminism and post-structuralism.

Intellectual fashions are neither neutral nor ungendered, and are as much a matter of politics as anything else. Like ordinary fashions, they are *made*, produced and

disseminated by interest groups in society. We need to analyse them both in terms of their cultural-historical significance and their provenance, that is to say, in terms of a politics of discourse. From that point of view, concepts, terminology and discursive habits are not just a matter of stylistic choice, but carry analytical, theoretical and political significance. Yet the social nature of discourse is such that we may acquire discursive habits and adopt particular terminologies and expressions, not because we are persuaded of their theoretical appropriateness, but just because they seem to be the terms currently most available.

When white male academics, following Foucault & co, started to foreground the body, that emphasis also began to exert pressure on the language of feminists. We can see this for instance in Maria Mies's book *Patriarchy and Accumulation on a World Scale.* Mies calls one of her chapters 'Body politics', even though what she discusses are in fact the central points of the sexual politics of the feminist movement: campaigns against abortion laws, the critique of the family and family law, the campaign against sexual violence, projects of building refuges for battered women, rape crisis centres, safe houses for children who have been sexually assaulted, etc. It is curious to call these, as Mies does, 'issues which were all in one way or the other connected with the *female body*' (p.24). You might equally say that they are all in one way or another connected with *women*; you might even say that they are connected, not just in one way or another, but in specific ways, to men.

If it is already a problem to call these issues 'women's issues', it is even more problematic to call them issues concerning the female body, for there is no living body of a woman without the woman. What men apparently do to women's bodies they are doing to women. And while many women may learn to bear what is done to their bodies, they do not learn to bear what is being done to *them*. A person may learn to bear the violence done to their body, but a person cannot bear the violation of their person. Which is why feminism is not a branch of medicine, healing the female body, but a politics fighting for women's human rights, their rights to personhood.

This is not just a linguistic quibble, it is the very crux of women's history in patriarchy. Women in our culture have been seen primarily as bodies — sexual bodies designed for sex and reproduction (though very useful in productive labour too). The nineteenth century called women simply 'the Sex' and every religious and later medical theory asserted women's primary function as wives, mothers and prostitutes, or in other words reproducers, raisers of children and providers of sex. The disenfranchised status of women, their status as chattel, the legal property of fathers, husbands or guardians, without political or legal rights of their own, was the material basis for this cultural understanding. What women thought, what women

wanted or felt, was neither here nor there. Culturally, politically and legally, women were objects rather than subjects.

The reduction of people to object status — be it women in patriarchy, or Black people in slavery — means their reduction to their materiality, their bodies. Their significance, their presence in the social world, is *as* bodies. As bodies, they can be objects of commerce, commodities and private property, and means of production and reproduction. Hence the political struggle of women — as of slaves — has been for their emancipation to human status, emancipation from their status as subjectless bodies to the status of political and legal subject. In cultural terms, this has also meant a struggle for public self-expression — the insertion of the voices of women, of Black people, of the dispossessed working classes — into a culture that so far had been the exclusive product of white, educated men. It is the very reason why cultural politics — the public expression of subjectivity on the part of oppressed groups — continues to play such a central role in their struggle for equality.

The culture of men, or rather white men — patriarchal culture as we know it — has in its obsessive dualism not only opposed mind to body and hierarchised mind *over* body, it has also attributed mind to males and body to females. Since women signified body, men (who were doing the signifying) meant mind, culture, reason. It is only very recently in the history of culture that men have apparently discovered their own bodies, and become unduly fascinated by them. After centuries of suppression, that is to say of relegating body exclusively to women, Blacks and animals, the body has made its triumphant entry into male intellectual culture, spearheaded, as is also known, by French intellectuals like Foucault, Lacan and the semiologists.

Seen from a cultural-historical perspective, this is no mean achievement, and as we know, it has been singularly fruitful. The intellectual pleasures of writing, of the visual arts, of cinema, or music, indeed of science and thought of every kind, are now being analysed as sensual and sexual pleasures, as expressions of a person who is not all mind. But while this discovery of the body may be exciting and new in the culture of educated white men, it turns into a massive irony when educated women try to appropriate it for women. For it is nothing new for *women* to return to the body — we never have got away from being identified with it.

We should therefore recognise men's newly found fascination with bodily pleasure for what it is: a delayed recognition of the mortal encasings of their own minds. As women, with a cultural history at the opposite end of their dualistic stick, we should have a very different perspective on this development. We may welcome men's recognition of their own corporeality, less as a discovery of their bodies than as one step towards a recognition of the fallaciousness of the mind-body opposition.

Our task, then, is to reflect on what the world will look like without it. How do we reconceptualise what has been conceived of as either body or mind, as not divisible in this manner? How much of our thinking, our values, not to speak of our symbolic systems, has been influenced by this conception? What is the significance, for instance, of the concept of 'pleasure' so central in contemporary thought? What sort of pleasure is it, and what is its function?

The academic debate on pornography may serve as an excellent test case for these questions, since in many ways it exemplifies the development I am describing. Pornography has been the site of male culture's repression of the body — its relegation to the very bottom of the cultural trash can — and hence is seen as what now most needs to be raised to the top, to where mankind's highest mental stirrings are going on. It is professors of the highest rank and renown who today are ploughing the field of academic pornographology, proving that we have overcome not just the mind-body split, but the split between high culture and low culture. But I shall skip the male professors, revealing as they may be, and concentrate on what female professors are doing in their wake.

The feminist campaign against pornography, as is well known, has met with strong opposition not only from men, pornographers, the publishing industry, the professionals of culture and lawyers, who all have an obvious stake in the issue, but also from women and specifically from academic feminists. This 'pro-pornography feminism' has based its argument squarely on pleasure. Not that pleasure even is the argument, rather it is the natural standard, the obvious criterion, the implicit norm on which the argument is built.

So it is noted by Marion Bower, for example, and apparently with surprise, that 'Pornography can also produce physical sensations of sexual arousal in women as well as men' (p 41). Research conducted among themselves as well as other women is presented as counter-evidence allegedly disproving the feminist case: a plethora of books and articles are devoted to proving that women, too, may enjoy watching and even producing pornography.

Yet we know that women may enjoy reading Milton or Melville, Shakespeare or Joyce, and that they even enjoy writing literature where the reader is also positioned as male. Toni Morrison notes in the preface to her book *Playing in the Dark*: 'For reasons that should not need explanation there, until very recently ... the readers of virtually all of American fiction have been positioned as white' (p. xiv). This has not prevented Black readers from enjoying American fiction, or indeed, from being moved by it, as Morrison herself eloquently proves. Saying that the literary imagination has positioned the reader as white — just as the cultural imagination

in general positions the cultural subject as male — says nothing about what Black people or women may do. It is an argument not about individuals and their social identity but about the subjectivity of reading and viewing, and how that subjectivity is structured by fictions or images.

As feminists we started from the assumption that women as much as men are socialised by this culture — that women too have internalised sexism. As subjects of culture and education, we are all of us socialised to assume an androcentric, sexist, or as we may say metaphorically, a 'male' point of view, just as we are all socialised to a racist, eurocentric or 'white' point of view. But point of view, cultural subjectivity or literary perspective is not what pro-pornography feminists are interested in: their interest is in physical response, bodily arousal, the stirrings of physiology. Far from being an exploration of how the body is part of a person's whole person, indivisible from their subjectivity or mind, their argument turns into an exploration not only of the autonomy of the body, but its supremacy over the mind.

Although patriarchal culture has treated women as bodies, supposedly without a mind, it nevertheless has long applied itself to the surreptitious knowledge that women are persons endowed with subjectivity. Thus while straightforward, traditional sadism might be said to ignore the victim's feelings, it actually presupposes that the victim objects to her victimisation: it is the thrill of sadism to violate the victim's will.

Sadism is the genre that goes with the historical legal bondage of women, their outright subjection and disenfranchisement. But ours is the age of sado-masochism; for the advanced sadism of the modern age aims at the subordination not only of the victim's body, but also of her will, since women's will has now become of consequence. Women may publicly express themselves, give voice to what they think and feel and how they interpret what they experience. Hence the subordination of women's will can only be achieved through control over its expression — that is to say, if the sadist himself invents, dramatises and represents it.

Masochism is not, as is popularly thought, an attitude of the victim, it is the sadist's invention of an attitude *for* the victim. The age of sado-masochism puts all the importance on the alleged pleasure of the victim: her acceptance of the sadistic rule of force used against her, her supposed pleasure in it. Thus the distinctive feature of contemporary pornography is the lascivious smile on the represented woman's face, saying how she welcomes, how she likes and desires her sexual subordination and exploitation. Her body is now being mobilised against herself, against her will.

While this is nothing new in the realm of sado-masochism, indeed, nothing new in the experience of women, what is new is the concerted intellectual effort to declare

the body as the site of truth. Once the body has spoken, expressed its 'pleasure' as physiological reaction, we proceed to read this as the woman's will, her consent to the vexation which produced it.

Thus women's collective political objection to pornography as a practice in society dwindles to a lie, at best a self-deception, in the face of physiological response. Even where a woman may report having experienced a physiological reaction against her will — for example in being raped — a reaction which distresses and upsets her, all her expressions as a conscious thinking intelligent and political being are deemed irrelevant compared to what is defined as her — or her body's — 'pleasure'. The expression of the body, its apparently marvellous autonomy has become the ultimate truth, as if it had nothing to do with culture, as if it put the lie to the mind. In particular, it has become the locus where the true self resides.

Thus Carol Clover writes in her introduction to the anthology *Dirty Looks:*

There *is* something awesome about the way that pornography can move our bodies, even when we don't want it to and even if we don't approve of the images that make it happen. (p.3)

And she adds in parentheses: 'If the unconscious were a politically correct place, it would not need to be unconscious'. The unconscious apparently *is* the body, or the body its direct expression, which comes down to the same thing. There is no theory here about any interaction between consciousness and the unconscious, of any dialectic between the physical and the psychological: there is only a direct aim at the body, bypassing the mind. What a person may think on reflection, on political and intellectual grounds, concerning, for instance, pornography is of no consequence when their body speaks.

Academic feminists advocating pornography not only uphold the old dualistic positivism of a mind encased in a body, they also uphold all the other patriarchal dualisms — insisting on the dirtiness of sex and on the badness of 'girls' devoted to it. 'Bad girls' is what Loretta Loach calls the women she spoke to who enjoy pornography: 'they are the hidden participants in the porn controversy, the transgressors, the bad girls who refuse to be repressed by politics' (p.268). The only difference from the patriarchy of the nineteenth century is that today it counts as the height of radical chic to be 'bad' and to talk 'dirty'.

While this has the ring of adolescent rebellion against the stern moral authorities of parents and church fathers, it nevertheless has more serious political implications. For the body also plays a crucial role in the thinking of the new Right, especially their

theorising of ethnicity and culture as being inscribed in the body (not to mention their unregenerate theorising of sex as biological). Thus we may read in *The Republican*, the party organ of the German ultra-right Republicans:

> The intuitive and emotional bond to one's own people, however, can develop only if we are born into that people, raised among that people, thus being able from the beginning to identify with it. In other words, if one has imbibed belonging to that people, as it were, with the mother's milk ... A Turk or a Nigerian does not simply become a German by being given a German passport. Because of the effectiveness of this inner bond he remains at heart what he always was: a Turk or a Nigerian. Only in exceptional cases may he detach himself — and even then only certain parts of his being — to become a German.

In other words, his body remains the true repository of his ethnicity, no matter what he does, learns, acquires in his life as a person. He may even get to know German culture better than a German who was raised in it, having consciously acquired and studied it — yet what is of interest and consequence is his 'being', that is, his body.

There is a concerted intellectual effort underway to locate the self back in the body as biological or bio-cultural fact. Everything else is but the superficial trimmings of a mind trying to disguise the truth of the body — an acquired foreign culture belying the truth of ethnicity, a conscious mind negating the body's truth. The purpose is to deal with bodies according to their nature, deporting them to where nature grew them, deploying them as nature designed them: Turks to Turkey, Nigerians to Nigeria, native women for the sexual purposes nature has so aptly equipped them for.

Primo Levi writes in *If This is a Man*, his account of being a prisoner in Auschwitz: 'there we learnt that our personality is fragile, that it is in much greater danger than our life.' We may learn to bear injuries to our bodies, but what is being done to us as persons — the violation *of* our person — is a peril different from the physical threat to kill our body. It is a danger which once again is being made invisible by a theory which insists on reducing the self to the body.

References

Bower, Marion (1986), 'Daring to speak its name: the relationship of women to pornography', *Feminist Review* 24.

Clover, Carol (1993) 'Introduction: Does pornography cause violence?' in Pamela Church Gibson and Roma Gibson (eds.), *Dirty Looks: Women, Pornography, Power*, London: BFI.

Levi, Primo (1991), *If This is a Man* and *The Truce,* London: Abacus.

Loach, Loretta (1992), 'Bad girls: women who use pornography', in Lynne Segal and Mary McIntosh (eds.), *Sex Exposed,* London: Virago.

Mies, Maria (1986), *Patriarchy and Accumulation on a World Scale,* London: Zed Books.

Millett, Kate (1977), *Sexual Politics,* London:Virago.

Morrison, Toni (1993), *Playing in the Dark: Whiteness and the Literary Imagination,* New York:Vintage.

15. Straight Talking (1995)

Stevi Jackson

M any feminists have drawn attention to the need to dissociate critiques of institutionalised heterosexuality from criticisms of individual heterosexual women, but this separation has not always been easy to maintain. I believe this problem is bound up with a wider one: we have yet to find satisfactory ways of conceptualising sexuality as fully social. While the majority of feminists agree that sexuality is socially constructed rather than natural, there is no consensus on what we mean by social construction, nor on how it should be analysed.

Three main strands of analysis have developed over the last two decades, which have, in practice, become associated with particular variants of feminism. Each emphasises a specific aspect of sexuality—the centrality of male domination, the variability and plasticity of sexuality or the construction of our individual desires. It is my contention that each of these facets of sexuality must be addressed and that we should explore the ways in which they intersect with each other. What has tended to happen, however, is that particular groups of theorists concentrate on one aspect of sexuality to the exclusion of others. Because each is pursuing its own political and theoretical agenda, little genuine exchange of ideas takes place.

I am not trying to find some neutral 'middle ground': I write from a particular theoretical and political position as a materialist radical feminist, and from a specific personal location as a white heterosexual academic feminist. I want to explore these issues and debates in order to seek a way forward for feminist analysis.

Sexuality and male power

The first tendency, which locates sexuality as a site of male power, had its roots in feminist political activism, in efforts to challenge men's sexual appropriation and abuse of women. This form of analysis has been pursued primarily, but not exclusively, by radical feminists. It has given rise to analyses of sexual violence and pornography and, more generally, of the ways in which sexuality has been constructed from a masculine perspective. The social construction of sexuality is here seen as serving the interests of men, as coercing women into compulsory heterosexuality. It is therefore linked to a structural analysis of patriarchy. Moreover, the erotic itself is understood as culturally constituted, so that current definitions of

eroticism are shaped by the patterns of domination and subordination intrinsic to patriarchal societies, and written into their cultural representations. (Examples of this argument can be found in Susanne Kappeler's *The Pornography of Representation* and Deborah Cameron and Elizabeth Frazer's *The Lust to Kill*.)

Curiously, radical feminist perspectives of this kind are often misread as essentialist, as implying that men are naturally sexually violent and predatory while women are innately loving and egalitarian. It is odd that a perspective dedicated to challenging and changing both male and female sexuality, and to radically transforming our ideas about what is erotic, should be seen as biologically determinist. Nonetheless this has become a familiar theme in attacks on radical feminism. Our emphasis on coercive aspects of sexuality and on the connections between sexuality and women's oppression has also led to the charge that radical feminists cannot deal with sexual pleasure and are simply anti-sex. This ignores the diversity of opinion among radical feminists, and equates opposition to specific sexual practices with a general anti-erotic stance.

There are, nonetheless, aspects of sexuality which are under-theorised from a radical feminist perspective. Radical feminists have not devoted much attention in print to the ways in which sexuality is constructed at the level of our individual feelings, identities and practices. While generally assuming that specific sexual desires and preferences are learnt, we have had little to say about how this happens.

The variability of sexuality

Radical feminists endorse the idea that human sexuality is historically and culturally variable. This is fundamental to all forms of social constructionism, since it challenges the notion that human sexuality is fixed by nature. Historical work on sexuality has been undertaken from a range of perspectives: radical feminists' contributions include Sheila Jeffreys' work on the pathologising of lesbian relations, and Margaret Jackson's analysis of sexological constructions of sexuality. The idea that radical feminists regard sexual relations as fixed and unchanging is another false stereotype.

The agenda for much academic writing in this area, however, has been set by other feminists, particularly those influenced by the French theorist Michel Foucault. The appeal of Foucault to feminists lies in his radical anti-essentialism and his view of power as *constituting* sexuality, rather than merely repressing it. On the other hand feminists have found fault with Foucault's blinkered attitude to gender and with his view of power as diffused throughout society. This conception of power—as every-where and nowhere, rather than concentrated in the hands of the privileged—is

difficult to reconcile with structural inequalities, with the real material power men have over women. This may explain why Foucault is so attractive to some of those who used to call themselves Marxist feminists, who were always reluctant to accept the degree to which individual men benefit from women's subordination.

Feminists working within a Foucauldian framework have explored the ways in which scientific, medical and legal discourses have historically defined the 'truth' of female sexuality and subjected it to regulation through the power of discourse to name, classify and categorise (e.g by distinguishing between 'normal' heterosexual femininity and lesbian 'perversity', or between the pure wife and mother and the impure whore). Such analyses are often useful in drawing attention to major shifts in the construction of female sexuality, but tend to overlook historical continuities. This, coupled with the denial of structural power relations, means that Foucauldian feminists fail to recognise the persistence of patriarchal domination, its resilience and adaptability under changing historical conditions.

Sexuality is also subject to variability at any given time. We need to consider the intersections of gender and sexuality with class, race and other social divisions, to think about the ways in which dominant discourses around sexuality have been framed from a predominantly white and middle class, as well as male and heterosexual, perspective. Although some attention has been given to these issues, Foucauldian perspectives tend to focus on sexual diversity *per se*, on 'sexualities'. Here the lack of attention to structural bases of power can become highly problematic: there is no way to establish the similarities underpinning diverse 'sexualities', relate them to dominant modes of heterosexual practice or locate them within power hierarchies. Instead attention is directed to the 'outlaw' status of various 'sexual minorities', each, from a libertarian perspective, equally worthy of protection from persecution. It is not recognized that there is a world of difference between a street prostitute and a millionaire pornographer, or between a man who has sex with a child, and that child.

Libertarian arguments lose sight of the way power constructs desire. Bodies and pleasures are treated as unproblematic, and diverse forms of sexuality are taken as given, already there to be outlawed. This brings us back to the model of repression which Foucault so effectively critiqued. The false equation of the transgressive with the progressive is in fact framed from within the very discourses it seeks to subvert. Both libertarian and authoritarian perspectives on sexuality tend to afford it an overly privileged position; sexual license is seen either as the route to personal fulfilment and social liberation or as leading to individual degradation and social disintegration.

I find Foucauldian analysis interesting in sensitising us to the many, often contradictory, ways in which sexuality has been constructed and regulated. But its inability to deal with the pervasiveness of patriarchal power, with the ways in which what counts as 'sexual' has been constructed in terms of gender hierarchy, is a major problem for feminist theory. The idea that our sense of what is sexual, including our desires and practices, is a product of the particular discourses circulating in our society is potentially useful. But we need to retain a concept of discourses as ideological, serving to obscure or legitimate relations of domination and subordination. Discursive constructions of sexuality have produced very particular 'truths', defining male dominance and heterosexuality as natural and inevitable.

Individual desires

This still leaves us with the problem of the relationship between our individual desires and the discourses circulating within society. On this question, Foucault is frequently abandoned in favour of psychoanalysis. Psychoanalysis has established a virtual monopoly on theorising the construction of sexuality at the level of the individual subject, despite numerous cogent critiques: many feminists and sociologists agree that psychoanalysis is ahistorical, and that it rests on essentialist premises. Moreover, it depends upon interpreting children's emotions through a filter of adult assumptions and then making incredible leaps from presumed infantile frustrations and gratifications to adult sexual desires and practices. No distinction is made between gender and sexuality: the two are conflated and ultimately reduced to the gender of our 'object choice'. Psychoanalysis has been so influential largely because of the lack of alternatives. It is not that there are no other theories, but that they are either inadequate or underdeveloped. For those who are sceptical of psychoanalysis, this is a major gap in feminist theory.

In theorising sexuality we need a means of understanding how we become gendered and how we become sexual without conflating gender and sexuality, without assuming that particular forms of desire automatically follow from feminine or masculine gender and without positing 'heterosexual desire' and 'lesbian desire' as monolithic entities. We need some understanding of how the process of becoming sexual is related to discourses on sexuality circulating within our culture and how these in turn are related to structural inequalities, particular gender inequality. We need to weave these strands together in such a way as to recognise the force of cultural and ideological constructions of sexuality and the constraints of social structure, but without denying human agency and therefore the possibility of resistance and change.

This enterprise, in my view, also requires that we do not over-privilege sexuality. Part of the problem we have in thinking about it derives from the symbolic weight it is made to carry, the way it is conventionally singled out as 'special', as qualitatively different from other aspects of social life. Feminists need to give more critical attention to this cultural obsession with sexuality, including the ways in which it shapes the theories that we ourselves have produced. We should be wary of treating sexuality as important in and of itself, since the importance it is accorded derives from the ways in which it is interrelated with other aspects of women's subordination. While I would insist on the necessity of relating sexuality to gender, I am firmly convinced that the latter is more important than the former. Here my perspective differs from that of some other radical feminists, notably Catharine MacKinnon, who sees gender as constructed through sexuality. My position is derived from Christine Delphy's argument that gender, the existence of 'men' and 'women' as social categories, is a product of hierarchy. Sexuality, in particular institutionalised heterosexuality, is woven into this hierarchy.

Heterosexuality and feminism

Radical feminists have always treated heterosexuality as problematic, and been sensitive to the pervasiveness of power within sexual relations. They have also analysed the ways in which the heterosexual framing of desire impinges on *lesbian* sexuality: analyses of heterosexuality have played an important role in anchoring critiques of lesbian and gay sexual practices (such as S&M) which eroticise power, and of the libertarian theorists who defend and celebrate those practices.

If we are serious about endorsing a social constructionist position, we must accept that those who are fugitives from compulsory heterosexuality do not necessarily escape from its influence. We all learn to be sexual in a society in which 'real sex' is defined as heterosexual penetration, in which sexual activity is thought of in terms of active subject and passive object, in which passion is often infused with fantasies of domination and submission. Thus it seems to me that a critique of heterosexuality needs to underpin all theorising about sexuality.

This is precisely what is missing from many libertarian analyses. In defending sexual 'pluralism' it is often forgotten that feminist theories of sexuality began by questioning the relations of dominance and submission inscribed in conventional heterosexual practice, suggesting that such relations were neither natural nor inevitable, but resulted from the hierarchical ordering of gender. Many of the 'sexualities' currently being defended or promoted reproduce these hierarchies, whether in the form of sado-masochism or 'cross-generational relations' (a euphemism for child sexual abuse). There is no questioning of where such desires come from.

As it is institutionalised within society and culture, heterosexuality is founded upon gender hierarchy, upon men's appropriation of women's bodies and labour (the implicit terms of the marriage contract). The benefits men gain through their dominant position in the gender order are by no means reducible to the sexual and reproductive use of women's bodies. In marriage, for example, the home comforts produced by a wife's domestic labour are probably far more important to a man's well-being and his ability to maintain his position as a man than the sexual servicing he receives. Nevertheless, a man does acquire sexual rights in a woman by virtue of marriage, and a woman who is not visibly under the protection of a man can be regarded as fair sexual game by other men. Fear of sexual violence and harass-ment is also one means by which women are policed and police themselves. The institutionalisation of heterosexuality also works ideologically, through the discourses and forms of representations which define sex in phallocentric terms, which position men as sexual subjects and women as sexual objects.

Because heterosexuality is the privileged norm in our society, it is rarely thought of as an identity. Nonetheless many of the identities available to women derive from their location within heterosexual relations—as men's wives, girlfriends, daughters or mothers. Attachment to these identities affects the ways in which women experience the institution and practices of heterosexuality. For example, women's ambivalent feelings about housework, their unwillingness to be critical of the appropriation of their labour, spring from their feelings about those they work for and from their desire to be good wives and mothers. In sexual terms, too, women's identities are likely to be shaped by heterosexual imperatives—the need to attract and please a man.

To name oneself as heterosexual is to make visible an identity which is generally treated as an unquestioned fact of life. This can be a means of problematising heterosexuality and challenging its privileged status. For women, however, being heterosexual is not a situation of unproblematic privilege. Heterosexual feminists may benefit from appearing 'normal' and unthreatening, but heterosexuality as an institution entails a hierarchical relation between (social) men and (social) women. Resistance to subordination within this hierarchy is fundamental to feminist politics.

It is hardly surprising that heterosexual feminists prefer to be defined in terms of their feminism—their resistance—rather than their heterosexuality, their relation to men. Resisting the label heterosexual, though, has its problems. It can imply a refusal to question and challenge both the institution and one's own practice. It can serve to invalidate lesbianism as a form of resistance to patriarchy and to deny the

specific forms of oppression that lesbians face. For these reasons many lesbian feminists may share Celia Kitzinger and Sue Wilkinson's scepticism about those who 'call for the dissolution of the dichotomous categories "lesbian" and "heterosexual"'.

Questioning this distinction, however, is by no means antithetical to radical feminism. The categories 'heterosexual', 'homosexual' and 'lesbian' are rooted in gender—they presuppose gender divisions and could not exist without our being able to define ourselves and others by gender. If we take Christine Delphy's argument that 'men' and 'women' are not biologically given entities but social groups defined by the hierarchical and exploitative relationship between them, then the division (also hierarchical) between hetero and homosexualities is a product of this class relation.

The practice and experience of heterosexual sex: power and pleasure

Recent analyses of heterosexuality, whether attacking it or defending it, have tended to focus on sexual experience and practice (by 'experience' I mean what is felt both sensually and emotionally, while 'practice' refers to what we do and how we do it. Specifically sexual experience encompasses our desires, our pleasure and displeasure). These debates have been centrally concerned with power, and the degree to which women can subvert or challenge it within heterosexual relations. The battle lines are drawn between those arguing that heterosexual sex is inescapably oppressive for women (e.g. Sue Wilkinson and Celia Kitzinger), and those who maintain that men's sexual power is fragile and vulnerable to subversion (e.g. Lynne Segal in *Straight Sex*). Both arguments are problematic. On the one side are those with an overly deterministic view of male power and on the other, those who minimise its effects and overestimate its instability.

From a materialist perspective, desire, as currently socially constituted, is inevitably gendered. This is as true of lesbian sexuality as of heterosexuality. Desiring 'the other sex' or 'the same sex' requires the existence of 'men' and 'women' as socially—and erotically—meaningful categories. What is specific to heterosexual desire is that it depends on gender *difference*, on the sexual 'otherness' of the desired object. This difference is not anatomical but social: it is the hierarchy of gender which 'transforms an anatomical difference (which is itself devoid of social implications) into a relevant distinction for social practice' (Christine Delphy, *Close to Home*, p 144).

Since it is gender hierarchy which renders anatomical differences socially and erotically significant, heterosexual eroticism is infused with power—but this

eroticisation of power is not reducible to the mere juxtaposition of certain body parts. It is not an inevitable consequence of an anatomical female relating sexually to an anatomical male, but results from the social relations under which those bodies meet. These social relations can be challenged. Even the most trenchant critics of heterosexuality and penetrative sex (such as Sheila Jeffreys and Andrea Dworkin) recognise that it is not male and female anatomy nor the act of intercourse itself which constitute the problem, but rather the way in which heterosexuality is institutionalised and practised under patriarchy.

But to argue that the power hierarchy of gender is structural does not mean that it is exercised uniformly and evenly at the level of interpersonal sexual relations, nor that our practice and experience is wholly determined by patriarchal structures and ideologies. There is room for manoeuvre within these constraints. To deny this is to deny heterosexual women any agency, to see us as doomed to submit to men's desires whether as unwilling victims or misguided dupes. It cannot be assumed that if women like heterosexual sex we must all be wallowing in a masochistic eroticisation of our subordination—the consistent message of the radical lesbian, or revolutionary feminist, position. Heterosexual feminists, here as elsewhere in their lives, have struggled against men's dominance. We have asserted our right to define our own pleasure, questioned phallocentric models of sexuality and in the process often changed our own desires and practices.

Nonetheless, I am acutely aware that negotiating sexual pleasure with men is often difficult, and depends on their willingness to give up conventional masculine

prerogatives. That there are a few (very few) men out there prepared to attempt more egalitarian sexual forms of sexual practice does not negate the structural power that accrues to men as a group. Moreover, some women are materially better placed to challenge this power than others. Academic heterosexual feminists are relatively privileged compared with most other women: we have access both to economic independence and to feminist ideas and support networks—hence we are in a stronger position to negotiate the terms under which we enter into sexual relationships with men. Many women have little option but to accommodate themselves to male desires and seek fulfilment in the giving of pleasure. (This attribute of femininity is not confined to sexuality: the ethic of service to men is also fundamental to other aspects of gender relations.)

In the end, what heterosexual feminists do in bed has little impact on institutionalised male domination. While the personal is always political, concentrating on the narrowly personal while ignoring the broader political context is not the way forward for feminism. It is impossible to imagine a truly egalitarian form of heterosexuality while gender hierarchy and hence gender division persists; and if that division were eradicated heterosexuality would no longer exist in any meaningful sense.

References

Cameron, Deborah and Elizabeth Frazer (1987) *The Lust to Kill,* Cambridge:Polity Press.

Delphy, Christine (1984) *Close to Home: A Materialist Analysis of Women's Oppression,* London: Hutchinson.

Dworkin, Andrea (1987) *Intercourse,* Secker & Warburg.

Foucault, Michel (1981), *The History of Sexuality, Vol I,* Harmondsworth: Penguin.

Jackson, Margaret (1994) *The Real Facts of Life: Feminism and the Politics of Sexuality,* London: Taylor & Francis.

Jeffreys, Sheila (1985), *The Spinster and her Enemies,* London: Pandora.

Jeffreys, Sheila (1990) *Anticlimax: A Feminist Critique of the Sexual Revolution*, London: Women's Press.

Kappeler, Susanne (1986), *The Pornography of Representation,* Cambridge: Polity.

MacKinnon, Catharine (1982) 'Feminism, marxism, method and the state: an agenda for theory', *Signs* 7(3).

Segal, Lynne (1994) *Straight Sex: The Politics of Pleasure,* London: Virago.

Wilkinson, Sue and Celia Kitzinger (eds) (1993) *Heterosexuality: A 'Feminism and Psychology' Reader,* London: Sage Publications.

theory

16. The desire for Freud: Psychoanalysis and Feminism (1983)

Stevi Jackson

t is no longer possible for those of us who reject psychoanalysis to ignore it. In the early days of the Women's Liberation Movement Freud's theories were rejected, but today new 'readings' of his work have gained many feminist adherents. I remain sceptical: I want to show that, despite the great claims made for it, the new brand of psychoanalysis has nothing to offer feminists.

The new readings are said to be 'anti-essentialist'; that is, to make no assumptions about biological differences between the sexes or biologically-based sexual drives. This is important, since an essentialist approach effectively denies the possibility of change. However, I argue that the new readings *are* essentialist, just as the old readings were. It is always important for feminists to understand ideas that seek to explain female subordination as 'natural', unchanging and unchangeable. That is why I ask you to bear with me as we pick our way through what may seem nonsensical rubbish.

Deferring to Freud

In debates around sexuality, psychoanalysis is often treated as if it were the only possible way of explaining things. Even those who are critical of psychoanalysis frequently display considerable deference towards it. There is a tendency to assume that any aspect of women's experience, especially sexual experience, that is not immediately explicable by any other means must come within the realm of psychoanalysis.

Michèle Barrett, for instance, makes some telling criticisms of psychoanalysis, but falls back on it as soon as she encounters an aspect of women's subjective experience which she believes not to coincide with objective fact. Discussing Masters and Johnson's insistence that all female orgasms are clitorally centred, she says that this 'did not tally with many women's lived experience of intercourse'. She goes on: 'It is at this point that Freud's account may be useful, precisely in demarcating the psychic processes that underlie the pleasure of this experience'. Even supposing she is right in saying that what women feel does not match with the known facts — which I would dispute — why should she suggest, even tentatively,

that Freudianism can explain it? Why is this the *only* possible explanation she considers? I would agree with her that we need 'an understanding of sexuality in terms of meanings, definitions, the discourse of pleasure in relation to our knowledge of the technical processes involved in sexual activity'. But this is precisely what psychoanalysis does *not* provide.

The original feminist gut-reaction against Freud was, I believe, justified. I do not accept that we read his work incorrectly or misunderstood and misrepresented him. It is sheer arrogance to suggest, as Juliet Mitchell does, that we could only come to this negative conclusion on the basis of second-hand, popularized versions of Freud, or because we only read the bits on femininity without understanding their place in psychoanalytic theory, or simply because we thought penis envy was a silly idea.

We are now told that new 'readings' of Freud, specifically those deriving from the work of Jacques Lacan, have purged his work of all the elements which feminists found unsavoury. The new readings say that we are not born feminine or masculine, but are constructed as 'sexed subjects' through our acquisition of language. Language structures both consciousness and the unconscious. It is also at this 'moment' of our 'entry into language and culture' (as they put it) that 'desire' is constituted, i.e. that we become sexual. Nor need we worry about penis envy any more, because it's all symbolic and has nothing to do with that organ being intrinsically 'better' than anything women are endowed with. To quote Rosalind Coward, who comes closer than most to expressing these ideas in plain English:

All reference to the anatomical superiority of the penis is removed. The phallus is the symbolic representation of the penis, not the actual organ. This is because of its role in the symbolic, the pre-existent linguistic and cultural order.

The role of this symbolic phallus is crucial for that all-important entry into language and culture. In Lacanian theory it is the 'privileged signifier' around which all 'difference' — which is taken to be the basis of language and culture — is organized. The meaning of the penis/phallus therefore has nothing to do with the physical difference between the sexes as such, but with the cultural significance which the phallus is given. In short, psychoanalysis is phallocentric only because it is analysing a phallocentric, patriarchal culture. We can forgive Freud his occasional misogynist lapses, since basically, it is claimed, he was right.

I remain unconvinced. One problem concerns the status of this reading of Freud. Lacan's obscure writings are seen as revealing what Freud really meant, and therefore

CATH JACKSON

Panel 1: I HAVE BEEN STUDYING WOMEN FOR OVER 50 YEARS

Panel 2: TRYING TO FIND OUT HOW THEIR MINDS WORK.

Panel 3: I HAVE FOUND NOTHING.

Panel 4: MY LIFE'S WORK! NOTHING!

Panel 5: I CAN COME TO ONLY ONE CONCLUSION ...

Panel 6: WOMEN HAVE NO MINDS.

anyone who reads Freud literally has got it all wrong. It seems to me, however, that Freud said what he meant and meant what he said. I hold the unfashionable view that the literal reading of Freud is the correct one, and that the insights claimed for Freud by the Lacanians are often little more than wishful thinking.

What Freud was concerned with was children's responses to their discovery of physical differences between the sexes. Briefly, he argues that a boy, seeing that girls lack a penis, thinks they have been castrated and fears that this will happen to him as punishment for desiring his mother and his rivalry with his father. This leads him to resolve his oedipal complex (his desire for his mother and hatred of his father) by giving up his desire for his mother. A girl on the other hand, seeing the penis, is overcome with envy, feels she is castrated, blames her mother for this condition and therefore turns away from her mother towards her father.

The tension between biological and cultural determination of human sexuality evident in Freud's writings is more often resolved in favour of the biological than his recent apologists seem willing to admit. There are, however, more fundamental problems which are not attributable to Freud's misogynist bias, but are intrinsic to psychoanalysis — its status as 'knowledge', its assumptions, its methodology. It is these problems which I wish to address.

The First Line of Defence: Discrediting the Opposition

The difficulty of modern psychoanalytic writings is widely acknowledged. The style is tortuous, the vocabulary esoteric and the concepts slippery. The unwillingness or inability of theorists to translate their ideas into terms which the uninitiated can comprehend has been rightly damned as elitist. It makes these writers relatively immune from criticism from outsiders: how can we presume to criticise something we don't understand?

Those working within this framework can smugly reassure themselves that if the rest of us have doubts it is only because of our ignorance. Juliet Mitchell's work, being less directly influenced by Lacan, is more comprehensible than most. But she makes up for this by constantly implying that if we reject Freud it is because we are too stupid to see the Great Truths he has uncovered. The whole tone of *Psychoanalysis and Feminism* is arrogant and condescending. But I believe we must resist being cowed into silence by elitist mystifications. This is all the more important since what psychoanalysis purports to offer us is an explanation of our 'lived experience' as women. We need, therefore, to challenge the strategies which prevent us from testing it against that experience.

The Second Line of Defence: the Mysteries of the Unconscious

Any criticism of psychoanalysis we might offer, on the basis of any data or experience, is subject to the instant rebuttal: 'Ah, but in the unconscious ...'. Juliet Mitchell repeatedly asserts that we must understand the nature of the unconscious, for without that understanding Freud makes no sense. She constantly chastises his critics for claiming to dispute specific points when in reality they are rejecting the whole idea of the unconscious. She makes that rejection sound like a neurosis. I am willing to admit, quite openly, that I suffer from this sickness. I cannot be convinced that we are dealing with a body of irrefutable fact concerning the unconscious. Whatever Mitchell says to the contrary, I submit that we are merely being asked to have faith.

I am not denying the existence of any psychic processes beyond our consciousness. What I *do* contest is that the non-conscious mind is knowable in the systematic fashion claimed by psychoanalysis, and that everyone's unconscious is subject to similar processes and contains similar repressed wishes or drives. By definition the unconscious is not knowable by the conscious mind: it is claimed that it can only be made available through analysis (that is, Freudian therapy), through

the piecing together of dreams, slips of the tongue and so on. But analysis is a highly intuitive process, and the results of such intuition can hardly be taken as objective fact. And in any case, much psychoanalytic theorizing seems to be based on pure speculation, with no reference even to the dubious evidence of analysis.

Not only am I unconvinced as to the 'scientific' status of this enterprise, I fail to see why you need to believe in the unconscious to see that our 'subjectivity', our sense of ourselves, is built up through a particular language and culture, in relation to specific social relations. These general conclusions could be arrived at without any preconceptions as to the nature of the unconscious, and the same is true of many more specific conclusions yielded by psychoanalytic theory. For example, Toril Moi, in a paper on sexual jealousy, after meandering through the usual Freudian arguments that jealous women are normally depressive, concludes:

Feelings of loss and wounded self-esteem are conducive to depression. In order to be respected and esteemed, women in patriarchal society must demonstrate that they can catch and keep a man. To lose one's lover/husband is interpreted as a blow to the woman's worth as a human being. It is easy to understand why depression should be a widespread reaction in women who discover they have a rival.

This seems a reasonable, common-sense explanation. But why did Moi have to jump through Freudian hoops, demonstrating that female jealousy is somehow 'pre-oedipal', to arrive at a conclusion that most of us could have reached without the benefit of the 'insights' of psychoanalysis?

When psychoanalytic accounts yield reasonable conclusions it is in spite of, rather than because of, their assumptions about the unconscious. But these assumptions can lead to very dubious arguments, especially those based on the notion of 'repression' — the idea that certain drives or needs are denied expression and therefore repressed. It is this which undermines the claims of many writers that they are dealing with the cultural construction of subjectivity, for it assumes the existence of 'drives' which exist *outside* culture—which are presumably innate, and which reside in the unconscious.

An example of what I find dubious is the explanation of our 'amnesia' about infantile sexuality as the result of repressing wishes which our culture does not allow to be fulfilled. Along with other psychoanalysts, Mitchell seems to assume that this amnesia validates the claims made about repression and the unconscious. I am sceptical of this for two reasons. Firstly, it presupposes that certain infantile

experiences are essentially, in themselves, sexual, independent of any such meaning being applied to them (except by psychoanalysts). This assertion seems to have no foundation beyond the fact that Freud said so. I would argue that nothing is sexual unless it is subjectively defined as such—a point I will return to later.

Secondly, most of us remember little or nothing about our earliest years. Are we to believe that *all* of this experience was repressed, that everything which happened in that phase of life comes under the heading of 'what our culture does not permit'? There is a perfectly simple explanation for the loss of these early memories, one which does not require any assumptions about repression or the unconscious: that we lacked the language with which to represent our experiences to ourselves.

Language, the Phallus and the production of sexed subjects

The process of acquiring language has become central to psychoanalysis. It is through this process that we become social beings, that we enter culture and culture enters us, constructing us as 'sexed subjects'. This I do not see as particularly contentious: I am quite prepared to accept that language structures experience. Language is not merely a tool with which we express ideas. It shapes how we think, indeed what it is possible to think about, and therefore orders the way we make sense of our experience. Psychoanalysis is far from being the only theoretical framework which makes this point.

What is more problematic is the idea of the oedipal situation and the role of the phallus as 'primary signifier'. The notion of penis envy as such is still very much there in Mitchell's work, albeit reconceived as envy of what the penis represents rather than of the physical organ. Coward and her associates place more emphasis on the importance of recognizing the phallus as the symbol around which entry into language and culture is ordered. What this apparently means is that the child cannot place herself in the world, specifically as a sexed subject, without having taken note of the crucial difference between having/not having the phallus; without this she cannot, therefore, become a fully social language-using human being. But while male children make a positive entry into the symbolic, girls enter in a negative relation, one of lacking, of not possessing the phallus, the mark of difference.

One aspect of this formulation which I find confusing is the exact relation between the constitution of the sexed subject and the learning of language—a confusion heightened by terminological obscurity. If writers meant merely that learning language involves being aware that one's position in the world is as a boy or a girl, then this would not be too problematic. Girls *do* enter into culture in a negative

relation, being defined in relation to the male, as not-male. What is problematic is the notion that the child cannot enter culture as a sexed subject and cannot speak until she has negotiated the castration complex.

While these explanations of our construction as sexed subjects rest on the symbolic function of the phallus rather than on envy of the penis itself, they nonetheless seem to assume an awareness of, a representation of, real physical difference. Yet it is surely quite possible for a girl to remain unaware of the existence of penises until well after she is fluent in language and has identified and placed herself as a little girl. More conventional studies of socialization have revealed that the processes contributing to the construction of gender and sexuality are many, varied and complex. I see no reason to discount these findings, or to dismiss them as superficial and inconsequential. At least they refer to real children, whereas psychoanalytic explanations seem to rest on a theoretical construct called 'the child'.

Psychoanalysis is also very bad news for anyone attempting to rear children so that they do not grow up to be walking feminine or masculine stereotypes. We know it is difficult, but the formulations of psychoanalysis suggest that it is impossible, that the processes involved are way beyond our control. So we may as well encourage girls to be vulnerable, narcissistic and masochistic, because that is how they will end up anyway.

The category 'woman' is taken to be virtually universal, applying to all (patriarchal) societies. Obviously, people are constructed as 'sexed subjects' in all cultures, but I doubt this happens in exactly the same way in all contexts. Mitchell maintains that while there may be variations in 'the expression of femininity', this does not fundamentally alter what it is to be a woman, the basic functioning of women's psyches. Patriarchal societies may be subject to variation, but since the significance of the phallus remains constant, so does female (and male) psychology. It is not clear, however, how Mitchell distinguishes between expressions of femininity and the fundamentals of feminine psychology. This looks like a form of words to avoid taking seriously any anthropological evidence which might otherwise contradict psychoanalysis. The assumption that evidence drawn from psychoanalysing women in Western societies can be applied to all other cultures is in any case clearly untenable.

The problem of sexuality

There are major problems with psychoanalytic ideas about sexuality itself. Just as Mitchell insists that we must accept the existence of the unconscious, so

we must take as indisputable fact Freud's 'discovery' of infantile sexuality. Other psychoanalytic analyses concentrate on the constitution of 'desire' when we enter into language and culture, but still retain some notion of drives which exist before this time. It is claimed that this is not an essentialist position: a drive is not the same thing as an instinct in that it has no 'object'; it is not oriented towards any particular outlet, any specific category of person. Sexuality is not seen as something we are born with, but is constructed in particular ways through our entry into patriarchal culture. Yet it still seems to be assumed that certain infantile experiences are intrinsically, *essentially* sexual.

Not only is this contradictory, the whole notion of sexual 'drives' is rather dubious. A drive is an inborn urge towards physical gratification. While the satisfaction of hunger, for example, can be seen in this way (since it is necessary for physical survival) other forms of sensual pleasure do not so easily fit this model. Obviously infants do experience sensual pleasure, but this does not mean either that this experience involves the gratification of a drive, or that it is specifically sexual. To think of sexuality in terms of drives is to see it as something we are impelled towards by inner urges beyond our control and beyond the reach of social forces. To see any form of sensual pleasure as sexual *in itself* is to view sexuality as a natural biological endowment rather than something which is learnt. Both these assumptions are essentialist. Both imply that sexuality is unchanging and unchangeable. The notion of sexual drives is also dangerous, as it implies an aggressive, male-defined view of sexuality; and the idea that children are intrinsically sexual can be used to justify sexual abuse of them.

In order to escape essentialism, sexuality must be seen as something which is socially defined rather than as something which exists independently of our definitions of it. Nothing, no act, no sensation, is sexual in itself. What is sexual depends on culturally defined and socially learnt meanings. We are born with a broad sensual potential, an ability to gain pleasure from certain sensations, but which of these become part of our sexuality depends on what we learn to define as sexual. An infant gaining pleasure from her own body cannot be said to be behaving sexually, even if she is doing something that an adult would define as sexual. She has not yet learnt language, and so does not yet have access to the concepts which would endow certain pleasures with erotic meaning. It is nonsense, therefore, to talk of 'infantile sexuality'.

Similar problems arise concerning the nature of the 'desire' supposedly constituted at the 'oedipal moment' when children become oriented towards the appropriate heterosexual 'object'. In what sense can a child be said to have desire

when the concept of desire, and indeed all knowledge through which she could make sense of her experiences as sexual, is not available to her? We are left not knowing what 'desire' is supposed to mean. In some contexts writers clearly are referring to sexual desire. At other times, however, they seem to be talking about something more nebulous: a desire to be completed by and to complete someone else, some sort of yearning after a 'wholeness' which is disrupted by the linguistic capacity to categorize and differentiate experience. I suspect the term 'desire' is favoured precisely because it is so ambiguous.

There are further difficulties with this slippery concept. It seems to me that the processes whereby we are conditioned towards genital, reproductive sexuality are far more continuous throughout childhood and adolescence than the psychoanalytic account allows for. I cannot accept that it all depends on what happens at the 'oedipal moment', which in any case seems to be more of an abstract, mythical 'moment' than a real event in time. *Most* of our learning experiences define sex for us in genital reproductive terms. Moreover, a full account of the social construction of sexuality needs to explain more than merely why most of us become heterosexual. If what we define as sexual involves selecting from a very broad sensual potential, then there are many possible forms of eroticism consistent with heterosexuality. Does heterosexuality have to involve passive femininity and active masculinity? Does it have to be genitally and reproductively focussed, involving the goal of orgasm as its end point? Psychoanalytic explanations of 'desire' imply that all this is essential to heterosexuality, that heterosexuality is fixed and unchangeable.

Nor can the existence of desire itself explain all facets of our sexuality. Both women and men may engage in acts conventionally defined as sexual without desire being their primary motive. What are we to make of acts such as rape, which may be motivated more by a wish to punish and humiliate than by sexual desires? Presumably psychoanalysis would conceptualise such wishes as sexual, but this merely confuses the issue.

A central difficulty here lies in the conflation of gender and sexuality. In psychoanalytic accounts the term 'sexuality' is often taken as synonymous with gender, or at least as subsuming it. I would argue that while gender and (erotic) sexuality are obviously linked, we should not confuse them; we should investigate the links rather than prejudging them. In psychoanalytic theory, however, both gender and sexuality appear to be constituted simultaneously at the oedipal moment. It is with the formation of desire, in taking the appropriate object, that we become sexed subjects.

It is this conflation which I think accounts for the failure of psychoanalysis, noted recently by Elizabeth Wilson, to confront the issue of lesbianism and homosexuality.

For if our desire is directed towards an object disallowed by our culture, how can we be fully sexed subjects? If gender and sexuality are one and the same, what gender has a lesbian or homosexual? The only way of resolving these questions within the psychoanalytic framework would seem to lead us back to the realms of limp-wristed men and Amazonian women.

Feminism and psychoanalysis: why the attraction?

I have argued that psychoanalysis, built on a dubious methodology, unfounded assumptions about the unconscious, and containing within it a residual essentialism, does not offer us a very fruitful means of analysing sexuality. As an explanation for the persistence of patriarchy and its effects on our consciousness it is an extremely depressing doctrine, for it offers us little chance of changing the situation. We are trapped in a vicious circle. Why is the phallus the privileged signifier? Because we live in a patriarchal culture. Why is our culture patriarchal? Because the phallus is the privileged signifier.

Why, then, should psychoanalysis appeal to feminists? Various reasons have been suggested: the most important of these is that psychoanalysis offers an analysis of patriarchy as a structure in its own right, and rests on a universalism that stresses the commonality of women's oppression. This being the case, it might be expected to appeal to radical feminists. But it is Marxist feminists who have adopted it. Elizabeth Wilson sees in this a potential retreat from Marxism, but I disagree. There are very good reasons for its appeal to Marxist feminists: it helps them to deal with theoretical difficulties which radical feminists do not have to face.

Psychoanalysis has been appropriated by Marxists to account for aspects of lived experience to which conventional Marxist categories are inapplicable. But it has a more specific appeal to Marxist feminists, because it creates a space for theorizing gender relations and sexuality without challenging pre-existing Marxist concepts and categories. By placing this theorization in the realm of the ideological, they avoid the problems of trying to relate women's subordination to specific modes of production.

The appropriation of psychoanalysis also serves to perpetuate another common omission in Marxist thought: its unwillingness to confront the issue of male power, and its preference for considering women's oppression solely in terms of structures (whether economic or symbolic) rather than analysing the ways in which real men exercise and benefit from power over women. Radical feminists have never doubted that patriarchy is worthy of consideration in its own right, have never been afraid of

confronting the day-to-day realities of male dominance, and are not trapped within the confines of any existing body of theory. For them, psychoanalysis can have little appeal.

References

Barrett, Michèle (1980) *Women's Oppression Today,* London: Verso Books.

Coward, Rosalind (1978) 'Re-reading Freud: the making of the Feminine', *Spare Rib* May.

Coward, Rosalind, Cowie, Elizabeth and Lipshitz, Sue (1982) 'Psychoanalysis and patriarchal structures', reprinted in M. Brake (ed), *Human Sexual Relations,* Harmondsworth: Penguin.

Coward, Rosalind and Ellis, John (1977), *Language and Materialism,* London: RKP.

Mitchell, Juliet (1975), *Psychoanalysis and Feminism,* Harmondsworth: Penguin.

Moi, Toril (1982), 'Jealousy and Sexual Difference', *Feminist Review* 11.

Wilson, Elizabeth (1981) 'Psychoanalysis: Psychic Law and Order' *Feminist Review* 8.

17. The Liberal Organ: Porn in The Guardian (1985)

Debbie Cameron & Liz Frazer

On May 20 1983, *The Guardian* carried a full-page advertisement for an exhibition by the photographer Helmut Newton. The image was a naked woman in bondage, while the caption wittily urged us to go and see the exhibition 'unless you're all tied up'. Women lost no time in complaining: several letters were printed during the following week deploring both the ad itself and the editorial policy that allowed it to appear. As it turned out, these letters were only the first of many. The correspondence raged until the end of July, covering every aspect of the debate on pornography. In all, 35 letters on the subject were published.

We collected these letters as a sort of political archive. Both of us were active in the feminist campaign against pornography and we had ourselves contributed to the *Guardian* discussion. As a result we were given more material in the form of private correspondence, including copies of an exchange between two men.

The contributions that came after the initial protest letters were overwhelmingly pro-porn; they were mostly from men, but a number of women also argued against the feminist position. Although this position was represented by several correspondents beside ourselves, it seemed to make very little impression on the course of the debate. So we were led to examine the whole question of why on this particular issue, ways of thinking are dominated by the 'liberal' tradition which *The Guardian* obviously represents.

Liberals are traditionally *less* our enemies than conservatives, because they are seen to preach the freedom of the individual, and this has for some time entailed a rejection of sexism. There is no justification for discriminating against particular individuals just because they are women. Liberals, in other words, support 'women's rights'. Many feminist issues are discussed within this framework of rights: abortion, for instance, where our slogan has long been 'a woman's right to choose'. It is no accident that liberal men have supported the demand for abortion as an individual right (which happens to be exercised by women), and equally it is no accident that they do not support our position on pornography. In the case of pornography they assert it is the right of the individual to use it in private. On the issue of pornography

a glaring contradiction appears between liberalism and feminism, where on other issues there need be no contradiction.

We want to examine the liberal arguments for the continued existence of pornography as revealed in the *Guardian* correspondence. What we aim to show is that these arguments are underlain by certain assumptions, hardly ever made explicit, about the nature of the individual. Furthermore, these assumptions are totally at odds with any *feminist* notion of the individual. Because of this, liberals are never the allies of feminism; because of this, we should stop demanding our 'rights' and replace the liberal concept of *right* with a much more straightforward insistence on *power*.

The correspondence

The first letters in the correspondence were from women, and expressed outrage: 'Even the tabloids ... stop short of ropes round her *neck*, for God's sake, and leather'. But when men entered the ring, a new note was struck, and the women were taken to task for what one writer called their 'prudish hysteria'. These cooler and more 'objective' correspondents introduced a number of points which were to recur throughout the debate.

One of these was the question of whether pornography directly causes assaults on women. Many writers denied that it did, and some asserted there would be more violence if porn were suppressed. This part of the debate illustrates the extent to which the feminist argument, that pornography *is* violence against women, simply is not understood; it also illustrates a liberal belief that private activities and attitudes are of no importance unless they can be shown to have measurable 'public' effects. We will return later on to this dichotomy between the public and the private.

Another recurrent concern was with *definition*. Men were worried about confusing pornography with 'erotica' or 'art'. Often, we felt this was just stone-walling. To avoid engaging with clear cases, anti-feminists challenged us to pronounce on the borderlines of offensiveness. But men were also worried about *who* defines an image as pornographic, and this concern shaded into a concern about authoritarianism: other people telling the individual what he (we use the masculine pronoun advisedly here) was permitted or forbidden to do. One correspondent remarked that feminists

are totally convinced that they know *better*. Whatever 'good' one seeks to do someone by deciding for them what they should be allowed to see does not diminish the odious arrogance of the attitude itself.

This arrogance became out and out authoritarianism when it was practised by the state through censorship. It was endlessly repeated that 'what censorship means in effect is more state control over our lives and greater police powers'.

But while neither the state nor women in general were felt to have any right to dictate to men, men were felt to have every right to look at pornography: indeed this was labelled by one writer as one of 'the basic rights of any free society'. Moreover, since pornography is entirely harmless, 'What right does Ms Cameron have to deny [men] even their fantasies of non-violent contact with women?' This defence of men's fantasies often went hand in hand with the idea that some men actually needed to gratify them with pornography, either because they were abnormal, or because feminists so often denied men anything more concrete in the way of sex. But the central question here was whether anyone had the right to deny the individual his private pleasures; and the commonest answer was no, especially when this might mean state intervention.

Our initial reaction to the general position taken by correspondents was to find it inconsistent and contradictory. We felt inclined to argue against the proposition that using porn was harmless unless it inspired a man to go out and commit atrocities that minute; we also wanted to deny that porn fulfilled a 'need' for any man. As for 'rights', the answer was that women have a 'right' not to be degraded, which conflicts with men's 'right' to use pornography. This line, which implies that the problem is fixing an acceptable balance of rights, was actually taken by two women correspondents. But on reflection we concluded it was not a very useful perspective. The apparent illogic of men's concentration on their *rights* and their *needs*, as well as the apparent falseness of their claim that porn is harmless, fell into place when we realised what was beneath the surface of the discussion: a concept of the individual which is fundamental to liberalism, but alien to us. It is that concept of the individual, and its political implications, that really need to be attacked.

The liberal individual

Liberals believe in an individual who is autonomous and above all *presocial* rather than being shaped by society. Society is a coming together of various, already fully-formed persons, and the major political conflict that exists is between the single individual and the larger society which constantly threatens to overwhelm him. (Again, our choice of pronoun reflects our understanding of the liberal individual discussed in political theory as prototypically a male individual.) Individuals therefore need to be protected from *society*; they are not naturally *of* it. Liberty, in this framework, lies in separation from others, and especially, separation from the collectivity.

Liberal political theory states that an individual has certain natural rights which exist before and regardless of social arrangements: the right to life, the right to property (which is needed to maintain life) and the right to go about one's business unmolested. It is because in a presocial 'state of nature' these rights could not be guaranteed (people would always be molesting each other) that individuals actually come together to form societies (this is the idea of the 'social contract'). In doing so each concedes a certain amount of his autonomy to the state; in return, the state will protect individual rights. However, the power of the state must be kept to the minimum necessary for this protection: individuals must retain as far as possible their presocial freedom of action. This leads to the division between the public domain, where authority is vested in the state, and private life, where the state may not encroach on individual freedom. Private life for the liberal is sacrosanct.

Many of the reforms which constituted the 'sexual revolution' of the 1960s were 'liberal' in this sense. For instance, the legalisation of male homosexuality between consenting adults was defended on the grounds that sex was a private matter and therefore something the state should not interfere with. Similarly with the relaxation of censorship (and the resultant increase in the availability and acceptability of pornography). Since porn was defined as sexual, it was outside the proper sphere of the state. This notion of an inviolable right to freedom in private clearly underlies the repeated equation of censorship and authoritarianism in the *Guardian* correspondence.

The concept of a public/private split also explains why so many correspondents could not see how the use of pornography could have harmful effects on other people. Since for the liberal, private life is outside society, the part of one's life on which society has no legitimate claim, it cannot possibly have social or political consequences.

Needs

Liberal theorists have traditionally argued that human individuals exist with certain needs (commonly mentioned ones include food, warmth, shelter and sex). Like the individuals themselves, these needs are presocial; they are not dictated or formed by society and its practices. This idea too has consequences for the debate on pornography. Since the need for sex simply and unproblematically exists for each individual prior to socialisation, the forms of sexual gratification that exist within a society are seen simply as responses to this pre-existing need. For the liberal, then, pornography testifies to men's need for the kinds of sex depicted in it, rather than appearing to mould sexual desire in a socially and politically loaded way.

The issue of need was made much more explicit in the *Guardian* correspondence than the concept of the individual and his rights. Some contributors pulled the strands together by insisting that the need for sexual gratification, though natural, should be confined to the private sphere:

> As it happens, I object to having my natural drives stimulated when I'm crossing London on business by being confronted with ... bare buttocks and a pair of pouting glossy lips. It fucks up my day for me. That's alright in the bedroom, but when it's on the street ...

This man clearly felt that *public* pornography was the main bone of contention because it tended to cause unacceptable public behaviour toward women. In the bedroom, however, it would be his own business. He did not entertain the idea that feminists might be criticising his sexual desire *itself*, because to him sexual desire is both private and natural.

Others felt that while men needed sex, they did not (or should not) have a natural need for pornography. They turned to it only when other more acceptable forms of sexual gratification were denied them.

> ... the primary function of pornography is to satisfy the unhappy needs of personalities which, for whatever reasons, are inadequate to meet the tasks of normal social and sexual behaviour.

This is something of a contradiction in the liberal position, since it seems either to assert that there is *not* an unproblematically given, presocial sexuality, or else that there are 'unhappy' or 'inadequate' persons who are not free to choose their mode of behaviour.

Elsewhere, however, the freedom of individuals to act as they wish is taken for granted, and this leads to the absurd claim that women are equal partners in the pornographic enterprise because they 'choose' to model for pornographers. The physical, mental and financial pressure that drives women into the sex industry is ignored, for the liberal insists we are all free and equal.

In a similar vein, women are said to have equal needs for and power over sexual intercourse, which they display in pornography. 'Hard-core porn portrays the woman as the active partner', as one man said. Another noted that men fantasise about being dominated by women, and concludes porn is about 'man's inhumanity to man' (*sic*!) Liberals do not appear to see the power structure in which the

customer is always superior to the goods. Even if women spent their whole sexual lives dominating men, it would still be men's fantasies that were being gratified by women, so that the women would not in fact wield power.

It is time to look more critically at this liberal perspective on pornography, and to point out the implications of rejecting it, as we believe feminists must.

Radical feminism and the individual

Feminism derives from certain insights about the world and about women's position within it. Three of these are especially relevant, since they are completely incompatible with the assumptions of liberalism.

1. *The individual is a social being.* Feminists have always rejected the notion that male dominance is a natural state of affairs, arguing instead that women and men are socialised or conditioned into different roles, which social practices and institutions coerce them into playing. We are the products of our relations with others in a given social and political system: there is no such thing as a 'state of nature' and there are no such things as needs, desires or 'rights' existing independently of the conditions in which we live.

2. *The social world is one of power inequalities.* Feminists take it for granted that the world which produces us is not one in which we are all equal. Men have power over women; men control the social institutions and through them, our potentialities as human beings. Thus it is nonsense to say, as liberals do, that women are free and equal individuals. None of us acts autonomously, since we are products of a particular social structure; but women have much less autonomy than men.

3. *The personal is political.* There is no sphere where social conditions and power structures are absent or irrelevant. Power relations are played out every day in our interactions with others: for women, the conflicts may be most obvious, and the oppression most acute, in the so-called 'private' space of family or sexual relationships. Thus feminists refuse to depoliticise sex, love and similar 'private' concerns: they reject altogether the liberal idea of an inviolable private life.

If women are social beings whose lives are permeated with conflict and inequality, it is ultimately no good demanding our 'rights' as individuals. The whole idea of individual rights implicitly rests on a belief that individuals are *equal*, and this is patently untrue.

One of the *Guardian* letters, written by a woman, put the point very clearly:

Unfortunately it is easy to assert a right to this or that but difficult to resolve the conflicts which may then arise. My neighbour may feel he has a right to play his records at top volume while I feel I have a right to peace.

The liberal notion of 'justice' assumes that such conflicts can somehow be resolved by the mediation of impartial judges. But once we realise that the judges themselves are products (and if they are men, most likely defenders) of the prevailing order—in other words that the dice are loaded — it becomes evident that *power* is the real deciding factor.

The same letter goes on to challenge the male defenders of porn:

... suppose they heard that in some neighbouring country a large proportion of the women derived pleasure from seeing men raped, humiliated, tortured or killed and furthermore that the women of that country were ... generally stronger than men, ie perfectly able to mete out such treatment, would they have any misgivings about visiting that country? Unfortunately with the reverse situation women do not have that choice. We are residents.

From this perspective, abstract talk of individuals and their rights is a red herring. What is really at stake is the collective power of opposing social groups: in this case, men and women.

We have sometimes been uneasy about a tendency in feminism toward a sort of libertarianism or anarchy which stresses the political pre-eminence of the individual. This emphasis on 'my needs' and 'my rights' is a double-edged sword, for it ignores the fact that needs and rights, indeed individuals themselves, do not arise in a social vacuum. We have a responsibility to question what we think we 'need' or are 'entitled to'. We must also recognise that rights cannot be demanded in a vacuum. Feminists are really aiming not for the recognition of each individual woman's right but for the advancement of women as a class; which means, in effect, the overthrow of male power.

Power not rights

Feminists must struggle for power rather than rights, and this struggle will be more effective if we are clear that we are struggling not only against the male monopoly on power, but also against the liberal ideology of the free individual and his rights, which conceals his power. We should set the terms of the debate, and make it clear that liberal democracy and feminist democracy are not the same thing.

18. The Amazing Deconstructing Woman (1992)

Stevi Jackson

Postmodernism is an intellectual fashion which has established a very strong position within academic feminism and is well entrenched in women's studies courses. Postmodernist ideas have spread beyond the confines of academia and are well represented in the media, cropping up for example on *The Late Show* and *The Guardian* Women's Page. This article is an attempt to explain what postmodernism is about, and why I think it is potentially dangerous for feminism.

Postmodern feminists tell us that feminism can benefit from a closer association with postmodernism because it corrects some of our regrettable 'essentialist tendencies'. The impression that we are being chastised by our intellectual superiors is heightened by the language postmodernists use. Their work is far from accessible to the general feminist reader. It has its own peculiarly slippery style of argument and its own esoteric vocabulary. It is also a very masculine tradition. The theoretical reference-points for most postmodern feminists are not other feminists, but male theorists such as Lacan, Derrida and Foucault.

While I do not support a position which rejects all masculine thought as useless by definition, these thinkers are not simply men. They speak from a position which is not sympathetic to feminism—indeed they can be downright misogynistic. Why are so many women sitting at the feet of these masters?

First we need to clear up some confusion over the term 'postmodernism'. There are at least three senses in which it is used, only one of which concerns me here.

First, *postmodernism* refers to an artistic and architectural style which borrows from and reassembles elements of past styles.

Second, it refers to the notion that we are living in a 'postmodern' world. There are different variants of this thesis, suggesting for example that we are living in a post-industrial age, that new technologies and new working practices have radically altered the relations between classes, or that social divisions are now based around the sphere of consumption rather than production. The overall picture is of a more fragmented and fluid society.

The third sense of the term, the one which I am dealing with here, refers to a body of theory which is also sometimes called *poststructuralism*. The word *postmodernism* is now used more frequently because it carries with it some of the ideas of the second usage — that old certainties have gone and a new mode of theorizing is appropriate.

The 'structuralism' to which this theory is 'post' (i.e., after) is a body of ideas about the structures underlying all human language and culture. It is also 'post' another form of structural explanation, marxism, and its adherents include many who used to call themselves marxist feminists. (One such is Michèle Barrett who has recently announced that she is 'nailing (her) colours to the mast of post-marxism'.)

The 'modernism' to which this body of theory is 'post', and from which it distances itself, is usually defined in relation to ideas which emerged from the 18th century, in the period known as the Enlightenment. This is a useful starting point since most postmodernists define their project in opposition to what they identify as Enlightenment thought, questioning ideas about language, the self, and truth which derive from that period. The basic tenets of postmodernism can be thus outlined as follows:

1. Language does not simply *transmit* thoughts or meaning. Thought and meaning are constructed through language, and there can be no meaning outside language. Meaning is also *relational*: a word means something only in relation to other words. Hence the word *woman* does not in and of itself mean anything. It is defined in relation to its opposite *man* (which also has no fixed meaning) and means different things in different contexts.

2. There is no essential self which exists outside culture and language. Subjectivity is fragmented and always in process: our identities are products of the way in which we are positioned (or position ourselves) within knowledge and culture. (This is referred to as 'de-centring the subject'.) Our own experiences as women cannot therefore be taken as an unproblematic starting point for feminist theory and politics, because there is no experience outside language and culture. For example, doing housework for a man can (theoretically) be 'experienced' as a labour of love *or* as exploitative drudgery, depending on whether it is understood in terms of a discourse of traditional femininity or a feminist discourse.

3. There is no objective scientific 'truth' which exists out there waiting to be discovered. Knowledges are 'discursive constructs'. This idea comes from

Michel Foucault, for whom discourses (ways of thinking and talking about the world) produce objects of knowledge, rather than describing pre-existing objects. Knowledges and discourses can be deconstructed — taken apart — in such a way as to reveal that they are not universal truths but rather discourses constructed from particular positions. This leads to the sceptical dismissal of grand theoretical 'metanarratives', like marxism, which purport to explain the social world. At its most extreme this scepticism implies a denial of *any* material reality.

On the basis of these propositions, postmodernists oppose all forms of 'essentialism', any perspective which posits social groups or structures (like 'women' or 'patriarchy') as objects which exist independently of our understandings of them. Feminist postmodernists, for example, contest the idea that women exist as a natural category. They seek to 'deconstruct' gender categories, to reveal the ways in which they have been culturally constructed, to demonstrate that they are 'regulatory fictions' rather than natural facts.

The idea of deconstruction derives from the work of Jacques Derrida. In general it means looking closely at any text, argument or assumption in order to reveal the inconsistencies and paradoxes which underpin it. Statements which define what women are can be shown to contain contradictory assumptions. For example, we are told that femininity is 'natural' and yet women are constantly exhorted to work hard at producing femininity. This suggests that 'femininity' is not natural but rather the product of the discourses which define it.

Some feminists, like Jane Flax, argue that feminism is necessarily postmodern; that postmodernism and feminism share a scepticism about knowledge, truth, language and the self. To some extent Flax is correct. Feminists have long questioned what counts as knowledge and have revealed the androcentric bias underlying much of what passes for truth in, for example, scientific 'proof' of women's inferiority. We have long known that language is not a neutral medium of communication, which is why we have been concerned to challenge linguistic sexism. We know that meaning is not fixed: that what it means to be a woman can shift, and hence we have always contested essentialist understandings of gender. We are also aware that there is no unitary, consistent self. What feminist has not experienced desires and feelings at variance with her political ideals?

To some extent, then, postmodernists seem to be reinventing the wheel. Yet postmodern feminists are keen to distance themselves from other feminists and to demonstrate that those others harbour essentialist assumptions. Radical feminism

in particular is castigated for this crime. Mythical radical feminists are cited who apparently believe in women's natural difference from men. Those who do espouse this view are in fact very few: some eco-feminists, some American radical feminists, and some European 'difference theorists'. Most radical feminists argue that masculinity and femininity are socially constructed and are just as concerned as any postmodernist to challenge essentialist conceptions of women. But postmodern feminism refuses to accord academic credibility to feminist theory unless it is affiliated to the work of fashionable male theorists.

But if we are all engaged in deconstructing the category 'women' and questioning the basis of knowledge, what's new about postmodern feminism? What is new is a theoretical project which takes deconstruction and scepticism to such lengths that it threatens to undermine the possibility of feminist knowledge and feminist politics. Three features of postmodernism are particularly crucial here.

Firstly, de-centring the subject means recognising that subjectivity is culturally constituted, that there is no fixed feminine identity, that what it means to be a woman for any one of us and can shift, can be contradictory. This is fine, but the emphasis on the temporary, fluctuating character of identity can undercut any positive identities we construct for ourselves. In particular it challenges the possibility of our taking a collective stance as women, or even as specific categories of women such as Black women or lesbians.

Secondly, postmodernism stresses meaning is not fixed in objects or events, but is a product of language and discourse. So meaning shifts, and can be contested. Feminists have, of course, consistently challenged the meanings of dominant patriarchal discourse. But if no one set of meanings is more valid than any other, who is to say that feminist meanings are any more valid than anyone else's? What basis is there for arguing that a feminist reading of forced sexual intercourse as rape is any more valid than the rapist's interpretation of it as pleasurable seduction? Regarding meaning as *entirely* fluid can mean denying even the starkest of material realities.

This view of meaning connects with the third aspect of postmodernism — scepticism about truth and knowledge. Postmodernist suspicion of metanarratives, of explanatory theory, raises questions not only about the possibility of any theory of women's subordination but of any systematic description of it. Even the statement that 'women are oppressed' is problematic, for what do we mean by 'women', and by whose criteria are they/we oppressed? Once they go this far, postmodern feminists' claim to be feminists becomes dubious. Indeed we might wonder why they cling to the identity 'feminist' and why they consistently address an audience of other feminists, when they call all categories and identities into question.

Feminist challenges to malestream knowledge have not usually been based on the assumption that no valid knowledge is possible, but on the idea that feminist knowledge, which takes account of women's experience, can be more valid than what previously passed for knowledge. But when 'women', 'experience' and 'knowledge' all become problematic concepts, we can find ourselves with no place from which to speak as women, make political demands or challenge patriarchal structures.

Postmodern feminists warn of the dangers of using 'women' as a unitary, absolutist category and of making statements about 'women' in general which actually only apply to particular women — white, Western, middle-class and heterosexual ones. Trying to come to terms with the complexities of these differences is a real problem for feminist theorists, but I am not convinced that postmodernists have the solution. In fact, although they harp on the arrogance of those who construct general theories of women's subordination, or who dare to speak for all women, they themselves are one of the most exclusive feminist groupings in existence. Their own work silences other women very effectively, and they are as guilty of white, middle-class heterosexist bias as anyone else.

For instance, Denise Riley's book *Am I That Name?* opens with a reference to a speech made by the black American feminist Sojourner Truth in 1851. Riley doesn't bother to quote the speech — apart from the refrain 'Aint I a Woman?' — but simply uses it to give political credibility to her historical deconstruction of the category 'women'. Here, in part, is what Sojourner Truth said:

> That man over there says women need to be helped into carriages and over ditches, and to have the best place everywhere. Nobody ever helps me into carriages...or gives me any best place! And aint I a woman? Look at me! Look at my arm! I have ploughed, and planted, and gathered into barns, and no man could head me! And aint I a woman? I could work as much and eat as much as a man — when I could get it — and bear the lash as well! And aint I a woman? I have borne thirteen children and seen most all sold off to slavery, and when I cried with my mother's grief, none but Jesus heard me! And aint I a woman?

This speech does of course challenge the naturalness of the concept of 'women', pointing out that the idea of women's 'natural' frailty is demonstrably false. It is also, however, an attack on the exclusivity of the category. Sojourner Truth's words can be read as a plea to be included, as an affirmation of her womanhood, rather than as a statement that 'women' do not exist. According to Riley, a new Sojourner

Truth might say 'ain't I a fluctuating identity?'! It is, as Tania Modleski comments, rather odd that a writer concerned to demonstrate the historical variability of the category 'women', should reach out 'across racial lines, historical eras and national boundaries to claim commonality of belief with a black female abolitionist'. In her view this demonstrates a lack of sensitivity to the fact that a black female slave in 19th century America had 'little freedom to fluctuate' in any way.

Treating the category 'women' as entirely fictional ignores the material realities which constrain us into membership of that category. Those constraints are more total for some women than others: as Modleski also says, it is only white, middle-class, academic feminists who have the luxury of being able to deny that they are women.

I do not, however, think it is useful to respond by asserting the existence of some essential womanhood which is suppressed by masculine theory. This is effectively the position taken by Somer Brodribb in one of the first feminist critiques of the misogynistic traditions of thought from which postmodernism developed. While impressive in many respects, Brodribb's book is marred by its assumption that such theory, and indeed male domination in general, derives from something essential about masculinity: a male denial of nature and repudiation of the mother, rooted in men's reproductive experience.

For Brodribb, anti-essentialism equates with being anti-women. For example, she criticises Gayle Rubin's notion of a sex/gender system because of its reliance on Claude Levi-Strauss's theory that 'the exchange of women' underlies all human culture. Her objection is not that this presupposes what it sets out to explain (i.e. women would have to be already subordinate in order to be exchanged as objects). Nor does it worry her that it is so universalistic that it represents little advance on the idea that women are naturally subordinate. What she objects to is that it is insufficiently biological, that it repudiates the body, that it represents kinship as an abstract relation between men. According to Brodribb, 'kinship is not an abstract concept for women: it is experienced materially… in the process of birth'.

Brodribb objects not only to postmodernism, but to any perspective which claims that gender is socially constructed. This she sees as a denial of the female body which is 'sexism not liberation', which implies 'a liberal laissez faire gender economy' and which privileges 'culture over nature once again'. Has she not noticed that the idea of women's 'natural' difference continues to be used to justify our subordination?

Brodribb castigates postmodernism for its anti-materialism, but her idea of materialism is not mine. She equates the material with the fact that women give

birth and men do not. Where does this leave those of us who are not mothers? Are we not women?

There is an alternative position, properly materialist and anti-essentialist, deriving from the work of feminists such as Christine Delphy and Monique Wittig. They maintain that gender has no natural basis, but they differ from postmodernists in claiming that it rests on material foundations. For Delphy and Wittig, sexual difference is the product, not the basis, of women's oppression. Women exist as a political category (and a class) because of patriarchy. Within this formulation it is possible to retain a conceptualisation of womanhood as a material reality without positing some essential, pre-given femininity. We can think of 'women' as a socially constructed category without denying the existence of women.

Although postmodernists say that they are sceptical of claims to truth, they make their own truth claims. Although they claim to be anti-essentialist, they essentialise other feminisms, especially radical feminisms. The charge of essentialism is used to deny the existence of women as a political constituency and to tell us we must think in terms of gender relations rather than women's oppression.

This may earn kudos within male-dominated academia, but it plays into the hands of those who would like to see women's studies de-radicalised, those who find the study of gender less threatening than knowledge constructed from women's standpoint, in a word, those who have no interest in women's liberation. We are facing the threat of 'feminism without women' (the title of Tania Modleski's book). 'Women' are being deconstructed out of existence and 'gender' is replacing women as the starting point of feminist analysis. The logical outcome of postmodern feminism, is, indeed, postfeminism.

References

Barrett, Michèle (1991), *The Politics of Truth: From Marx to Foucault,* Cambridge: Polity Press.

Brodribb, Somer (1992), *Nothing Mat(t)ers: a Feminist Critique of Postmodernism,* Melbourne: Spinifex.

Delphy, Christine (1984), *Close to Home: A Materialist Analysis of Women's Oppression,* London: Hutchinson

Flax, Jane (1990) 'Postmodernism and Gender Relations in Feminist Theory' in Linda Nicholson (ed.), *Feminism/Postmodernism,* London: Routledge.

Modleski, Tania (1991) *Feminism Without Women,* London: Routledge

Riley, Denise (1988) *Am I that Name?* London: Macmillan

Rubin, Gayle (1984) 'Thinking Sex: Notes for a radical theory of the politics of sexuality', in Carole Vance (ed.), *Pleasure and Danger: Exploring Female Sexuality,* London: Routledge & Kegan Paul.

Wittig, Monique (1992) *The Straight Mind and Other Essays,* Hemel Hempstead: Harvester Wheatsheaf.

19. Back to Nature (1997)

Debbie Cameron

Simone de Beauvoir said it in 1949: women are made, not born. Anatomy is not destiny, and sexism is not explained or justified by the facts of biology. This view is now orthodox liberal wisdom. Belief in biological determinism is confined to saloon-bar bigots and the sort of crusty old judge who has never heard of the Beatles.

Or is it? Intellectual fashion is as fickle as any other kind, and there are signs that biologism is becoming respectable again. In the 1970s it was Marx trendy intellectuals talked about, in the 1980s it was Freud, and now it's the turn of a third Bearded Victorian Patriarch, the evolutionary theorist Charles Darwin.

I first got wind of this a couple of years ago, when a friend put me on the mailing list of something called 'The Darwin Seminar', based at the London School of Economics. She thought I might want to keep a feminist eye on its doings, since as she put it, 'these people are sinister'. The Seminar proceeded to bombard me with literature: papers, summaries of papers, briefing notes, announcements of meetings. Whatever was being discussed, the theme was invariably that Darwin had all the answers. Writers were scathing about social scientists who treat standards of beauty or patterns of violent crime as social constructs.

The seminar's outpourings were sometimes reminiscent of religious fundamentalist tracts—ironic, when you consider who Darwin's main enemies were in his own time. The thought crossed my mind that it might be a front for the sort of right-wing crackpots who gave Darwin such a bad name in the heyday of the eugenics movement, and who still stir up controversy with their ravings about the 'underclass' or Black people's IQs.

But the Darwin Seminar is much subtler than that, much closer to the liberal mainstream. And the mainstream is increasingly taking notice of what it has to say. Its conferences get coverage in the quality press, books by its participants are widely reviewed, and the fashionable think-tank Demos recently devoted a whole issue of its house magazine *Demos Quarterly* to the seminar's ideas. The issue was called 'Matters of Life and Death: The world view from evolutionary psychology', and it ends with 'Ten Big Challenges from the Evolutionary Agenda', essentially a list of social policy proposals.

This does make me uneasy, since it suggests the new Darwinists are actively courting political influence. If there's a chance people with real power might take it

seriously, perhaps it's time to take a closer look at 'the world view from evolutionary psychology'.

Evolutionary psychology: back to (human) nature

Put in its simplest terms, evolutionary psychology (EP) is the application of Darwin's ideas to the study of human behaviour — how we think, feel and act. The main thesis of EP is that there is such a thing as 'human nature': a universal set of mental/emotional/behavioural traits which do not vary across cultures or change over time. These traits have become established because it was advantageous to ancestral humans to possess particular mental characteristics — just as it was advantageous to them to possess certain physical traits.

To understand what's being claimed here, it's useful to know that present-day evolutionary science has moved on from the Darwinian concepts most of us vaguely remember, such as 'survival of the fittest'. Probably the most important innovation is the theory of the 'selfish gene', according to which it is genes, rather than whole organisms, which compete for survival. For genes, 'survival' means being passed on to offspring. So an 'advantageous' characteristic in evolutionary terms is not necessarily one that keeps me alive longer or makes my life easier, it is simply one that maximises my chances of having offspring that carry my genes.

Humans reproduce sexually; evolutionary psychologists hypothesise that certain ways of thinking, feeling and acting enabled our ancestors to do this more success-fully, and so they became part of our 'nature'. For example, it's suggested that our capacity for language and for cultural production (art, literature, etc.) originally served the purpose of making individuals who had those abilities more attractive to the opposite sex.

One of the more obviously barking contributions to *Demos Quarterly* applies this to politics, speculating that when students at Columbia University in New York protested against investment in South Africa in 1986, they were less interested in registering their disgust with apartheid than in advertising themselves to like-minded people who might want to mate with them. Unconsciously, protesters would reason: 'if s/he cares so much about people s/he's never met in South Africa, s/he will obviously be highly committed to the children who carry our genes'.

The 'unconsciously' is important here, for no one is arguing that humans *consciously* go to political rallies with the intention of picking up a suitable mate and having their children (this would be a particularly poor explanation of women's involvement in feminist politics!) The things we do now do not have to serve the same purpose in contemporary reality that they are said to have served for our

distant ancestors (who did not of course go to political rallies at all). Once evolution has made some psychological disposition the norm, we will go on expressing it in our behaviour regardless of whether it serves any purpose at all.

When it comes to sex-differences (evolutionary psychologists do not believe in gender) the key point is that women and men play differing roles in reproduction, and this is not just a physiological matter. The social costs of reproduction are different for each sex, and during the evolution of humankind it would therefore have been an advantage for males and females to develop different ways of thinking, behaving and feeling. As Darwin Seminar convenor Helena Cronin sums this up: 'Evolution made men's and women's minds as unalike as it made our bodies'.

In support of this argument Darwinists cite studies showing that in culture after culture, men seek 'mates' (scientist-speak for women/wives) who are younger than they are and meet certain standards of attractiveness, such as having symmetrical features and a waist to hip ratio of around 0.7. These desired qualities

are supposedly shorthand indicators of female fertility. Men's ancestors reproduced more successfully when their sexual preferences stopped them wasting time and genes on women who couldn't have healthy babies; present-day men inherit the 'advantageous' preferences.

Women, for their part, must invest considerably more time and effort in reproduction — at a minimum, the nine months of pregnancy. They are therefore more interested in whether a prospective mate can provide for them and their offspring. That's why studies find that women rate men on the size of their wallets rather than their waists. It's also why women are (allegedly) more hurt by men's *emotional* infidelities than their purely sexual ones. If a man has withdrawn emotionally he may decline to provide for his children. For men, it's women's sexual infidelity that poses the real threat. Women know the children they bear are carrying their genes; men have more reason to be anxious about this. In other words, given the unalterable facts of human sexual reproduction, natural selection would 'logically' favour men who felt sexual jealousy and women who prioritised emotional commitment.

Those of us who prefer sociological accounts are unlikely to be convinced by this reasoning. It is hardly surprising if women prefer men richer than themselves in a world where the vast majority of communities distribute wealth so unequally between the sexes. Women, by and large, *are* the poor: that in itself seems sufficient to explain why they so frequently marry men who are richer than they are.

Darwinists are curiously selective about *which* culturally widespread behaviours they choose to focus on. For example, the abuse of children by their stepfathers crops up repeatedly: statistics suggesting that stepchildren are at greater risk than natural children are seized on eagerly, because selfish gene theory predicts that men have a motive for harming children who do not carry their genes. (This is extrapolated from the behaviour of certain animals which will kill another male's children so their mothers stop lactating and become available to mate with the killer.) One of Demos's 'Ten Big Challenges' proposes that social policy around fostering, adoption, child protection and so on should take account of the deep-rooted tendency to favour one's own kin.

But this argument seems to miss out huge swathes of what feminists know to be reality. We know, for instance, that men's abuse of their natural children is not rare, nor is abuse by men who have no involvement with their victims' mothers (e.g. in residential care). It is also evident that abortion and infanticide (by mothers or their close female kin) are culturally and historically widespread practices. In these cases women decide not to bear or nurture children who obviously *do* carry their genes. Strangely enough, none of the contributors to *Demos Quarterly*

discuss the evolutionary advantages of this behaviour or call for the law to reflect its pervasiveness in human societies past and present.

From romance to rape

The assumptions Darwinists make about sex and reproduction lead them to some particularly strange and objectionable conclusions about rape. Robert Wright, in a piece for *Demos Quarterly* titled 'The dissent of woman', argues that the 'anguish' a woman feels after rape is much the same thing as she feels when she has (consensual) sex with a man who then leaves her. Women have intercourse willingly, apparently, only when they believe the man is committed to any offspring the act may produce. If it turns out the man was only pretending commitment, the woman feels duped. In the case of rape, she knows from the beginning that he is not committed to her or their joint offspring, and that is what makes the act uniquely unbearable.

If this were not so offensive you would laugh at the sheer absurdity of it, remote as it is from any actual experience of rape. It overlooks the physical and verbal abuse which often accompanies forced sex; it also overlooks that rape has much in common with sexual assaults which do not involve intercourse and so cannot result in conception. The woman's own body and sexuality are treated as being of no consequence; nor is there any recognition of the anger and outrage women justifiably feel when their wishes as well as their bodies are violated.

Robert Wright suggests that rape is what men resort to 'when other forms of manipulation fail' and there is thus no legitimate way to do what a man's got to do, which is ensure the survival of his genes. The problem men face is that women — the sex which invests more time and energy in reproduction — are choosier than men about who they mate with. Robert Wright describes the 'typical rapist' as 'lacking the material and personal resources to attract women', i.e. too poor, ugly and/or socially unskilled to be chosen voluntarily as a mate.

This shows a typically cavalier attitude to the research literature in disciplines outside biology, which consistently stresses how similar rapists are to other men. As one of the women who participated in Sue Lees's research on rape said about the man who attacked her, 'My mother couldn't believe how normal he looked'. Plenty of rapists also have 'legitimate' sexual relations: Sue Lees notes that 'many of [the serial rapists in her sample] are married or have girlfriends'. It is depressing that a scientist like Robert Wright should recycle the myth of rape as the expression of some desperate unmet need to have sex, when all the evidence decisively contradicts this view.

Repulsive though it is, Robert Wright's argument has some unexpected points of contact with radical feminist analysis. The feminists this author has real contempt for are liberal 'equality' feminists who vainly imagine that women and men can be held to a single, genderless standard of behaviour. Andrea Dworkin and Catharine MacKinnon make more sense to him — at least as he reads their arguments. Thus he quotes Andrea Dworkin's statement about what men can do to get sex from women: 'steal it (rape), persuade her to give it away (seduction), rent it (prostitution), lease it over the long term (marriage in the US) or own it outright (marriage in most societies)'. And he adds: 'this would strike some Darwinians as a fair thumbnail sketch of the situation'.

Wright believes that the mindset produced in women by natural selection makes us 'uniquely vulnerable' in ways that ought to be recognised by the law. One of the 'Ten big challenges from the evolutionary agenda' is:

Male and female psychologies have evolved to be distinctly different in assessing the costs — indeed, the very notion — of anti-social behaviour. *Our legal system should reflect these differences if it is to promote true equality before the law* (p.48, original emphasis).

The suggestion that women's distinctive 'nature' be reflected in law illustrates a difference between the new Darwinism and cruder forms of pop sociobiology. The latter often seemed to be saying: 'this is how things are; they can't be changed, so get used to it' — where 'it' could be anything from war to sexual harassment to men spending all their time bonding with each other in the pub. New Darwinists not only suggest that we *can* make better social arrangements (since intelligence and altruism are also part of evolved 'human nature'), some believe this is the most important use to which scientific knowledge about our 'natures' can be put.

Another difference between EP and earlier sociobiology is that the new Darwinists are smart enough to realise that overt displays of sexism and antifeminism will not help their case. Instead, their strategy is to insist that feminists have nothing to lose, and even something to gain, by taking Darwinist approaches on board: appealing to biological difference actually *strengthens* the feminist argument on issues like rape.

This is a bit like saying that because radical feminists and fundamentalist Christians agree in opposing pornography, they are 'really' political allies. True, if Demos's 'big challenge' quoted above were taken seriously, the outcome might not be a million miles from certain feminist ideas about reforming the criminal justice system. Many radical feminists agree that so-called gender-neutral justice works against women: in

certain cases (such as the proposed self-preservation defence for battered women who kill their abusers) feminists do want women to be treated differently in law. But the reasoning behind the Demos proposal is light years away from radical feminism: what feminists criticise is not the law's failure to recognise biological sex-differences but its failure to recognise material differences of *power*.

Another strategy the Darwinists use to neutralise feminist criticism without appearing overtly antifeminist is to appeal to the truth and objectivity of science, branding critics as ignorant, superstitious ideologues. Helena Cronin provides an example:

> Science simply tells it like it is; it doesn't dictate goals. But how can we promote a fairer world—from social and legal policy to personal relationships — unless we understand differences, unless we let truth, not ignorance, be our guide?

This is highly disingenuous, glossing over the way scientific 'truth' is shaped by the power structures of the societies in which science is done. Even a cursory glance at the history of theorising about sex-differences casts doubt on the claim that 'science simply tells it like it is'. The 19th century experts who claimed that higher education would shrink women's ovaries said the same things about scientific truth that Helena Cronin says: if we are sceptical about the motives behind the earlier claim (not to mention knowing for a fact that it was drivel), why should we take analogous claims at face value now? History tells us that the political costs invariably outweigh the benefits of locating women's 'nature' in our reproductive organs.

The dangers of Darwinism

Gross abuses have been perpetrated in the name of Darwin, most notably where ideas about 'survival of the fittest' have been used to justify the sterilisation or, in Hitler's case, the wholesale extermination of the so-called 'unfit'. By comparison, the political pretensions of evolutionary psychology look benign; at least its agenda is not genocidal. It is, however, potentially oppressive and reactionary, for it rests on the idea that if some arrangement is 'natural', rooted in the fundamental needs and instincts of human beings, it is by that same token the arrangement most conducive to happiness and social justice.

The idea that our social and political arrangements should work with the grain of our 'nature' runs through the whole tradition of western political thought, where it was well-established long before science arrived on the scene. But the tradition in question is a classically patriarchal one, centring on the nature, the needs and rights

of 'Man', i.e. white European property-owning males. At different times, its concept of what is 'natural' (and thus politically desirable, or inevitable) has encompassed the enslavement of Africans, the wholesale destruction of indigenous populations by colonisers and the condemning of poor people in vast numbers to death from disease and starvation. In other words, definitions of the 'natural' have reflected the perceptions and interests of those doing the defining.

That is why I find it shocking when Helena Cronin — a woman and in her own estimation a feminist — affirms that 'evolution made men's and women's minds as unalike as it made our bodies'. I cannot help hearing echoes of every misogynist thinker — Rousseau, Nietzsche, the fascists of the early twentieth century — who ever proclaimed the same doctrine. Different minds, separate spheres, *kinder, küche, kirche*: even dressed up in new Darwinist clothes, how can such concepts be compatible with feminism?

The short answer is, they can't: modern feminism was founded on an explicit rejection of the belief that women and men have naturally different minds. Two centuries ago, writers like Mary Wollstonecraft argued that ideas about 'natural' sex difference were a key ideological weapon in men's struggle to maintain their unjust dominance over women. They still are.

In order to resist 'the world view from evolutionary psychology', we need not get bogged down in 'nature versus nurture' arguments about whether there really is a gene for female intuition, or ironing, or whatever the scientists have come up with this week. The point we have to get across is that nature, or difference, is not the issue. What matters to feminists is not whether our social arrangements are 'natural' but whether they are *just*.

The point is made neatly if we turn once again to history. When the suffragettes were fighting for women's right to vote, they used the slogan 'justice demands it'. Their opponents by contrast said it was 'going against nature' to burden women with political responsibilities. Nature is the sexists' trump card; justice is ours. And justice demands that we expose Darwinist ideas about men's and women's 'natures' for the half-baked and wholly ideological claptrap they are.

References
Cronin, Helena (1997) 'It's only natural', *Red Pepper* 39, August.
Demos Quarterly no. 10 (1996), 'Matters of life and death: the world view from evolutionary psychology'.
Lees, Sue (1996), *Carnal Knowledge: Rape on Trial,* London: Hamish Hamilton.

history

20. Mothers of Invention (1985)

Rachel Hasted

For me, the issue of the Witchcraze has been central in raising questions about the possibility of feminist history. I was worried by the conflicts between my own work on the Lancashire witch trials and the very positive image of the witch I found in many feminist writings. Was my work intrinsically feminist at all? What did I think feminist history was for? How were feminist writers using history, and would my work contribute anything meaningful to the political debate? Was I, in fact, confusing the issue by concentrating on an incident in which women did not play an heroic role, or show themselves as admirable victims of patriarchy?

I am using the word 'witchcraze' to mean the period which seems to have begun in the 14th century and lasted until the late 17th century, when purges were carried out by male officials of Church or State against individuals — mainly women. They were accused of belonging to a secret society of witches, all of whom were said to have entered into a pact with the Devil. These purges occurred equally in Protestant and Catholic countries of continental Europe, in Scotland, and to a lesser degree in England where the terror never became as acute, because extreme physical torture was not used to extract confessions.

How has feminist thinking about the Witchcraze evolved? Reclaiming the Witch as a foremother is not an immediately obvious theme in 19th century feminist writing, and this is not surprising since some were Christians, and all belonged to a christian but science-worshipping society, in which to be linked with outdated superstition would be more of a political handicap than a strength. I believe that it was Jules Michelet, the French historian, who began the rehabilitation of witches as political figures with his book *La Sorcière* published in 1862. Michelet based his work on a wide study of archive material, but his interpretation was very personal. He accepted the records left by the witch-hunters and interpreted what he saw as a massive turning away from Christianity by the peasantry as a form of rebellion. For the anti-clerical Michelet the Church was a major weapon of class war, and he saw the witches as pagan priestesses leading a doomed peasants' revolt against the oppression of a christian ruling class. The 19th century American historian HC Lea meanwhile took up the cause of the witch as scientist, persecuted by religious fanatics who wished to keep the people in ignorant obedience.

Both of these ideas were taken up in turn by Matilda Joslyn Gage in her book *Woman, Church and State*, originally published in America in 1893. Gage was one of the more radical leaders of the US suffrage movement and a long-standing researcher into women's history. She seems to have been the first US feminist to suggest that in prehistory society had been matriarchal, egalitarian, and people had worshipped a female deity. She believed that witchcraft and the occult were forms of knowledge, once highly developed under the matriarchy, but later outlawed by a jealous patriarchy. She saw the Witchcraze as evidence for this thesis.

In her chapter on witchcraft, Gage refers the start of the Witchcraze to the increasing insistence of the Church on priestly celibacy, itself a sign of increased woman-hating according to her. Gage uncompromisingly identifies the Witch as Woman, and never addresses the problem of the men who were also accused. Although admitting that many people were executed who were in no way out of the ordinary, Gage claims that:

> A vast amount of evidence exists, to show that the word 'witch' formerly signified a woman of superior knowledge. Many of the persons called witches doubtless possessed a super-abundance of the Pacinian corpuscles in hands and feet, enabling them to swim when cast into water bound, to rise in the air against the ordinary action of gravity, to heal by a touch, and in some instances to sink into a condition of catalepsy, perfectly unconscious of torture when applied.

Pacinian corpuscles are found in the sensory nerves of the hands and feet. Their discoverer referred to them as 'organs of animal magnetism', and this gave rise to the idea that they might hold a physical explanation for 'supernatural' phenomena such as witchcraft. Gage further claims that 'natural psychics formed a large proportion of the victims of this period'.

Her major thesis however is that 'The clergy fattened on the torture and burning of women'. She suggests that the Church consciously used witchcraft charges to discredit women in religious life by referring to pagan priestesses as witches, and by showing women to be easy prey of the Devil. Thus the Church kept women in subjection while confiscating their goods. The State was also active against witchcraft because of its need to suppress unauthorised sources of power and leadership, such as the witch/priestesses.

Gage was a phenomenal worker, organising conventions, making speeches, editing a newspaper, taking legal action over voting rights, writing articles, collaborating on *The History of Woman Suffrage*, and doing her own research.

I think it is unlikely that she ever had time to go back and check original documents — in any case the majority of those relating to the Witchcraze were still in Europe. She relied heavily on secondary sources, and did not question the interpretation of established authorities such as Michelet and Lea when these fitted with her own theories on matriarchal cults and women's special spiritual powers. They are her sources for many claims that witches were great scientists and healers.

In questioning previous male readings of history on other points, in making women visible and in indicating the role of patriarchy in shaping women's history, Gage was an important source of inspiration for feminists. The re-discovery of her work by Mary Daly and others in the 1970s, and the re-issue of *Woman, Church and State*, have been a major influence on our thinking about history. However, I am disturbed by the stamp of unqualified approval given to Gage's work by Mary Daly and Dale Spender. Both are deeply impressed by Gage's claim that the Witch was: '...in reality the profoundest thinker, the most advanced scientist of those ages...'. I, on the other hand, find Gage's views on witchcraft unhelpful. What evidence is there to show that witchcraft purges grew in direct relation to increased insistence on celibacy in the priesthood? Protestant Germany killed more witches than Catholic Spain. Appropriation of goods did not provide a motive for accusations against the poor, and in England it was never an issue, yet poor people were tried all over Europe.

Gage never deals with the reality of witch-beliefs amongst ordinary people, beliefs shared by some at least of the accused; nor does she back her claims for women's healing skills with evidence. What does it mean, to call the witch a scientist? How is 'scientific' research possible without benefit of scientific method, with no idea of cause and effect, an inaccurate system of medical diagnosis, and a profound belief in the supernatural cause of physical misfortunes?

Gage quotes statistics with immense confidence and gives no sources for them. She is the earliest source I have found for the claim that nine million women were executed for witchcraft, ('after 1484' she stipulates). This, I suspect, was her own calculation — she gives no references for it. There simply is no way of estimating how many were killed: guesses vary from 30,000 up. Obviously the figure would be appallingly large whatever it was, but we have nothing on which to base any calculation. The figure of nine million women executed has become an important part of a new mythology about the Witchcraze, and I will come back to it later.

However, before the rediscovery of Gage in the mid-1970s, American feminists were already interested in witches and the Witchcraze, and I want first to look at what they thought about these issues. Robin Morgan's collection of writings from the Movement, *Sisterhood is Powerful* (1970), contains documents from a

group calling itself WITCH (Women's International Conspiracy from Hell, or Women Inspired to Commit Herstory). Groups of this name popped up all over the States after Halloween 1968, when the 'mother coven' in New York did an action in Wall Street, and put out a leaflet explaining that:

> ...witches and gypsies were the original guerrillas and resistance fighters against oppression — particularly the oppression of women — down through the ages. Witches have always been women who dared to be: groovy, courageous, aggressive, intelligent, non-conformist, explorative, curious, independent, sexually liberated, revolutionary. (This possibly explains why 9 million of them have been burned)...

The initial emphasis on witches as resistance fighters is familiar as far back as Michelet, and the idea of the non-conforming explorer from Lea and other 19th century sources. The 1960s here adds its own vision of the 'groovy chick' to the composite picture. Even more attractive was the idea that any woman could join. The pamphlet went on: 'You are a Witch by saying aloud 'I am a witch' three times, and thinking about that'.

The Chicago WITCH Coven put out a more closely argued (undated) leaflet reclaiming the witches as an important part of women's history:

> Like other oppressed groups women have not been allowed to develop a consciousness of their own history... We demand to learn about the history of women in the same way that we demand that history be the history of the people, not of the elite.

The brief outline history of the Witchcraze that follows is heavily influenced by Michelet and possibly also by Margaret Murray's works, *The Witch-Cult in Western Europe* (1921), and *The God of the Witches* (1931), both of which argue that witchcraft was an organised, pre-christian religion surviving on amongst the peasantry, in whose rituals women played a prominent part. Here the Witchcraze is explained as the long struggle for supremacy between pagan and christian faiths. The witches are depicted as resisting the Church.

The pamphlet goes on:

> ...the witch was chosen as a revolutionary image for women because they did fight hard and in their fight they refused to accept the level of struggle which society deemed acceptable for their sex... as women today must assume positions of

leadership if radical politics are to relate to the real oppression of people, and mutually, if women are to gain true equality in a revolutionary movement.

This final paragraph, I think, comes close to the reasons why American women were interested in the witches in the early 1970s. These women were confronting a radical movement dominated by men, and attempting to argue for equality with the men on their own political terms. The appeal to historical precedent is very much in line with the left-wing political thinking from which WITCH emerged. Morgan notes that the group, and her own reports on its activities in the radical press, were intended to gain approval from the male left for women's liberation.

The historical identification between WITCH and the original witches always remained rather playful, a stance taken for effect, according to Morgan:

> We in WITCH always *meant* to do the real research, to read the anthropological, religious, and mythographic studies on the subject — but we never got around to it. We were too busy doing actions.

As a result the group accepted ready-made 'facts' about the Witchcraze (such as the 9 million burned) which happened to fit their case, without questioning the sources too closely, and gave great publicity within the movement to the idea of the witch as revolutionary. I would argue however that this is a piece of myth-making based more on a dream of what they would have liked it to have been.

The publication, in 1971, of Thomas Szasz's book *The Manufacture of Madness*, which interprets the Witchcraze as a massive repression of non-conforming individuals by the Church, and makes a direct comparison with contemporary practices in psychiatry, added a further dimension to the picture of the witch as a woman in rebellion against the might of State power. 'The Burning Times' continue, but now with electric shock therapy.

To Szasz the witch is not a heroic resister so much as a victim. He takes up comparisons originally made by Hugh Trevor-Roper between the witch-hunts and the persecution of Jews in Nazi Germany. The emotive figure of 'nine million burned' (which in fact neither author gives credence to), has also been linked by feminist writers to the 6 million Jews who perished in the Holocaust. In a footnote to her account of the Witchcraze, Mary Daly writes:

> The witch trials in Germany were characterised by extreme brutality combined with masterful meticulousness. Yet most authors... write about the massacre of the Jews as if such sadism were without historical precedent.

What is Daly saying here? European Christians had been massacring Jews on a grand scale long before the Church turned its attention to witches, and the two persecutions continued side by side for centuries. Gage, writing of the European Witchcraze, specifically mentions a place of execution in Madrid, known as the Quemadero de la Cruz. Here, she says, layers of ashes left by inquisitorial burnings lie feet deep, and implies that the victims were all convicted of witchcraft. In his book, however, Thomas Szasz, looking at the same evidence, comments that the Spanish Inquisition burned fewer witches than anywhere else in continental Europe — because it was too busy exterminating Spanish Jews. It was the Jews who refused forced conversion to Christianity who were burned at Quemadero de la Cruz.

Why have feminists insisted so strongly on the comparison between the Witchcraze and the Nazi persecutions? I would suggest that it has something to do with the moral status accorded to women as victims. Lynnette Mitchell has commented on the determination with which some women cling to the highest estimated death-rates they can find when discussing the Witchcraze. She points out the profoundly anti-feminist politics of glorifying Woman as Victim.

The moral authority of any argument which has several million murdered people behind it is obvious. As a weapon of debate it was unanswerable. It was a clear, dramatic proof that women had been oppressed in the past just for being women, but it put the blame for this on the institutions of Church and State, rather than on individual men. This left it open for men on the radical Left to recognise women's legitimate claim for liberation, without feeling personally attacked.

Meanwhile, in 1973 Barbara Ehrenreich and Deirdre English published a pamphlet entitled *Witches, Midwives* and *Nurses* on the history of women's involvement in health care (the bibliography credits Jules Michelet and Thomas Szasz, along with Margaret Murray) which argues that

The great majority (of witches) were lay healers serving the peasant population... The women's health movement today has ancient roots in the medieval covens, and its opponents have as their ancestors those who ruthlessly forced the elimination of the witches.

The emerging male medical profession, they argue, sought the suppression of female healers in competition with them. The witch was a practical scientist, experimenting with herbal drugs and learning from her results.

The idea of woman as especially suited to, and skilled in, the healing arts is taken up by other writers. Shuttle and Redgrove take it to extremes in *The Wise Wound*, where they argue that:

In the Middle Ages it has been estimated that nine million women were burned as witches for exercising their natural crafts of midwifery, hypnotism, healing, dowsing, dream-study and sexual fulfilment.

Mary Daly talks in *Gyn/Ecology* of the 'native talent and superiority of woman' in healing, and considers the Witchcraze as an attack by patriarchy on: '...a spiritual/moral/know-ing elite cross-section of the female population of Europe.'

Some of these authors make a claim for special female powers, which they say lay behind the witches' abilities. For Shuttle and Redgrove it is the power of menstruation: 'It seems likely' they conclude 'that the persecution of the Witches in the Middle Ages was one enormous menstrual taboo.' For Daly the Witches were: '...the possessors of (unlegitimated) higher learning, that is, spiritual wisdom.' The evidence for these claims is not given in any detail. I find them problematic, as I am unable to accept that women are biologically destined to be the healers and spiritual leaders of the human race, any more than I can accept the concept of 'maternal instinct'.

Looking at the literature that I have been discussing, one can find claims that the witches were revolutionaries, proto-feminists, lesbians, pagan priestesses, alternative medical practitioners, experimental scientists and general super-women. The Witchcraze is explained in terms of sexual politics, religious struggle, the control of knowledge, and class war. The historic basis for many of these interpretations seems to rest on a few 19th century sources. Does it matter? The image of the witch is very powerful, and a fertile source of inspiration for feminist writers. Surely it is legitimate to make what we want of it?

I think, however, that the authors I have referred to were interested in more than a folk-image. They refer back to the Witchcraze in order to prove something about the present. They are arguing upon historical precedent, implying that history has a sort of factual reality which makes it a touchstone against which to test their views. So it should matter to them that their historical evidence is as good as possible. Yet we find Mary Daly quoting with approval Monique Wittig's words: 'Make an effort to remember. Or, failing that, invent', as a motto for feminist researchers. Dale Spender meanwhile recommends a 'knowledge strike', and argues that feminist historians have a duty to write selectively, presenting only positive views of women's

achievements, because patriarchy makes '...valuable use of any negative evidence we may construct about other women'..

Should I not then gladly accept all the possible positive interpretations of the Witchcraze on offer? Does it matter that the small study I have made brings up a picture of women's lives in one obscure corner of 17th century Lancashire which conflicts with the claims made by these authors? Perhaps I have stumbled upon an exceptional case?

I am not at all sure of the answers, but I think the question matters. When we are arguing political conclusions from historical precedent our evidence ought to be investigated all along the line; if we come to believe in myths we may miss a more valuable insight into our own condition. It matters to me that as feminists we should share what we find out about women's history with other women honestly,

not over-simplifying and not glossing over our areas of ignorance. It is not in our interests to sell short the complex history we have — in fact we should be telling other historians that their level of awareness on women's history just isn't good enough.

It also seems extremely short-sighted to attempt any deliberate bias in handling the evidence we do find. In time such manipulations will be discovered, and feminism in general discredited through our work. The difference in a feminist analysis of historical evidence must lie elsewhere than in the subject matter itself. I would suggest it might be in the value placed on the subject, and the relative importance given to issues within it. In the case of the Witchcraze this might involve asking not: 'What did witches do?' but 'Why did men engage in a witch-hunt?' Initially it might seem that attention was being shifted away from women here, but in fact the answer to the second question might tell us more about the nature of women's oppression.

The witches have been described as revolutionaries and guerrilla fighters, but I have yet to see the evidence to convince me of this. Undoubtedly women were among the surgeons and healers of their day, but many practised medicine without being accused of witchcraft, while very poor and ignorant women (no threat to male doctors) were prosecuted. We do not even begin to have enough information on which to base an explanation of witch-hunting; but meanwhile a comforting belief in a group of super-women gets us nowhere, nor will a sentimental piety for 'the smoke of our nine million martyrs' bring the end of patriarchy one step nearer.

The literature I have been looking at seems to me often to imply a sense of choice and independence among women in the periods under discussion which is out of place. One gets the impression that many accused witches had made a clear choice to struggle against patriarchal society. The horrifying thing to me, by contrast, was to see witch persecution as something that happened to perfectly ordinary women, not because they chose to fight, but because they were powerless to stop it. To me witchcraft was a symptom of women's weak position in society, not of some special strength. I believe it is only by allowing ourselves to see the real nature and depth of oppression in the past and present that we can realistically hope to end it.

The victims and heroines approach will not help us here. I do not dispute the need to reclaim the names and deeds of women for the historical record, but the way in which individual women are ripped from their context to stand as models for uncritically accepted virtues such as being a powerful ruler, or even worse, for the extreme quality of their suffering. By concentrating on the victims and heroines we run the risk of missing valuable information about the ways in which women

have survived. We might look harder at women's strategies of resistance within a hostile society.

To some extent this is already happening. Christina Larner's books on Scottish witchcraft trials are superb examples of detailed and critical attention to the evidence. There is, however, an immense amount of catching up to do, and meanwhile I would argue that we have a right to ask each other to take great care over the use of historical material in the service of political analysis. If there is to be a feminist history it will have to start from a profound distrust of accepted sources.

References

Daly, Mary (1979), *Gyn/Ecology*, London: Women's Press.

Ehrenreich, Barbara and English, Deirdre (1973), *Witches, Midwives* and *Nurses*, London: Writers & Readers Publishing Co-op.

Gage, Matilda Joslyn (1980), *Woman, Church & State*, London: Persephone Press.

Larner, Christina (1981), *Enemies of God*, London: Chatto & Windus.

Mitchell, Lynette (1984) 'Enemies of God or Victims of Patriarchy?' T&S 2.

Morgan, Robin (1970), *Sisterhood Is Powerful*, New York: Vintage.

Shuttle, Penelope and Redgrove, Peter (1978), *The Wise Wound*, Harmondsworth: Penguin

Spender, Dale (1982), *Women of Ideas, and What Men Have Done to Them*, London: RKP

Szasz, Thomas (1971) *The Manufacture of Madness*, New York: Harper & Row.

21. You're a Dyke, Angela! (1987)

Rosemary Auchmuty

Friendships have always provided women with vital social, emotional, professional and political support. They are also important in any examination of the construction of sexuality. Tolerated, even encouraged, when perceived to keep women content and not meddling in men's affairs, they become profoundly threatening whenever women seem to be banding together to plot against men's power, either publicly (like the suffragettes) or privately (as lesbians, for instance). Because schoolgirl stories are fundamentally about female strength and bonding, they provide an interesting example of a phenomenon which was at first tolerated and even encouraged, but which came to be seen as a threat of such magnitude it had to be exterminated.

School stories were a Victorian creation, a product of the middle class that emerged in Britain after the Industrial Revolution and rose to cultural domination in the 19th century. The long haul up the social ladder was accomplished by means of education. New public schools like Marlborough and Rugby, set up for middle-class boys, were copied by the pioneers of girls' education at Cheltenham, St Leonard's, Wycombe Abbey and Roedean. Lacking an alternative model for a genuinely equal girls' schooling, feminists like Emily Davies campaigned for a structure and curriculum identical with boys', garnished with the odd concession to 'feminine accomplishments'. They argued that men would never take women seriously unless they could be seen to succeed in the same system. Middle-class girls' schools thus acquired the familiar characteristics of boys' schools: examinations, compulsory games, school uniforms, prefects, a moral code based on honour, loyalty and playing the game; and, of course, they were single-sex institutions. These ideas were taken over in turn by the girls' high schools and passed on, after the Education Acts of 1870 and 1880, to Board School children by ex-students who went into teaching. Hence, although the schoolgirl culture and the books which described it were the privilege of a small proportion of the population, compulsory education created a large new reading public steeped in middle-class ideals and aspirations, who were to become the main market for the schoolgirl story.

The credit for writing the first Victorian school story belongs not to Thomas Hughes for his *Tom Brown's Schooldays* (1857), but to Harriet Martineau, whose novel

BACK TO BASICS:
THE SCHOOL SONG

LET US NOW PRAISE FAMOUS MEN AND OUR FATHERS WHO BEGAT US

The Crofton Boys appeared in 1841. Girls' school stories were a later development. The real founder of the genre must be Angela Brazil (1869–1947), who published her first school story in 1906 and went on to write nearly 50 more. The 1920s and 1930s were the heyday of the formula. Its popularity was enhanced by the evolution of the series, whereby the same characters featured in a number of books as they traversed the path from schooldays through marriage and motherhood to the daughters' schooldays.

The typical successful writer of schoolgirl stories was female, middle-class and unmarried. Apart from this we know little about her; there are few biographies and critical studies are generally uninterested in such 'inferior' authors. From the information we do have, one significant factor emerges; in real life, as well as in their

writing, they devoted their energies to girls and women. Angela Brazil organised parties for local schoolgirls; Elsie Oxenham was an enthusiastic member of the English Folk Dance Society and a Camp Fire Guardian; E.M. Brent-Dyer, as well as teaching girls, was into folk dancing and the Girl Guides; Dorita Fairlie-Bruce was involved in a similar organisation, the Girls' Guildry. To judge by the dedications in their books (dedications are always very revealing), their chief friends were women. Most were emphatic that they wrote out of love for their subject and their audience, which were, of course, the same: girls and women. 'I confess I am still an absolute schoolgirl in my sympathies', wrote Angela Brazil in her autobiography, entitled (naturally enough) *My Own Schooldays*. Brent-Dyer's biographer suggests that her imaginative world was in part a kind of wish-fulfilment, depicting the life she would have liked for herself.

Both adult women and girls read schoolgirl stories. Older correspondents to the *Chalet Club Newsletter* were among E.M. Brent-Dyer's most enthusiastic fans, confessing that they read the Chalet School books because they were 'more interesting' than anything else, and describing the characters as 'almost real — one knows them as friends'. Schoolgirl stories enjoyed conservative support because they represented conventional values. But they were also bought by many whose outlook was progressive, if not feminist. The right to education had been one of the great battles fought by the Victorian women's movement and their victory was still fresh in their beneficiaries' minds. As Sara Burstall, former headmistress of Manchester Girls' High School, wrote in 1933:

> For generations men have felt loyalty and gratitude to their schools; emotion which has found its way into song not only at Eton and Harrow and Clifton. Stirring and beautiful as these songs are, they do not express more than is felt by women who, under the new era, have gained from their schools opportunity, knowledge, discipline, fellowship, and who look back in loyalty and affection to those who taught them.

For such women, many the mothers of young readers, school story ideals were revolutionary, representing women's new-found freedom and dignity.

School stories also offered hope in the face of a strong social reaction against feminism in the years after the first world war. This was a profoundly repressive era for women. The general opinion was that women had become too independent as a result of the political and economic gains of the Victorian and Edwardian women's movement and their war work. They were being forced back into the home, with

marriage and motherhood presented to them as the only acceptable female goals. At a time when their outlook was shrinking, the timeless, apolitical, independent nature of schoolgirl stories offered a liberating role. Even in books where the heroines did grow up and marry, they still managed to preserve an independent spirit and close links with the girlfriends of their schooldays.

The Abbey Girls in Love

One of the most popular series of schoolgirl stories was Elsie Jeanette Oxenham's Abbey books[1]. To dip into the early volumes of this series is to be transported into a world where women's love for women is openly and unselfconsciously avowed on almost every page. And to follow the rise and fall of these books' popularity gives a fascinating insight into the changing attitudes to women's friendships over the years.

The Abbey books appeared at the rate of about one a year from 1920. While clearly intended for the female juvenile market, they are only loosely linked to the school the girls attended and its customs (in particular, country-dancing and the annual crowning of a May Queen). The early books really focus on the relations between the various women characters, even after they have left school. Though individuals fall in love with men and marry, these events are seen in terms of their effect upon their women friends. In the 1920s EJO considered women's loyalty to other women sufficiently important and socially acceptable to lavish page after agonising page upon it:

> Mary: 'I ought to be thinking about Jen. I've been sorry for her all through, and I've wanted to help her; but I've been thinking about myself, what *I* wanted, how *I* felt. Ann forgot all about herself, and thought only of helping Jen. But almost from the first I was thinking how I'd failed her and how awful it was; and it made me still less able to help... I was hardly any use; I just collapsed like a baby — and it was because I was so much upset because she turned from me to Ann...' (*The Abbey Girls Win Through*, 1928, p.73)

Some extracts from an early volume, *The Abbey Girls Go Back to School* (1922), illustrate EJO's struggle to balance love for one's women friends and love for one's man. At a vacation school of the English Folk Dance Society, the Abbey girls meet 'Madam', of whom Cicely remarks: '*Like her*! There isn't anyone else!... If she looked ill, I'd feel there was something wrong in the universe' (p.187). But this heroine-worship must give way to the greater claims of heterosexual love. By the

end of the book, after an extraordinarily brief courtship (mercifully concealed from the reader), Cicely is engaged to be married, and 'Madam's' place has now been filled more appropriately by 'Dick'.

But husbands are strongly resented by the unmarried women for taking their friends away. When Joy marries, in *Queen of the Abbey Girls* (1926), Jen moans: 'I daren't face the thought that we've really lost Joy; it doesn't bear thinking about' (p.129). And when Joy returns from her honeymoon, leaving her husband shooting game in Africa, Rosamund declares: 'It's ripping to have Joy come back alone. We like Andrew of course; but I'm quite content to have him in East Africa' (*The Abbey Girls Win Through*, 1928, p.175). So, clearly, is EJO, who contrives to have him murdered on safari by some 'wild natives' so that Joy may be left free to bring up twin daughters with the help of her women friends.

The 1930s brought a change. When the eleventh book in the series, *The Abbey Girls Play Up*, appeared in 1930, the characters had moved on a few years. The focus is now very much more domestic; Joan, Joy and Jen all have young families and a new and even less convincing approach to heterosexual romance is in evidence. Jen introduces Maribel to her husband's cousin and a relationship develops which seems to be entirely based upon meaningful looks: 'Mike Marchwood's eyes had been saying something very emphatic, which he might not put into words' (p.163). Maribel discusses the phenomenon of love with her chum, but the subject embarrasses them: 'Oh, I say, Bel, don't let's be idiots! Come and play tennis, and forget all this tosh!' (p.166). Would that they did! But Maribel is engaged by the end of the book.

In the early and mid-20s the members and activities of the English Folk Dance Society were of central importance to EJO. But by the late 1920s she had come to feel that her attitude to them was no longer appropriate. Would it be too far-fetched to suggest that the Society and its activities represented more to EJO than healthy exercise? And is it just a coincidence that her change in attitude is expressed in a book she was writing in 1928, the year of the trial of *The Well of Loneliness*?

Lesbians at the Abbey

Lesbianism was not seen as a threat to morality before the 1920s. Indeed, it was hardly even recognised as an idea. Close friendships between women, particularly young women, were encouraged in Victorian times. After 1885 male homosexual acts were made illegal, but no mention was made of women. By the 1920s the writings of Havelock Ellis, Krafft-Ebing, Hirschfield and Freud on normal and deviant sexuality were well-known in intellectual circles in Britain, and an attempt was made

in 1921 to bring lesbian acts within the Criminal Law. It was argued, however, that silence about this 'abomination' would be a better preventative than criminalisation and the Bill was defeated. As a result, lesbianism was slow to enter the popular consciousness. The trial of *The Well of Loneliness* in 1928 put an end to that. The press coverage of this famous scandal was probably the most significant factor in creating a public image of lesbianism, as defined by psychiatrists and sexologists. Though Radclyffe Hall's novel was banned, there could hardly be a reader in the country who did not know what it was about. EJO and her sister-writers must surely have begun to realise that the behaviour of their characters was open to 'misinterpretation'.

Take, for example, the introduction to Norah and Con in *The Abbey Girls Win Through* (1928):

> They were a recognised couple. Con, who sold gloves in a big West-End establishment, was the wife and home-maker; Norah, the typist, was the husband, who planned little pleasure-trips and kept the accounts and took Con to the pictures. (p.9)

Descriptions such as these caused critics great amusement in the 1950s and afterwards. How could EJO have been so naive, or so explicit? But these words were written before *The Well of Loneliness* trial, before the lesbian scare had made women in couples into objects of suspicion and disgust. EJO was simply describing a phenomenon which she and her readers were familiar with, which they saw all about them in the male-depleted generation after the first world war. In the same book Ann observes that:

> Perhaps Miss Devine remembers that girls often live in twos. She used to be in the office herself; she'll know girls don't like to go and leave their other half alone. (p.12)

EJO does distinguish between 'healthy' and 'unhealthy' relationships between women, but in the early books the distinction was not the one that Freud and Havelock Ellis would have made. 'Unhealthy' relationships were unreciprocated, uncontrolled crushes. For example, Jen, in *Queen of the Abbey Girls* (1926), speaking of Amy's unreciprocated crush on Mary:

> I've heard the girls at school talk like that about certain mistresses, but I didn't know grown people in business kept it up... Of course it's a sign there's

something wrong with the girl. ...that she should let her liking run away with her, as if she were a schoolgirl. That's wrong. It's uncontrolled; want of balance. (p.186–7)

From 1930 on there is an ever-declining expression of love between women in the books and much more of a feature is made of heterosexual romance, marriage and motherhood. Possibly because it was now clear that only young women could safely be open about their feelings for one another, EJO made the decision in 1938 to revert to the pre-marriage years of her original characters. She produced seven stories which filled in gaps in the first sequence. The title of the first of these, *Schooldays at the Abbey*, is revealing of the switch. Though the books continued to be about women's friendships, the relationships described are reduced to the level of schoolgirl passions. Meanwhile heterosexual love is idealised. Here is Joan, aged about 18, in *Schooldays*:

It must be a wonderful thing. I don't suppose it will ever happen to me, but it must be the happiest thing in the world (p.116)

Contrast this with Jen in *The Abbey Girls in Town* (1925):

It's that man. Being in love's a fearful disease. I hope I never catch it. (p.299)

If the early Abbey books were about women's friendships, the later ones are about marriage pure and simple. Even Mary, the only spinster among the principal characters and the one who earlier stood for EJO's own experiences and aspirations, becomes a mouthpiece for the marriage party-line. World-famous ballerina Damaris gives up her career to marry: 'Other people can dance, but only Damaris can marry Brian', says Mary, incredibly. 'Other people don't dance as she does', Nanta objects. 'You do think she ought to give it up, Mary-Dorothy?' 'To be married — yes, Nanta, I do.' (p.172).

Two Queens at the Abbey (1959), the last in the series, is yet more preposterous. With a sense, perhaps, that she had to tie off all loose ends before she died, EJO launched every character into frenzied heterosexual activity. Nanta, aged 19, marries and falls pregnant; Littlejan, aged 19, marries and has a baby; Rosamund has her seventh, Jen her ninth. Jansy, Joan's daughter, talks of marrying Dickon, Cicely's son (both are aged 16); Lindy gets engaged to Donald, one of Maidlin's rejects. When good old understanding Mary prepares supper for Littlejan (Queen Marigold),

whose husband has just gone off to the Antarctic, she remarks that 'Marigold is hungry for more than sandwiches tonight' (p.65). In 1924 Mary had been hungry for a sight of Jen!

The Abbey Girls Sink Without Trace

As a source for attitudes to women's friendships over 40 years, the Abbey books are remarkable. They show how in the 1920s schoolgirl story writers had a unique freedom to explore all the dimensions of women's love for women. As the years passed this freedom was progressively curtailed, with writers becoming more and more confused and restricted by the new heterosexual demands and the negative image of lesbianism. In later decades critics looked back and sneered at their naivety, or amused themselves by exposing (or denying) the homosexual tendencies of schoolgirl heroines and their creators. A.O.J. Cockshut, for example, takes up 'The Lesbian Theme' in his *Man and Woman: A Study of Love and the Novel*, commenting that 'an inferior writer like Elsie Oxenham might in her innocent unawareness use language seeming to imply a lesbian relationship, while meaning no such thing'. He noted, however, that the public showed a 'calm acceptance' of her 'puerilities'. 'Lesbianism simply did not enter into most people's calculations'. Of course it didn't. This was because during the period in which the schoolgirl story flourished, lesbianism was progressively redefined. From a deviant sexuality caused by abnormal genetic or social development, it was extended to encompass all intimate relationships between women, whether explicitly sexual or not (in which case they were categorised as 'latent' or 'unconscious'). This was represented as a newly-discovered scientific fact, not the man-made invention that it was. A new equation sank into the public mind; close friendships between women = lesbianism = sexual perversion.

Among those who swallowed this version of women's psychology were Mary Cadogan and Patricia Craig, authors of the immensely readable but often unsympathetic study of girls' fiction *You're a Brick, Angela*! They dismiss Madam in *The Abbey Girls Go Back to School* as a 'stop-gap love object' for Cicely, for whom 'a more potentially satisfying relationship' in the person of her future husband is subsequently provided. They seize upon the many instances in which EJO's heroines share a bed as evidence that the women's intimacy is (however unconsciously) not 'healthy' or 'normal'.

In the 1960s 'sleeping together' became a synonym for sexual activity, but it is a misreading of history to impose this idea on the social mores of the 1920s. For EJO and her public, sharing a bed with a girlfriend was but one way of showing affection

and a perfectly acceptable one at that. In *The New Abbey Girls* (1923) Jen (aged 18) establishes this point when she suggests to Joy (aged 21) how she could make shy 14 year old Maidlin feel she is welcome in the Abbey household:

> Why don't you have her to sleep with you, at Jack's? [Jack is Jacqueline, a former school chum of Jen, whom she refers to as 'husband'.] You know Jacky-boy said she'd get a bed ready for the heiress! You could tell her not to and Maidlin could go in with you, and I'd tuck in with my husband. You know she always wants me to! (p.175)

What this reveals is not unconscious perversion but a very conscious love for women, which in 1923 was fine and after 1928 became abnormal and unhealthy. It represented a level of intimacy which was too threatening to be allowed to continue. Censorship was inevitable.

From the late 1950s to the early 1970s a handful of Abbey books were reprinted in cheap condensed editions. EJO's often tautologous prose can take a bit of blue-pencilling, but it is significant that the portions excised were frequently the passionate and, to post-Freudian eyes, sexually suggestive scenes between women. In the bowdlerised version of *The New Abbey Girls* (1959), for instance, Jen no longer suggests that Joy sleep with Maidlin.

Elsie Oxenham died in 1960. By the mid-seventies her Abbey books, along with virtually all schoolgirl stories, had disappeared from the publishers' lists. Readers were told that there was 'no demand'. The truth was that the critics had condemned them to death; the later books for being appallingly written (which they were), the early ones for their lack of 'relevance' and 'social realism'. It would be more truthful to say that the destruction of the schoolgirl story is a major piece of evidence of the imposition of compulsory heterosexuality in 20th century Britain.

References

Burstall, Sara (1933) *A Retrospect and Prospect: 60 years of Women's Education*, London: Longman.

Cadogan, Mary and Craig, Patricia (1976) *You're a Brick, Angela!* London: Gollancz.

Cockshut, A.O.J. (1977) *Man and Woman: A Study of Love and the Novel 1740–1920*. London: Collins.

Note

1. All the Abbey books mentioned in this chapter were published by Collins.

22. Writing Our Own History: Storming the Wimpy Bars (1983)

Sara Scott interviews Lilian Mohin

Sara: *When were you first involved in the Women's Liberation Movement?*

Lilian: Literally, physically, in 1970, when I came to live in England. I'd been reading feminist literature, avidly, in America, but had been too frightened to join up with any of the feminist groups that were available where I was living, mainly because I felt they were big and strong and wonderful and I was not. That was to do with a kind of media hype that I don't think exists here.

Once here, I felt I had a sort of foreign status and could sally forth immediately which I did. This was 1970 and I was married and had two children and I went off to my first consciousness-raising group meeting in Notting Hill.

Sara: *What sort of awareness did you have, at that time, of being part of a movement, of there being other things going on?*

Lilian: A lot really. There was already the Women's Liberation Workshop in London which was a kind of umbrella for lots of small CR groups. It seemed necessary for the groups not only to talk and develop theory from that, but also to come together regularly and do things, and then go back into our groups and see whether that had worked and what it meant… At that time there was a demonstration against the 'Miss World' competition at the Albert Hall. I didn't go to the 'Miss World' demonstration, I felt it was not appropriate for me to get arrested—who would look after the kids? But not long after that I was involved in the Wimpy Campaign in 1971, have you heard about that?

Sara: *No! Miss World, yes, but Wimpy Bars?*[1]

Lilian: Ah, well, it was one of the many things that were going on, I think in the rest of the country as well as London. The Wimpy chain had a rule about not serving what they called 'unaccompanied women' after 10 pm. If you wanted to eat after 10 you had to go in with a man, and they were putting up signs in Wimpy Bars that said this. Although why anybody wanted to enter a Wimpy Bar anyway was not clear. Still we were concerned that we weren't allowed to go, even though most of us didn't want to.

So there were demonstrations. In Golders Green they tried letting off stinkbombs, but no-one noticed! It was just awful, no-one did anything. Eventually, there was a planning group of all the groups that were involved in this Wimpy business. We got legal advice and learned that any place open to the public at night could exclude anyone on the grounds that they were likely to be criminals. The categories considered most likely to be detectable at a glance were thieves and prostitutes. And they decided only women could be prostitutes...

We were very angry, with that sense of exhilaration that came with a first heady taste of anger on our own behalves, not just anger like when someone is mean to you personally, but a righteous blaze for all women, for ourselves as part of all women, superseding the individualism we'd all been brought up on.

We sent letters to the managers and owner of Wimpy Bars—Metropolitan Hotels—who took little notice. Companies House provided their names and even home addresses which was handy. To encourage them to shape up we wrote to the tourist board asking for censure of the Wimpy Bar chain on behalf of women tourists and to Nicholson's Guides who, like the tourist board, publish guides to late night eating places. We got articles—all in our favour—in the Evening Standard and in local papers too. But what was much more important than any minor triumph like being allowed to eat without men after 10 pm in a Wimpy Bar, or being noticed and patted on the head by the establishment, i.e. the press, was what we learned about our strengths, our own intentions, our capacities for working together, for being inventive together. Sure, we made trouble wherever we could for 'them' but what we really did was make sense to and for each other.

We formed a co-ordinating group and at last mounted a massive demonstration outside the Marble Arch Wimpy Branch. Gay Liberation Front men and women and a women's theatre group came dressed in a huge variety of drag. Small children were brought along, too. We wanted to make a noticeable point about assumptions— what is a woman? When is 'she' accompanied? If she's brought a child? With a child of what sex can she be deemed to be 'accompanied'? What if she's wearing men's clothes? How about men in dresses? What does any of it MEAN?

Sara: *How did it go on the day?*
Lilian: I'd gone into Covent Garden and hired a costume from *The Sound of Music* for one of the women in my CR group, so she went in a very wonderful royal blue nun's habit. It was very exciting. We marched. We had picket signs of our own creation—not anyone else's slogans. Exhilarating. Fun even.

In the week before that demo several women in the planning group had become ill or had other reasons for not being able to manage the last minute organising and I was left doing most of it. To me this seemed temporary, an accident. But at the demo there were suddenly a lot of cops piling out of vans in a determined looking sort of way and a few fought through the crowd to get to me—small mousey-looking me—to say, archly, 'Who's in charge here?' I gave our standard reply, 'We do not have anyone in charge, thank you very much'. They didn't bend to this but departed leaving the uneasiness which may have been what they intended.

The manager closed down the Wimpy Bar early and we felt so pleased with ourselves that some of us rushed off to another Wimpy branch in Paddington. That was very different. Evidently the Marble Arch lot had been alerted to our demonstration before it happened and were prepared. So were the cops. So it had been in reality fairly civilised. But at the one opposite Paddington Station the manager was completely unprepared and panicky. We must have looked like dangerous maniacs approaching his nice plate glass window—a mob headed by a heavily made-up nun. There was a revolving door into this place and my friend in the nun's outfit, who also had a calliper on her leg which wasn't visible under the habit (she had had polio as a child) led the way into it. Just as she got in the door compartment, the manager stopped the door, crushing it against her leg and locked it, with the patrons inside and us outside. She screamed. We screamed. The people inside the Wimpy Bar screamed. We demanded to get in and rescue our friend. The people inside were desperate to get outside. This sudden terribleness. The police came again but different ones than at Marble Arch.

Everything lost that cheerful fantasy air very fast. Although they made the manager extricate the nun at once, they were interested in protecting the Wimpy manager and in what evil we represented. At that time there was a lot of publicity around the Angry Brigade[2] and the police asked if we were anything to do with them. Some of us hadn't heard of the Angry Brigade, others assumed the question was were *we* angry and we were, of course, and said so.

Sara: *So what happened in the end?*
Lilian: Eventually we were released. I returned the nun's habit to the hire place, albeit with pancake make-up on the wimple. Wimpy Bar management invited us to a discussion which was in fact a polite capitulation.

Sara: *What do you think you learnt from the action? Did it seem like a victory?*

Lilian: Sure, a small one in a way. But, as I said, the importance of this and other early actions was in what we learned both about how the world operates and about what we might be able to do for ourselves. Working on what we really wanted—which for most of us didn't include Wimpy Bars in any way—followed. Even symbolic action had to be closer to our own lives than this.

That demonstrations are so heavily, so rigidly, structured in the minds of the police and also in our own minds was very revealing. If we hadn't hared off to Paddington perhaps it would have been less obvious that we had been playing by rules, somehow allowed to demonstrate, naughty little girls given a small space in which to misbehave. It reminded me of all I'd read about why guerilla warfare works. Somehow I think we had collaborated in a standard view of the situation, of ourselves. A demonstration is such a predictable number, so within male expectations... so bloody useless, really. Talking about what we'd done, what we'd thought, led us into quite other areas, away from such obvious lefty and traditional actions. Confrontations with authority were played by rules that we accepted somehow but certainly didn't create. For me, that particular demo illuminated the necessity to concentrate on us, not them.

Notes

1. Wimpy Bars were a chain of inexpensive restaurants whose signature menu item was a hamburger and chips. Invented in the 1950s in imitation of American fast-food restaurants, they were once ubiquitous on Britain's high streets, but their popularity diminished after McDonald's crossed the Atlantic.

2. The Angry Brigade was an anarcho-communist group which was responsible for a bombing campaign in Britain in the early 1970s.

23. Taking on the Dinosaurs (1997)
Liz Kelly interviews Monica McWilliams

Liz Kelly: Let's begin with how the Northern Ireland Women's Coalition came into being.

Monica McWilliams: It was around April of 1996. The government published a list of parties they had decided were going to stand in the elections for the peace talks and to a new body called The Forum. I and the women I know were furious when we saw this, because we had been engaged in a whole range of conferences with women's groups across Northern Ireland about increasing the participation of women in mainstream decision making. One of these was in response to the framework document published by the British and Irish Governments. They hadn't mentioned women once in the entire document! It wasn't that we weren't political animals, we have been extremely active in grassroots politics, community politics, trade union politics and the various professional and voluntary sectors. Yet here was this opportunity that was being denied to us, to have a role in the new negotiating machinery.

At the same time an organisation called the European Women's Platform had written to all the political parties asking them where they were putting women in their lists and whether they had given serious attention to the number of women that would be elected. The response to that was abysmal, with replies from only three small parties — the Communist Party, the Democratic Left, and the Workers Party. We figured that if we wrote to the government and demanded they change the legislation, then if they said no then we would publicly go to press on it, and if they said yes we would have to do something quickly. They responded by saying that they had taken on board our views and they had agreed to change it — and what was the name of the party!

We called meetings of over 200 groups, faxed every group we could think of. We called meetings in Belfast and other areas. We still had not made a decision whether to stand but we were informing people that there was now an opportunity to create a women's party.

There were different views at those meetings. Against it was the view that this wasn't the election for us because the issues were constitutional; if we did stand and didn't do well we would be doing a disservice to the whole idea of women going into politics. The view for was that this was a unique election because it

was about getting the small parties to the table. You only needed about 1% of the vote, approximately 10,000. If we stood 100 women and each of them went out to seek 100 votes, knowing that they didn't have to be elected themselves because the votes would be aggregated, every woman would be standing for someone else, she wasn't necessarily standing to be elected for herself. That was a very comfortable space to be in. Realising that we were going to form a coalition the other parties suddenly began to say that they were promoting women, they were doing this and that. So we had already met one of our objectives, which was to put pressure on the other parties.

Decisions were made at open meetings which were advertised in newspapers. We also advertised for candidates because we felt that just using the networks was not always the best way to do it. We wanted to be as public and as transparent about it as possible. It was fun but chaotic in that we just covered walls in huge sheets of paper and put up all the names of constituencies and went round the rooms and women put their names up and when they saw that other women were prepared to do it then others came up. It was like an evangelical meeting. Women saying, well if she can do it, I can do it. We had the youngest candidate standing ever in an election and we had disabled candidates. In every constituency we had at least three or four candidates standing.

We found many interesting things along the way. For instance in relation to disability the lack of access into the polling stations — the fact that you could only take a male or female partner according to marriage to the count with you, you couldn't take a female partner. There were lots of things like that which we managed to have changed when the election was over.

It was only six weeks from the start of the campaign to the day of the election. We had to get the media on board so we started working really hard with them. We ran lots of training sessions for all the local women because that was the part they were most terrified of, actually having to take on the media. We had to keep reassuring them — did they ever hear much better from the people who'd been elected over the last 25 years? We picked the suffragette colours, green white and purple, and our slogan was Women For Talks, Women In Talks. For our canvassing papers we had just the manifesto and the joke in the papers was that was the only 'man' we had about us. The press kept that line up, another one was that the closest we would get to the negotiating table would be to polish it!

When we got elected the journalists were ill-prepared. They had produced these graphics for the front of the main Belfast newspaper showing ten little men with black ties on sitting around the table. Someone informed them by the evening

edition that they'd better change it because we'd been elected; so they took the little black ties off the graphic in the last edition of the paper. I guess they felt they were paying us a compliment when they titled their piece 'The Hen Party Leaves The Nest In Style'. We picked the slogan 'Wave Goodbye to Dinosaurs' and produced these huge purple white and green posters with that spread across them and white T shirts with a large X saying 'eXpress yourself' and 'Vote Women's Coalition'.

Liz: *How did you decide which were the two women who were going to go into the talks?*

Monica: We decided at a public meeting that there should be a woman who would be catholic and active in the women's movement and there should be a woman from a working class protestant/loyalist area. The group decided that one of those women should be me. I didn't really want to stand at all but women were quite fearful of putting themselves forward. Also we didn't actually know what it was going to entail, whether the talks were going to last for a day and collapse or whether you were giving up a year or two years of your life. The other woman is Pearl Seger, a loyalist working class woman with a community activist background.

I got nominated as the leader of the Coalition. Even though we don't use the titles of leaders they had to fill in somebody's name on the electoral papers and they nominated mine. One of the things we have done is to try and get away from this notion of leader. When we went into the talks each of the parties had a room and alongside each of the party rooms there's a leader's room and we couldn't believe it. So I took snopake and snopaked out the word 'leader'. Of course somebody thought our door had been vandalised and reported it and I said no it was me who did it because we don't believe in these titles. To this day, everywhere we go, people have difficulty with that. They still can't accept that we're a collective, that there are two of us elected with equal rights not one of us as a leader and the other as a follower.

Liz: *Tell us a little bit about the experience of the talks.*

Monica: The beginning was incredible. I mean the first day was intense — it was a very historic occasion. The world's media were there and incredible crowds of people. We were walking into this room which had a negotiating table in it and we sat down, Pearl and I and the three women who were our negotiators sitting behind us. I looked around and we were the only women in the room. We had been confirmed in everything we had thought the whole way through because all the

other parties had said that of course they were going to be putting women in their negotiating teams, but when it came to the crunch they didn't. So we were the only two women at the negotiating table. That was something. For me it was historical. After all the work that women had done over the 25 years we had created a space for them to have their voices heard at the table.

It's been sexist and sectarian. We are the double other and we are confusing as the other because we are coming from different backgrounds — we are not them as they see it. So we have become a target of their abuse. They threaten us, stand and shout at us, they prevent us from having our emergency motions heard. Whenever I'm speaking I have to make sure that the chairman calls order because I can't hear myself talking. They even comment on what we're wearing, if we're not wearing skirts and are wearing trousers. We've invaded their space, space that they feel belonged to them. We frighten them. They say this is radical, because when we feel that something's wrong we go out and shame them. We blame them and we name them and they've never had this done to them before. So they accuse us of running to the media all the time, but since there's no sanction on their behaviour internally and since they're not prepared to restrain themselves inside the place we've decided that the only sanction we have is to publicly expose them and we will do that at every stage of the process. We've got an insult of the week notice board up at the inner offices and we just write down everything with the date. We're letting them know they are under surveillance.

Liz: *What do you think the future looks like?*
Monica: We'll be staying together for at least the next two years because the talks will go on for two years. We will stand in the local elections and that's where we could do well because it's proportional representation. We will be putting up candidates for the general election but know we won't do well because it's going to be a bitter election. But we will put up three candidates to continue to get across our message and highlight the lack of women in politics. Also to get across our policies on domestic violence, on equal pay, on the issues that we feel very strongly about and that no one has bothered to raise.

Liz: *Talk about how you've taken what's going on in the talks back out to women and how you've been building the coalition outside the talks.*
Monica: On the last Saturday of every month we hold a public open meeting which is actually a coalition meeting but we make it known that we welcome any woman who wishes to attend. Occasionally men have attended as journalists and

we ask them to declare what they are there for and when they've got their bits down we ask them to leave, or if there are women journalists we ask are women comfortable and they can either stay or go. We are so open that it could be a problem for us but so far we prefer to stay open. If there are problems we prefer to let other people see how we work them out. We rotate those meetings across Northern Ireland, so they are not always in Belfast. We try to ensure that there's disabled access, a creche and that every woman has transport to the meetings. Those are quite well attended, big meetings. In between we have team meetings and they are held in people's houses.

Then we have consultative conferences that we hold every three months which are big public open conferences that everyone is free to attend and everybody gets their lunch. One was in Belfast and one has been down in the middle of Northern Ireland in Dungannon. We have made a point of ensuring that they are not coalition member only meetings, that they are meetings for other women from outside of the coalition as well as from other parties. We also have a newsletter that we send to everybody who is a member as well as to anybody that's made contact with us and has written their name on a sheet of paper. Every week we do a mailing on something.

What we try to do as much as possible is to do outreach, to disseminate our decisions when they are taken to others who haven't been at the meetings, and to ensure that the meeting itself has as many opinions about what we're doing, so that no woman feels in a dangerous or vulnerable position when she leaves the meeting that she could be attacked afterwards for having taken a decision that other people would disagree with or that she feels she couldn't go back into her community and live with. Those are the kinds of reasons why we take the decisions we take.

Liz: *We both know that the women's movement is often fraught with conflict, but that we find it difficult to openly disagree with one another, and then continue working together. How have you managed to build this atmosphere that enables this?*

Monica: That's a good question. So far I think it is because women feel there's a space where they can really make their voices heard. But when you get a different viewpoint coming in there's a listening going on and maybe that's because we have worked out of such a terrible struggle and because it's been dangerous for us not to listen. Women know what happens when there's too much grandstanding and so there's a preparedness there that this thing has to work. Also I think it's facilitated by the process. I think if decisions were taken that people felt they hadn't

been involved in then maybe there would be an awful lot of ill feeling. It's also because there's such honesty. Some of it is so honest and so blunt that it goes right to the jugular but that's not a bad thing because it then means the person has said it and we've got to work out of that position towards a position in which that person may end up saying well I can agree with that but I couldn't have agreed with what we started out with. That's why we end up with compromise. Compromise sounds like a terrible bloody word, in Northern Ireland people are told not to use it because it's seen as such an extreme word, can you believe that. We try and use the word 'accommodation'. For us it's the most difficult thing to arrive at but we're determined when we get there that it's something that people actually do feel comfortable around.

Liz: *When we talked last year you mentioned opposition from women in other parties to the idea of the Women's Coalition. I get a sense that some of that has shifted?*

Monica: There was some antipathy towards us from the Republican women at first. They press released a protest without actually calling a meeting with us. We discovered afterwards that a couple of people whose names were on the press release hadn't even been asked to sign it and were furious. But all of that has gone and the antipathy has gone because they now realise that we have borne the brunt of sectarianism and in some senses have acknowledged the stand that we have had to take which has been a fairly tough stand. I think they were worried that we were only going to take a stand on women's issues and not stand on constitutional issues. We said from the very start how dare anybody be so patronising to think, first, that women's issues weren't constitutional issues and secondly that we wouldn't have a strong say on anything like police reform, prisoners, and the list of things like that. We said look we have policy statements on every one of these things and by the way when we say reform the police we say reform the criminal justice system of which the police is only one part, we want the whole criminal justice system to be reformed. We have produced papers to that effect. They obviously had not read any of our documents. Now that has changed a bit.

The other parties, the mainstream parties, had their noses put out of joint. The Unionist party was totally opposed to positive action and said that women would get there in their own right, (they've done such a good job that they have one woman out of 35 men). The SDLP (Social Democratic and Labour Party) argued that we were opportunistic. They began to change their views a bit but because an election has started they are actually going out saying don't vote for the Women's

Coalition, they are single issue and don't have a stand on the constitution. I've been on TV that much, people now know that we have stands on everything.

Liz: *It sounds like the women in the Coalition are fantastic!*

Monica: They are just wonderful. Every time you turn around somebody's got a press statement, a policy statement, a speech, they've got ready for you. There's a terrific team atmosphere in the place. The women who are quietly working in the background are the strategists who don't seek media attention, who people don't even know belong to the Coalition and yet have probably taken the most important roles. For some there is the difficulty that because the Coalition is seen as a political group they can't publicly let it be known that they belong: their jobs would be in jeopardy, or their centres wouldn't get any money, the women's centres in particular. Councillors have threatened to close down the centres if they find out that any single one of them has been involved with the Coalition. They can't do it publicly so they do it privately either through financial donations or by writing speeches or by giving us whatever support they can, and they've been brilliant.

Liz: *For me it's an example of just what women can do if they set their minds to it.*

Monica: Oh absolutely. We never thought that we would be where we are and it has made such a difference to politics here. People say they'll never behave like that again because we've exposed the culture and the TV keeps repeating the ritual humiliation of me and Pearl and people say look, that's working because if they are doing that to women what must they have been doing over the years to the political negotiations. We never stood for election simply to be humiliated but if that is an outcome of exposing 'men behaving badly' then so be it. The other thing that I think is beginning to change is that they now realise that we are serious players here and that every strategy that we've engaged in has been so effective that they are now becoming quite intimidated by us.

Yesterday for instance at the Talks after my speech Ian Paisley berated me for one hour, the guts of which was that he was going to ensure at the end of the day that his people would breed for Ulster, so that they could outbreed the likes of me and others. Last week we walked out in protest, we just picked up our books and walked out. We had been promised that our Emergency Motion would be heard, we'd asked for the suspension of one of the committees on the grounds of corruption and Paisley got to the chair and said 'if you dare let those women speak' and the Chair gave in. So they wouldn't let me speak, I had to get up three times

on a point of order and remind him that he wasn't sticking to the rules. When he refused to hear me Pearl and I picked up our stuff and walked out and went straight to the press and told them what we thought of what had happened.

Liz: *It is difficult to imagine doing something similar in England, Scotland and Wales without proportional representation, but do you think that as a political strategy it's a good thing for women to do?*

Monica: Absolutely and don't let anybody start putting you down, because it's separatist and it's single issue and nobody will be interested in you. It was really important. Our time was right, one of those times when there was a window of opportunity, we couldn't have forgiven ourselves if we had let it go by. We could have waited around and they would have solved the Irish question before they would have resolved any attempts to be more inclusive of women!

Liz: *Has the Coalition been a route for women to discover feminism?*

Monica: Some of the women would have had difficulty owning that label at the start but they are much more comfortable with it now. Working class women in Northern Ireland in particular would have found that a difficult label, and even middle class women. It does cross class, that antipathy that existed in more conservative society towards feminism. But they wouldn't have a difficulty with it now. There are women, but they would be small in number, who would still not be prepared to say I'm a feminist, but the vast majority of the women in the Coalition are there because they believe in feminism.

24. Dispatches from the Front Line (1998)

Sarah Maguire

I want to talk about silence. I want to talk about the silencing effect of sexual violence, both in the national and international context. I want to talk about silence because rape is one of the most effective mechanisms men have for controlling and silencing women. Three days ago I was talking with some of the women who have survived the fall of Srebrenica in Bosnia; they have retreated into silence because nobody listened then and nobody is listening now.

We have two war crimes tribunals, what they call ad hoc tribunals — the International Criminal Tribunal for Former Yugoslavia (the ICTY) and the International Criminal Tribunal for Rwanda (the ICTR). The Yugoslav Tribunal is vastly under-resourced; the Rwanda Tribunal is virtually unresourced — and there's no prize for guessing why there should be a difference in funding for a European tribunal and funding for an African one.

All over eastern Bosnia and Herzegovina, you ask the women: 'What about the Tribunal?'; 'Will you talk to the Tribunal?'; 'Why not go to the Tribunal?'; and the answers they give are various: 'The Tribunal hasn't been here'; or 'They came here but they did nothing'; or 'They came but we won't talk to them'. You also hear — and this is usually from men: 'Our women are different; our women won't talk; our women have silence; our women have dignity; it's different for our women'. Well, that's complete rubbish, isn't it? It's 'different' for all women; we are all 'different'. It's not always that those men don't care, or that they want to hide what has happened to women, but that it's easier for them - easier for all of us, probably — not to confront the reality of sexual violence. And this holds true for sexual violence in the international or the domestic context. It's easier not to talk about it.

Personal silence

Although sexual violence affects all of our lives, it's an issue that we rarely discuss, even if we are feminist activists, in terms of our personal lives. We don't like to

admit, even to each other, about being scared of sexual violence. We don't like to tell each other that we fear the step behind us on the dark street at night. Women don't like to tell each other that they may fear the man behind our own closed door. It's the same silence, nationally or internationally. We are expected to get on with our lives; we are expected not to make a fuss. We talk about 'date rape'; we don't talk about rape by known men.

The other day, a friend of mine in Bosnia was telling me that the Minister of Health had been to visit their organization. It's a fantastic organization; it works with women exclusively and has done since around 1992. The Minister of Health was very impressed and he said: 'You know, it's amazing about our women. You can beat them and beat them and the only thing that happens is your arm gets tired. Women don't break.' We are expected to stay silent.

Rape as a war crime

In this context, it's amazing that both of the ad hoc tribunals have recognized that rape constitutes a war crime; that rape can be a constituent of genocide, of crime against humanity, or a war crime - a grave breach of the rules and customs of war. I still think that the whole concept of 'war crimes' is bizarre: the notion that it's acceptable to do certain things in war, but if you go a little bit too far, if things get out of hand, then that's a breach of the normal and acceptable code of practice for two sides (or rather the men from two sides) who have decided that they're going to start fighting each other.

Rape wasn't recognized as a war crime in the Nuremberg trials after the Holocaust. It just wasn't an issue; it wasn't addressed; it didn't happen, and if it did happen, it was something to be kept silent about once again. So the fact that rape is recognized by the ad hoc tribunals, and by the permanent International Criminal Court, is a huge step forward. It's a step forward that we made - feminists from all over the world. We made that step forward by insisting on being heard, year after year, and going on and on about the need to recognize sexual violence and to name it for exactly what it is.

So rape is now a war crime; it can be genocide and a crime against humanity. But what's actually happening? Are men by the score from former Yugoslavia or from Rwanda being prosecuted? Are the prisons full of serial rapists, or of men who order the mass rape of women in schools and other camps? No. The tribunals are failing women. I fully support the tribunals and recognise the need for them, and am a passionate advocate for the permanent International Criminal Court. But they're failing for various reasons.

A case for the prosecution

First of all if you're going to have a trial, you have to charge somebody, and the tribunals are not charging anyone with sexual violence. There are a few indictments, but by and large they're not charging. Part of the reason for that, I am told, is that it's easier to prove genocide. It's easier to prove genocide simply by pointing to the murders of — usually — men. The way that the war in former Yugoslavia was conducted was that, for instance, a village would be targeted — 40 men would be taken from the village, put on a bus, taken to a mass grave and shot through the head. Forty women would be taken, put on a bus, taken to a school or somewhere similar, and raped systematically over a period of weeks or months. But you don't need to charge the rape, because you've got the murders and you can prove the genocide that way. So once again there is silence over what happened to the women.

Secondly, to charge rape, you have to have a witness, and witnesses have to testify. For a witness to testify, she has to be protected, and not just at The Hague when she goes to the Tribunal, but before and after. It's no good dumping women back in the centres for displaced persons — and saying, 'Thanks very much for giving your evidence, thanks very much for talking to one of our investigators, sit there and wait, and while you wait, the man you accused, who probably lives up the road in Republika Srpska, will know that you have given evidence, will know that you have talked to the investigators, and you and your family — what's left of it — will not be protected. But please just sit and wait.'

Thirdly, to be a witness, the woman has to believe that what she's been through is not her fault. Now, you'd think, wouldn't you, that where women have been raped in war, no-one would believe it was their fault. But even in that context, a woman can believe that she was somehow different from the women who managed to escape rape, and that somehow it was her fault. In this way, women find themselves stigmatized and further silenced.

Fourthly, the women have to be supported. When I talk about support for rape victims and for witnesses, I'm not talking about sitting around on beanbags and making cups of tea. What I'm talking about is adequate provision for people whose rights the international community claim should be protected. When a woman has been raped, her fundamental human rights have been breached irrevocably, and we - the international community - have a responsibility to take care of her and all such victims.

A particular crime

Some have questioned whether rape is a particular crime, or whether rape victims are a particular group of victims. Rape is a particular crime because of its

relationship with heterosexuality. It's a particular crime because of what it does to women, what it does to its victims — what men do to their victims when they rape. It's not the women who are the particular victims, it's the crime itself, and that's what we have to recognize. Because of feminist activists and feminist lawyers, there are provisions in the ad hoc tribunals that are useful for protecting victims of sexual violence — provisions that could and should be brought into domestic jurisdictions. For instance, it is not possible for a man accused of rape as a war crime to cross-examine the victim about her previous sexual history. This practice is outlawed. Now if this is possible with a man accused of mass rape, or even raping just one woman, in a tribunal at The Hague, then why can't it happen at the Old Bailey? Why can't it happen at the Crown Court in Doncaster?

As a lawyer, I would maintain that previous sexual history is *never* relevant. I work as a defence barrister and I refuse to take rape cases, despite the risk of being disbarred. I refuse to stand up there with my advocacy skills, and say to a woman, 'You had sex in the back of a car once, didn't you?' How can I do that? How can I stand there in my wig and gown and criticize a woman for being a woman? Because that is what allowing sexual history evidence really means. I absolutely refuse to do it.

The 'consent defence' in war crime

In the ad hoc tribunals, consent can only be an issue where the defence raises it. They have to show that it's relevant to that trial. Some would say that if you're talking about anonymous rape or a perpetrator who has ordered the rape of many women, then of course consent can't be an issue. In fact, many of the women who were raped during the war in the former Yugoslavia, were raped largely by men who knew them very well — by school friends, neighbours or men who lived in the next village, so one could imagine these men arguing that: 'I'd known her since we were schoolmates and, despite me being a Serb and she being a Muslim, and despite the fact that our country — now our countries — were at war, in fact she's always fancied me, and this was just an opportunity'. But at the ad hoc tribunals, if a man wants to raise consent as an issue, he has to show why, and the burden is upon him to establish that consent really is a relevant issue. Again, if it can be done there, then why can't it be done here?

It is necessary for victims to operate within a 'culture' of belief. For example, last August I visited the UNHCR in Zagreb where I spoke informally to a women refugee protection officer about a woman I had met from 'K' who told me that she and all the women from the village had been taken to the local primary school and

had been subjected to sexual assault over a long period of time. The protection officer said, 'Oh yes, 'K', but it happened such a lot that they're all now saying it happened, and you can't believe *them*'. Now, if you can't believe *them*, who can you believe? Without a culture of belief, women will not come forward and testify. I would not take myself from a village where I was trying to repair my life and my home and find out what had happened to my relatives and put myself in a place where people were going to sneer at me and say 'Raped? Pah! You're making it up.' I wouldn't do it and I wouldn't ask anyone else to do it.

Bringing rapists to justice

Finally, even if you have all these things: you've got a charge; you've got an indictment; you've got a witness who's prepared to testify; she's protected; she's supported; she's believed — you then need a defendant. The prisons at The Hague are going to be empty by the end of December. Not because there's a shortage of war criminals, or of *indicted* war criminals. Not because the streets and the walls of Bosnia are not almost papered with wanted posters — made by women's groups, not the United Nations — which list and describe and give photographs of wanted war criminals. There's no shortage of men waiting to be arrested; there's also no shortage of French soldiers for instance, standing beside them, watching them have a cigarette; there's no shortage of British and Welsh soldiers watching those men having cups of coffee in coffee bars: the big four - as they're known - are occupying positions of power and influence throughout the former Yugoslavia. Our elected representatives and others negotiate with them or their representatives on issues of national and international security. Well, the women say 'Why should I bare my soul, put myself in danger, isolate myself from my community, risk being accused of lying and of fantasizing, when the states who are responsible, and who have the power, do not implement the very law that I am expected to employ? Why should I?'

One of my plans before I went to Bosnia was to learn enough Bosnian to walk up to Radovan Karadžić [the leader of the Serbs in Bosnia] and say: 'Are you Radovan Karadžić? Pleased to meet you. I've got a warrant for your arrest.' I talked to my friends about it and they said: 'We'll come to the funeral'. But there are plenty of men – soldiers - in the former Yugoslavia, who we pay for, who could do exactly that. But they won't. They won't because people say: 'We don't want to risk our boys.' But we were prepared to risk our boys to go and fight in the Gulf; we were prepared to risk our boys in the Falklands, over territory and oil; but we're not prepared to risk our boys for the lives of women. Once again, women's lives, women's futures are

being sacrificed to some nebulous idea of political stability. As women, we know that while the threat and the reality of sexual violence against us hangs over us and permeates our everyday lives, we do not have political, or any other, stability.

Despite all this, I welcome the fact that sexual violence *has* become an issue for the war crimes tribunals. It's because of us and because of our feminism and our activism and our bloody hard work. Never give up. Refuse to be silenced. And keep up our demands for justice and fair treatment for women.

culture

25. 12 Steps to Heaven (1989)
Cath Jackson

- Is having 'somebody to love' the most important thing in your life?
- Do you constantly believe that with 'the right man' you would no longer feel depressed or lonely?
- Are you bored with 'nice guys' who are open, honest and dependable?

Then, lady, you are *sick* and do I have the cure for you.

Robin Norwood's *Women Who Love Too Much* is the latest — oh, if only it was the last — self-help text to cross the Atlantic, sweep to the top of the bestseller lists and spawn a nationwide cult of women's health groups working around its suggested 'program of recovery'. Norwood's thesis is that women can be addicted to men in the same way as we can be addicted to drugs, alcohol, high carbohydrate foods. Women who repeatedly find themselves involved in destructive relationships with 'unhealthy, unloving partners' are suffering from 'loving too much'.

WWL2M, first published in the UK in 1986, and its sequel *Letters from Women Who Love Too Much*, have spawned WWL2M groups all over the country. A recent survey of Well Woman Centres reveals that WWL2M self-help groups are among the top three most popular, together with sexual abuse and compulsive eating. *WWL2M* has upstaged not only classics like *Fat is a Feminist Issue* but all the other 'I've been there too' and 'female-friendly' how-to books covering women's sexual and emotional well-being, from incest survival to the joys of heterosex. By the devastatingly simple tactic of including everything from compulsive eating to apparent frigidity as sub-clauses to its own thesis, *WWL2M* has made itself a seemingly impossible act to follow — although this may be wishful thinking on my part.

'Loving too much' is, says Norwood, the inability of women to detach themselves from destructive, physically and/or emotionally violent relationships with men. Typical of the whole genre of self-help books, Norwood is careful to point out that she herself, although currently working as a therapist, is not writing as an objective expert; she is 'a woman who loved too much most of my life'; she not only understands; she has been there too. Again in common with others of the genre, *WWL2M* is written as a series of case histories interspersed with analysis and solution, building up to the 'Road to Recovery' in the final chapter.

The case histories are pathetically repetitive: Jill, 'pert and petite, with blond Orphan Annie curls', who can never keep her man; Trudi, who drove her car over a cliff because her married lover chucked in their relationship; Lisa, artist and 'beauty', who married a Mexican transvestite to get away from home and then got involved with a drug-addict who slashed all her paintings; Brenda, the bulimic model, whose alcoholic husband Rudy sleeps around with other women.

These women, says Norwood, have all grown up in a 'dysfunctional home in which (their) emotional needs were not met', and this, she believes, is the root of their problem. It is an analysis which now also dominates establishment explanations of child sexual abuse: the family is 'dysfunctional', not the abuser.

Her definition of 'dysfunctional' is pretty encyclopaedic, including alcohol or substance abuse, compulsive behaviour (obsessive eating, working, cleaning, dieting...), 'inappropriate sexual behaviour', constant arguing and tension and more. Another major factor is that villain of the piece, the absent, emotionally distant father and his sidekick, the clinging, demanding, over-emotional mother. The child from such a home only feels 'comfortable' in an adult relationship which reproduces the 'dysfunctional' pattern of her family, with its emotional highs and lows, intensity, violence and threat of rejection. It also makes her desperate to win affection and approval, to patch up the cracks, to compensate for her own unmet emotional needs by 'becoming care-giver, especially to men who appear in some way needy'. She constantly makes excuses for the behaviour of her man and puts up with psychological and physical violence and abuse because this, says Norwood, is the only way she knows how to relate intimately.

So how do we know when we are 'loving too much'? When being in love means being in pain we are loving too much. When most of our conversations with intimate friends are about him, his problems, his thoughts, his feelings — and nearly all our sentences begin with 'he...', we are loving too much. When we excuse his moodiness, bad temper, indifference or put-downs as problems due to an unhappy childhood and we try to become his therapist, we are loving too much. When our relationship jeopardises our emotional well-being and perhaps even our physical health and safety, we are definitely loving too much.

Recovery is achieved through individual therapy combined with the so-called 'twelve step program' of the Anonymous groups — Alcoholics Anonymous, Narcotics Anonymous, and other such 'survivor' groups. Recovery is the ability to sustain a relationship with a 'steady, dependable, cheerful, stable' man — 'nice... even if... a little boring'. Recovery is also the ability to transcend the initial 'chaotic emotional experience' of first love and go on to the 'ever-deeper exploration of what D H Lawrence calls

"the joyful mysteries" between a man and a woman who are committed to each other' — a combination of Agape ('feelings of serenity, security, devotion, understanding, companionship, mutual support, and comfort') with Eros (passion).

Only the utterly blinkered heterophile would deny that women all too often find themselves trapped in an unhappy relationship with a man, ranging from the demanding and unfulfilling to the outright violent and abusive. Nor is there anything controversial about Norwood's analysis of the 'game' where each partner adopts a particular role and both become locked in a repetitive pattern. Relationship counselling commonly includes the simple ways to defuse these circular 'games' which Norwood herself suggests: to this extent *WWL2M* is a practical and useful manual to tuck under the marital pillow and does no doubt offer great comfort to women locked in the stranglehold of a stale and embittered relationship.

The problems with Norwood's thesis come when she goes on to elaborate her theory of 'loving too much'. For, says Norwood, women involved in a destructive relationship are in the grip, not just of an unhappy partnership, but of an addiction to 'dysfunctional' relationships with men of such intensity it warrants the classification of a disease.

> I am thoroughly convinced that what afflicts women who love too much is not *like* a disease process; it *is* a disease process, requiring a specific diagnosis and a specific treatment. (*WWL2M* p. 187)

More than that, it can be a fatal disease: 'Whatever the apparent cause of death... loving too much can kill you' (*WWL2M* p. 195).

And beyond that still, 'loving too much' is an inherited, physiological disorder that is passed from addicted mother to addict daughter, like some faulty gene:

> Lisa in relation to Gary, like her mother in relation to alcohol, suffered from a disease process, a destructive compulsion over which she had no control by herself. Just as her mother had developed an addiction to alcohol and was unable to stop drinking on her own, so Lisa had developed what was also an addictive relationship with Gary.

In combination the 'dysfunctional' family background and the predisposition to addiction make for disastrous consequences:

> Many women like Margo, because of their emotional histories of living with constant and/or severe episodes of stress in childhood (and also because they

may have inherited a biochemical vulnerability to depression from an alcoholic or otherwise biochemically inefficient parent), are basically depressives... Such women may unconsciously seek the powerful stimulation of a difficult and dramatic relationship in order to stir their glands to release adrenaline... (*WWL2M* p.183)

So we start with the outlines of the fairly typical 'how to be a happy heterosexual' text and end with a fully fledged pathology, underpinned by plausible, sub-Freudian psychobabble. Norwood's breadth of examples makes it easy for her reader to identify with enough 'symptoms' to be convinced. It amounts to a self-fulfilling prophecy.

Susie Orbach's *Fat is a Feminist Issue* (FIFI) was, if not the first, certainly the most influential of this breed of self-help therapy texts. Whatever its failings, FIFI has the undisputed merit of genuinely applied feminist principles. Orbach took the radical step of 'naming', identifying as a disorder, what was widely assumed to be a symptom of female inadequacy. Women who were overweight, who ate quantities of food beyond their physiological requirement, were not 'greedy'; food obsession was a rational response to women's gender-specific social circumstances: to the pressure to conform to male definitions of acceptability and normality; to women's powerlessness. Food obsession was, Orbach proposed, clearly linked to the self-hatred engendered when, denied the power to change the situation, women are left with only themselves to punish and blame.

Orbach used explanation to achieve understanding and, by explaining, provided the basis for recovery. More than that, she placed recovery in the hands of women themselves, outside conventional psychiatric and therapeutic medicine. An important part of that was that Orbach claimed herself to have been a compulsive eater; thus she was not an objective expert pronouncing on other women's failings, but a co-sufferer and a proven 'survivor'.

Norwood appears to start from the same spot, that of 'naming' and 'sharing' as a recognisable condition what is commonly perceived — by men and women alike — as female inadequacy. But gradually, as the book unfolds, what began as a description of all-too-common patterns of heterosexual relationships mirroring the inequalities of power between men and women, becomes a description of a specific, medical condition. With mesmerising simplicity she reduces a complex and universal situation to a single-issue, individual problem that will respond only to a specific prescription, the 'twelve steps' to recovery:

...I have never seen a woman who took these steps fail to recover, and I have never seen a woman recover who failed to take these steps. If that sounds like a guarantee, it is. Women who follow these steps will get well. (*WWL2M* p.198)

And thousands upon thousands of women read her books and say, 'Yes, that's me'.

Dear Ms. Norwood,
I just purchased a copy of *WWL2M* and I have had to stop reading it at work because my cries of 'Oh, my God!' are disturbing my boss. (*Letters from WWL2M* p.51)

Dear Ms. Norwood,
I fit the prototype in your book quite exactly, and if I had known you, I would have been quite upset that you wrote about me and spread my intimate thoughts and feelings on the pages of your book for the world to see.

So what's the problem? Many of us are only too familiar with the desire to develop some concrete physical ailment on which to pin the mental and emotional misery we feel. Thus, perhaps, the enthusiasm with which we take on board as a medical 'condition' pre-menstrual tension; thus the enthusiasm with which women accept the premise that the menopause is a deficiency, a disease in fact, for which hormone replacement therapy is a 'cure'. But what does this approach mean in terms of heterosexual relationships?

When Erin Pizzey put forward her theory that women in violent heterosexual relationships were biologically addicted to violence itself, there was a widespread outcry and condemnation from feminists. Pizzey's theory was that women who stayed with, returned to or repeatedly got involved with violent men were hooked on the high they got from the rush of adrenaline when the fists began to fly. Feminists pointed out that such theorising was simply reclothing the old argument that women 'ask for it' in pseudo-medical jargon. It was, they said, letting men off the hook yet again. It was also paying court to the convenient convention that women are 'martyrs' to their biology; that women cannot help themselves when it comes to the dictates of their glands.

Beyond that, it was a recipe for passivity. What would be the point of walking out of a violent relationship if you were doomed by your hormones either to return to it or to repeat the pattern? What was the point of looking for other reasons for violent

relationships, such as inequality of power, male violence, male ownership of women and children, women's limited freedom of choice, if the cause was biological?

Yet here we have Norwood putting forward a theory that is different only in the words she uses. The approach differs from common prejudice only in suggesting that women actively seek and stay in violent relationships not because we like it but because we are too sick to leave. Yet, for this 'genetic disorder', she offers only a social cure — behavioural therapy. The contradiction takes your breath away with its enormity: it also utterly destroys her argument.

Nowhere does Norwood seriously question the nature of heterosexual relationships themselves. Indeed in *Letters from Women Who Love Too Much*, she takes pains to distance herself from any implication that 'loving too much' is a strictly heterosexual syndrome. With disarming innocence she writes: 'I seem to have inadvertently implied that I thought all relationship addicts were heterosexual. I know better than that'. The truth of the matter is that, herself a heterosexual, 'that was (and is) the variety of relationship addiction I know and understand best'. Too late she realises the awful implications of her narrow focus: that what she describes is intrinsic to the heterosexual nature of the relationships she analyses.

Norwood works entirely with the assumption that the sexes are in all ways equal protagonists. She writes about choice:

> Most of us who love too much are caught up in blaming others for the unhappiness in our lives. while denying our own faults and our own choices. This is a cancerous approach to life that must be rooted out and eliminated... When you let go of blaming others and take responsibility for your own choices, you become free to embrace all kinds of options that were not available to you when you saw yourself as a victim of others... (WWL2M p.224)

What about the dependency created by lack of money, the presence of children, the physical and social vulnerability of women without men? These factors are, it seems, just avoidance tactics, 'contingencies' that women use as an 'excuse' not to 'recover'. The very potent emotional and practical factors which govern women's freedom to stay in a damaging relationship are dismissed as symptoms of the addiction itself. Pathologising the situation allows Norwood to skip lightly over the very ordinary fact that, having invested their financial and emotional security in a relationship, women are understandably reluctant to abandon it for the terrors of the unknown and understandably keen to believe him when he promises to change.

Norwood's Alcoholics Anonymous-based programme of recovery fits perfectly with this concept of the guilty victim. 'Anonymous' programmes are heavy with pseudo-Christian overtones. The process of recovery follows the identical path to Christian redemption: transgression, confession, avowal to no longer 'sin', redemption/recovery. Like Christianity, they are confused about predestination and free will. On the one hand, they work on the assumption that an addiction has a physiological root cause — inherited 'allergy-addiction'. On the other they demand that the individual admit personal blame for their failure to resist the addiction. An addict is predisposed to addiction, just as man is born to sin: recovery is begun by an admission of guilt and responsibility just as salvation can only follow an admission of sin. In both cases redemption can only follow a 'surrender' of will to a 'Higher Power'.

If there was any doubt that Norwood holds women individually responsible for their mental and physical abuse at the hands of their partners, her 'RA' (Relationships Anonymous) programme makes her position all too clear. Women should, she says, learn to 'surrender' any attempts they are making to exert control over their lives ('control' in the hands of women is a very dirty word in the Norwood book), or over the lives of their partners or children; 'accept' their partners' unacceptable behaviour; become 'selfish' — that is, put themselves and their own needs first; learn to love themselves; overcome their fear of rejection and, finally, re-engage in 'the sexual realm' in a new way which 'requires not only that we be naked and vulnerable physically, but that we be emotionally and spiritually naked and vulnerable as well'.

When the going gets tough Norwood has a selection of 'affirmations' to take the pain away.

> Twice daily, for three minutes each time, maintain eye contact with yourself in a mirror as you say out loud...
>> I am free of pain, anger and fear...
>> I enjoy perfect peace and well-being...
>> All problems and struggles now fade away; I am serene...
>> I am free and filled with light...

and more, sung to the tune of *ad nauseam*.

It is yet more of the deception — and self-deception — applied to women over the centuries to lull, daze, numb them into an acceptance of the status quo. Often it is only when the lulling and numbing, the distracting fails, that the violence really begins. Indeed it is significant that books like *WWL2M* only really took off when feminists

Put all the 'Can'ts' in one
heap and make
CAN. for one.
Stop saying
'If only' for
an hour......

Angela Martin©

began to actively and vociferously question the inevitability of heterosexuality, when women began, in large and organised numbers, to fight back.

Norwood's whole approach appears to rest on masking the harsh reality of the here and now by advocating a new addiction in its own right. Reading the *Letters* it becomes painfully obvious that many of Norwood's readers need help in overcoming their addiction to self-help itself.

> Ms Norwood,
> I've just finished reading your book. I thought after the first few pages I would never pick up that book again. I cried because I found out that I had yet another disease. I'm already a recovering addict and alcoholic. I've been in Narcotics Anonymous and Alcoholics Anonymous for over a year... I've been in therapy for a year and a half and I've also been in two rehabs. I'm an adult child of an alcoholic and I probably qualify for Overeaters Anonymous.

Norwood is simply offering women yet another distraction, another fake solution; yet another addiction with which to mask the anguish of women who have — for want of a more subtle description — been fucked over by men.

That women are buying *WWL2M* and following its programme in such numbers is a sign, not of its worth but of the extent of women's need to find an answer to the question: 'How can we stop men doing all this to us?'. It is also vivid proof of how unhappy the majority of women are with their heterosexual relationships. What Norwood describes as an extreme has been seized on by so many women that it is almost impossible not to conclude that what she calls 'loving too much' is, in fact, to her readers the norm.

Comparison with a parallel book written for men makes this analysis even clearer. *The Casanova Complex* is for men what *WWL2M* is for women. According to the author, Peter Trachtenburg (himself a 'recovered' Casanova), some men are addicted to multiple relationships, constant 'womanising', one night stands and chronic infidelity. The reasons for this 'polygyny' are, says Trachtenburg, again the 'dysfunctional' family upbringing: the absent father, the over-dominant mother.

> To be a Casanova is to conquer and manipulate women, to *act* on them. What a relief to those who in childhood felt colonized and invaded by omnipotent mothers and still fear being subjugated as adults! Every time these men seduce women, they turn them into drugs — inanimate objects that can be ingested and then disposed of.

Here, yet again, an extreme expression of the power imbalance in male-female relationships is pathologised and excused away. The irony is that, intentionally or otherwise, Trachtenburg is using the vocabulary of radical feminist condemnation of the institution of heterosexuality itself.

And what, according to Trachtenburg, are the motivations for men to abandon this way of life? They may, says Trachtenburg, lose their jobs, lose their friends, run the risk of catching AIDS or, worse still, discover

> they are too old to attract new partners and find themselves alone, without the comforting supports of age, and afflicted with desires that they no longer have the means or health to satisfy (*Casanova Complex* p.270)

It's like capitalist industrialists suddenly going green: not because they have any genuine respect for or belief in the philosophy of conservation or regeneration but because they have suddenly woken up to the harsh fact that they are running out of the very resources on which their continuing viability depends.

The Casanova Complex is the mirror image of WWL2M. Together they attempt to conceal behind pathology the inescapable fact that heterosexual relationships in the context of socially endorsed sexual inequality are 'dysfunctional' by definition.

References

Norwood, Robin (1986), *Women Who Love Too Much,* London: Arrow.
Norwood, Robin (1988), *Letters From Women Who Love Too Much,* London: Arrow.
Trachtenburg, Peter (1988), *The Casanova Complex*, New York: Poseidon.

26. Men of Tin (1991)

Sigrid Rausing

I n Iron John: A Book about Men, the poet Robert Bly tells us that

When a father now sits down at the table, he seems weak and insignificant, and we all sense that fathers no longer fill as large a space in the room as nineteenth-century fathers did. Some welcome this, but without understanding all its implications. These events have worked to hedge the father around with his own paltriness. D. H. Lawrence said: 'Men have been depressed now for many years in their male and resplendent selves, depressed into dejection and almost abjection. Is that not evil?' (p. 98)

If you are a man, and if you agree with Bly that men have become weak, insignificant, paltry, depressed into dejection and (almost) abjection, you are probably a masculinist. This phenomenon is the latest manifestation of American identity politics. After two decades of the most recent feminist wave, men are writing books about their oppression—not about having to repress their more tender feelings, but about how men are forced to repress their 'natural' masculinity: about men's emasculation. Writers use the language of essentialist feminism to express this oppression: they like talking about the mystical differences between men and women. They don't, of course, have to rely on nebulous matriarchies in the distant past: the not-so-distant past, as they like to point out, was a state of glorious and healthy patriarchy.

Robert Bly's authority on this subject derives from his workshops for men, where a lot of drumming, brandishing of swords and mock-fighting goes on to promote male affirmation, and where the existential pain of American men became apparent to him. A year ago in the US he published Iron John: this immensely popular book (it spent 40 weeks on the New York Times bestseller list) has since become one of the fundamental texts of the masculinist movement. It was published in Britain in September 1991.

Bly's argument is that men in industrialized societies have become emasculated: they are no longer 'real men'. He uses one of the fairytales collected by the Grimm brothers, 'Iron John', to indicate stage by stage precisely what is wrong with American men and, by extension, American mothers who have let them grow up

that way. The hero of the story is a little prince who helps Iron John, a kind of hairy, monstrous giant, to escape from the castle where he is imprisoned. He goes with him into the forest, where various significant events happen; he leaves and becomes a kitchen boy in the castle of another king; he rescues the land from the enemy with the help of Iron John, and is given the king's daughter in marriage as a reward. Iron John is thereby freed from his enchantment and returns to *his* former identity as a king. Bly analyses these stages in some detail from a Jungian-poetic-mythical point of view.

American men, according to Bly, are in a bad way. Industrialisation tore the father away from the home, leaving the son to the mercies of the mother who is then free to 'indoctrinate' the boy to believe that the father, and by extension masculinity, is bad. Without the father's protection, this can lead to a form of 'psychic incest' between mother and son: 'Much sexual energy', Bly reveals, 'can be exchanged when the mother looks the son directly in the eyes and says, "here is your new T-shirt, all washed"'(p. 185). Industrialisation and popular culture have destroyed the 'heart connections' men had with each other, and undermined the respect they deserve from the rest of the community. 'Zeus energy', 'male authority accepted for the sake of the community' is (regrettably) in decline. Bly blames the entertainment industry:

> Many young Hollywood writers, rather than confront their fathers in Kansas, take revenge on the remote father by making all adult men look like fools. They attack the respect for masculine integrity that every father, underneath, wants to pass on to his grandchildren and great-grandchildren. (p. 23)

Eventually, however, 'a man needs to throw off all indoctrination and begin to discover for himself what the father is and what masculinity is'. It takes a long time to reach that stage, but

> Somewhere around 40 or 45 a movement towards the father takes place naturally — a desire to see him more clearly and to draw closer to him. This happens unexplainably, almost as if on a biological timescale. (p. 25)

Jung and D. H. Lawrence provide much of the intellectual basis of the book and its theory of men's loss of manliness. Bly describes Lawrence's analysis of what happened to men's values after the introduction of compulsory education where, significantly, 'the teachers are mostly women':

The children of his generation deduced that their fathers had been doing something wrong all along, that men's physical work is wrong and that those sensitive mothers who prefer white curtains and an elevated life are right and always have been. (p. 20)

The industrial revolution produced soft men, 'sanitised, hairless and shallow'; men who were not only indoctrinated by women but who also in some senses became like women. These men, apparently, are becoming increasingly passive and naive, endangering their masculinity (with its inherent qualities of activity and wisdom). They can't fight back when women attack them because they lack 'natural brutality'.

The 'active man' has been strangled by industrial society. 'During the last 30 years', says Bly, 'men have been asked to follow rather than lead, to live in a non-hierarchical way, to be vulnerable, to adopt consensus decision-making' (p. 61). Bly himself is no admirer of consensus. He tells of a young man in one of his audiences who was disturbed by the important point in the myth of Iron John that a key had to be stolen from under the mother's pillow:

'Robert, I am disturbed by this idea of stealing the key. Stealing isn't right. Couldn't a group of us just go to the mother and say, 'Mom, could I have the key back?'. His model was probably consensus, the way the staff at the health food store settles things. I felt the souls of all the women in the room rise up in the air to kill him. Men like that are as dangerous to women as they are to men. (p. 12)

Myth and instinct

Myths, Bly theorises, are vehicles for instinctual knowledge. Expressing 'nature' rather than 'culture', myths are, so to speak, transcendentally true: a truth to which 'primitive' people have a live and organic connection. 'Modern people', on the other hand, are alienated from these myths; but they can still be helped by them. When a man gets to the point when his biological timetable tells him he needs to throw off his mother's indoctrination, the reading of myths will encourage his budding sense of manhood:

For that task, ancient stories are a good help, because they are free of modern psychological prejudices, because they have endured the scrutiny of generations of women and men, and because they give both the light and dark sides of manhood, the admirable and the dangerous. (p.25)

The mythical/mystical movement to which Bly's theories belong has had a certain amount of bad press by association with Nazi ideology, but it is now being resurrected in the New Age movement. This is also where Bly is coming from. He elevates myths to the level of holy texts, expressing meanings which transcend individual cultures. They are external to history, belonging to the realm of the collective unconscious or, in Bly's vocabulary, the instinctual. This is inevitably reductionist, but perhaps more importantly, it excludes the possibility of making a critical analysis of the texts. The archaic power structures in the myths are seen as part of a natural, pre-given pattern from which we have deviated. Any criticisms in terms of power are easily dismissed as neurotic anxiety: an inability to come to terms with yourself as a 'real woman' or a 'real man'.

This bizarre advocacy of myths as guides to life opens up the question of what myths actually are. In my view, they are simply stories which have gained a certain amount of charisma by having been around for a long time. The reasons for their longevity are complex, and are connected with the development of the 19th century antiquarian movement, in which Jakob and Wilhelm Grimm were the most important figures. To simplify somewhat: the urban bourgeoisie developed a sense of apartness from the rural peasantry, which could then be objectified by being investigated in various ways. The collection of myths by the Grimm brothers was very much part of that process, as was the development of ethnography and the establishment of ethnographic museums towards the end of the 19th century. The origins of the myths became controversial, but it is by no means clear that they are, in fact, particularly ancient. The Freudian psychoanalytic approach regarded fairy-tales and myths as racial dreams externalising unfulfilled wishes and unconscious desires. Jung took this a step further, with the theory of cultural transcendent archetypes which constitute our innate psychological make-up. This, more or less, is the approach that Bly follows, with the added veneer of 'masculinism' — feminism turned upside down.

Oppressed men?

Masculinists, like feminists before them, are trying to find a voice to express their feelings of oppression. There is, however, a difference between *feeling* oppressed and *being* oppressed. Arguably, within the ideology of western individualism, we must all be oppressed to a degree. The development of psychology in conjunction with individualism has led to a situation where, theoretically, there are no limits to oppression, if oppression is defined as any obstruction to individual self-fulfilment. In discourse on power and oppression, therefore, it is important to refer

to objective measurements. Bly confuses oppression with loss of power: men in his view are oppressed by the system of industrialism because that system has dismantled patriarchal modes of being, and inhibited the expression of 'natural' male domination.

Bly has become a kind of high priest of the myth-oriented men's movement, and it's a movement which is spreading fast. In the US the television personality Bill Moyers has done much to popularise it, initially in a six-hour long interview with Joseph Campbell, 'The Power of Myth with Bill Moyers', and later through interviews with Bly and Sam Keen, the author of *Fire in the Belly: on Being a Man*. These shows are some of the most popular Bill Moyers has ever done: according to the *New Republic,* the interview with Joseph Campbell attracted 30 million viewers.

The men's movement, however, also has a more sinister edge. The US National Coalition of Free Men publish a journal called *Transitions*; four months after the Canadian student Marc Lepine shot 14 women students dead in Montreal, screaming, 'You're all a bunch of feminists! I hate feminists!', they published an article stating that Lepine had been misunderstood and that 'in their relentless pursuit of "emancipation", perhaps many women did make life more difficult for him'. About 40,000 American men are believed to be active in organisations like this, which purport to defend 'men's rights'.

As a movement, masculinism is post-New Age, coming from a philosophy of extreme relativism where external realities, and particularly external political realities, are seen as unimportant compared to one's own 'Inner Journey'. The 'inner life' is the arena in which the oppression of men is supposedly played out. Bly's notion of 'psychic incest' is matched by Sam Keen in the second chapter of *Fire in the Belly*, 'It's a WOMAN's world'. Subheadings are: 'Man's Unconscious Bondage to WOMAN', 'WOMAN as GODDESS and Creatrix', 'Woman as Mother and Matrix', 'WOMAN as Erotic-Spiritual Power', 'Saying Good-bye to WOMAN'.

Feminists write about oppression that is particular to women. Masculinists, on the other hand, tend to follow the time-honoured male tradition of confusing men and Man, and writing about human difficulties in western societies as if they were specific to men. Likewise, in an easy reversal of essentialist feminist claims, the masculinists proudly assert that history is, literally, man-made. In Sam Keen's account, women feature merely as part of the nature that men triumphantly conquered:

Without the historical introduction of the notion of a transcendent God who ordered his subjects to name the animals and to have dominion over the

earth, neither individualism nor empirical science and technology would have developed. Life in the garden of the goddess was harmonious but the spirit of history called for man to stand up and take charge. Now, centuries later, after we have been inundated by the tragedy of warfare and sickened by the side effects of irresponsible science and runaway technology, it is easy to forget the triumph of that moment when men rebelled against their fate, threw off their passivity, and declared: Thank you, Mother, but I can do it myself. (p. 96).

Yes, indeed.

The feminist version of the same story, which laments rather than celebrates that moment of triumph, is contemptuously dismissed:

The mythology of ideological feminism (sic) goes something like this: Once upon a gentle time we all dwelt harmoniously within the garden of the goddess. In those days life was organised around feminine values — co-operation, sensitivity, nurturance, sharing. …Then…came the barbarian hordes of horsemen armed with swords sweeping into the peaceful agrarian, matrifocal cultures of India, Old Europe, Asia. They brought with them fierce and vengeful male gods — Zeus, Yahweh and Allah (sic) — a warrior ethic, the habit of holy war, and a masculine mind that was henceforth to divide and conquer everything in its path — empires, women and the atom. And the most disastrous of masculine inventions was technology itself, which gradually allowed men to conquer and destroy nature herself.

'This …theory of history', he sums up, 'renders men responsible for all of the ills of society, and women innocent' (p.198-99).

Masculinism, then, is very much the flipside of essentialist feminism. Its advocates like to point to the 'mysterious' differences between the genders, and the 'natural' leadership of men. Despite the fact that men apparently single-handedly created western civilisation, women mustn't blame them for the less attractive attributes of that civilisation. This is an 'existential and moral fallacy', says Keen, fuelled by 'simplistic sexist moralism'.

There is an element of fundamentalism in all this—a supreme disregard of facts, social and historical, leading to a grossly simplistic explanation of the world and what went wrong with it. For the masculinists it's the psychological rather than the personal which is political; the logic which says that, ultimately, we are all victims. The pop-psychological-spiritual view sees humankind as an endless queue of

individuals, painfully working through their ostensibly quite trivial wounds on the path to feel-good perfection.

It is within that logic—the logic of oppression as self-repression—that men are regarded as oppressed. It is an irony of history that this should be expressed in the vocabulary of essentialist feminism. The two movements could now fuse, in fact are now fusing, in a blissful New Age union, where the men happily learn to be Men again, strong and wise, and the women to be Women, loving and nurturing. I'm sure the men, at least, will love it.

References
Bly, Robert (1990) *Iron John: A Book about Men*, New York: Addison-Wesley.

Keen, Sam (1991), *Fire in the Belly: On Being a Man*, New York: Bantam Books.

27. Bad Apple (1994)

Joan Scanlon and Julia Swindells

Virago, Britain's most publicly successful women's publishing house, was twenty years old last year—an anniversary it marked with a star-studded celebration, and by publishing the Virago *Keepsake*. On the cover of this book, which they were giving away, was a tableau of women in glittering frocks: one held a large surreal apple (intact) — the Virago logo without the teeth marks.

In the year of Virago's 15th anniversary it had been reported that whatever the beleaguered state of feminism, women's publishing houses, then numbering 11 in Britain and Eire, were alive and growing. Last year, the Women's Research and Resources Centre listed 21 women's publishing houses. An article in the *Times Educational Supplement* commented on the rise of feminist publishing against the backdrop of an industry that was generally in dire straits. But amid all the triumphalism and the glittering birthday parties, what exactly are feminists meant to be celebrating?

It is easy to overlook just how politically radical the feminist presses were in their initial project, and how unpopular they promised to be in the world of mainstream publishing. As Ursula Owen, arguably the most radical of Virago's founding directors, put it: 'one forgets how disturbing and unmarketable feminism was in the early 1970s'.[1] Similarly, The Women's Press, celebrating its tenth birthday, recalled the sniggers which greeted its debut. That political radicalism, that capacity to trouble the mainstream publishers and the public, was captured in the term 'virago' ('a bold, impudent or shrewish woman, an amazon or female warrior') and in the controversial logo of The Women's Press, an iron steaming ahead.

There is no doubt that in the early days the literary establishment were needled. When Virago published Dorothy Richardson's *Pilgrimage* in 1989, Anthony Burgess prefaced his unqualified appreciation of the novel with a characteristically vitriolic attack on the publishers:

By no stretch of usage can Virago be made not to signify a shrew, a scold, an ill-tempered woman, unless we go back to the etymology — a man-like maiden (cognate with virile) — and the antique meaning — amazon, female warrior — that is close to it. It is an unlovely and aggressive name, even for a militant

feminist organisation, and it presides awkwardly over the reissue of a great *roman fleuve* which is too important to be associated with chauvinist sows.

But even in 1978, Fay Weldon was saying in the *Times Literary Supplement* that Virago had changed the connotations of the word 'virago', and that it now conjured up the image of 'an industrious and intelligent lady'. Ursula Owen quoted this on Virago's 15th birthday as a testimony to the press's capacity to shift perspectives on women's writing. But it is possible to see it in a less celebratory light. What had been potentially disturbing and provocative — 'an impudent and shrewish woman' — has been accommodated to the idea of 'an industrious and intelligent lady'. What had been undeniably connected to a movement, a group, a group-consciousness of women, is moved to the individual writer, 'industrious and intelligent', and 'a lady' at that.

Marketing and radicalism
Carmen Callil, one of the founders of Virago, told *The Bookseller* in 1986 that

Virago was founded with two main aims. One was ideological, the other a marketing belief. The idea for a feminist house grew out of the feminist movement which was reborn in this country at the end of the '60s. Virago was set up to publish books which were part of that movement, but its marketing aim was quite specific: we aimed to reach a general audience of women and men who had not heard of, or who disliked and even detested, the idea of feminism.

But marketing is itself an ideological process, one whose power we should not underestimate. What happens to feminism as a consequence of being marketed to people who dislike or even detest it? Can we be sure that in that process feminism is not being neutralised, deprived of its ability to issue a challenge or to provoke detestation in some sectors of the community?

This is a far cry from the politics of the press as articulated by Ursula Owen, who left Virago in December 1990. Not only did she insist that the reprint list was an important acknowledgement that feminism existed before 1969, she was also clear that feminist publishing was inextricably linked to the ongoing need for feminism as a political movement:

What I'd like is a world where you don't need women's publishing companies or women's pages, but I don't see it in my lifetime or my daughter's lifetime or

my grandchildren's lifetime. We are playing a small part in what is a very long and difficult process.

The meaning of greatness

In both Virago's publicity material and interviews with its directors, a recurring theme is the need to succeed in the battle for inclusion in school and university curricula—which implies a commitment to the literary values which determine what is worthy of being studied as 'great literature'. In fact, the press has always had that commitment. But nowhere is it apparent what it means by 'great literature'. Is gauging this a matter of editorial intuition and sound literary taste, as the critical establishment would have us believe? Or is 'great literature' also subject to the scrutiny which feminism has focused on other forms of cultural production?

The impression one gets from the collective voice of Virago's directors is that the literary establishment's aesthetic criteria remain the touchstone for editorial judgements, but precedence is sometimes given to other, political criteria. Yet the following remarks made by Ursula Owen suggest a certain unclarity, or defensiveness, on this point:

> We also wanted to show what women have been writing about in novels over a long period, whether they are considered in 'the great tradition' or not. Some of our Virago Modern Classics are great novels: Christina Stead, Willa Cather, and Edith Wharton are great novelists. Some of them are not...

Even as she explains that Virago's interest in women's writing goes beyond 'the great tradition' as taught in British universities, she proceeds, in the same breath, to recycle that tradition's judgements.

Whereas what constitutes 'good writing' seems to be undisputed (and timeless) common ground, what is taken to constitute politically important writing is continually shifting. Another prominent theme in recent statements by Virago's spokeswomen is the idea that the central strand in feminist thinking has shifted away from the socialist feminism which dominated the 1970s towards a preoccupation with race in the present. It seems then that Virago's political judgments are based on different criteria from its literary ones, reflecting in-house perceptions of what is central to feminism at a particular moment, be that historical accounts of suffragists in the mills and factories of northern England, theoretical works on psychoanalysis and postmodernism, or current concerns with the politics of race.

All this may help to explain why Virago has been so strongly identified with its reprint list (though it did not begin as a reprint publisher: the first of its 'Modern Classics', Antonia White's *Frost in May*, did not appear until 1978, five years after the press was launched). At a time when feminism was 'disturbing and unmarketable', the political project of discovering and reprinting neglected works by women meshed seamlessly with a more mainstream commitment to publishing works of 'literary merit'. Even if, like Anthony Burgess, it deplored their appropriation by and for feminism, the literary establishment had to acknowledge Virago's role in publishing works that it could not help but recognise as literature.

Moving into the mainstream

But if the historical project of Virago's Modern Classics managed to satisfy both feminists and the literary establishment, its approach to contemporary women's writing has made its distancing from feminism more apparent. Virago's stress on 'women's lives' and embattled positions had suggested a strong commitment to taking risks with new projects. However, the creation of an identity for the press's original fiction, as distinct from its reprinted titles, was justified by marketing director Lennie Goodings in terms of the need to compete with mainstream publishers: 'we're aiming at the Black Swan, Picador, Faber department. We're saying "trust our editorial judgement"'. Similarly, Virago's non-fiction list has become difficult to distinguish from the women's (or gender) studies lists of mainstream academic publishers like Routledge or Blackwell.

Virago's strategy was, in the words of managing director Harriet Spicer, to be 'specialist and mainstream, and to widen the definition of what is perceived to be mainstream'. They can certainly be said to have succeeded in being mainstream. The question is, though, what do they mean now by 'specialist'? When they speak of 'brand loyalty', whose loyalty do they have in mind?

Virago marked its 15th birthday celebrations with a publication called *Writing Lives*, consisting of recorded conversations between women writers. Its initial manifesto had highlighted a concern with 'women's lives': the move from 'women's lives' to 'writing lives' is indicative of a more general (and disturbingly self-referential) move into writing about writing and about writers. The publicity for *Writing Lives* asks what Maya Angelou, Molly Keane, Rosamond Lehmann, Rebecca West, Eudora Welty, Paule Marshall, Mary Lavin, Rosa Guy and Grace Paley have in common, and answers 'writing lives' — not feminism, not a relationship to the women's movement, not politics, but writing. Those interested in the lives of women writers, in writing, in 'the literary', may have been pleased. But some of us were not.

What's a feminist book?

The presses have, from time to time, been called upon to address the question of what a 'feminist' book is. Carole Spedding, who organised the first Feminist Book Fortnight in 1984, proposed that 'it's a book on any subject written by a woman which is informed by a critical analysis of her position in society as a woman', and this seems a fairly uncontentious place from which to start defining the remit for feminist publishing. We are rightly under pressure to continue producing such definitions, to clarify the purpose of the feminist presses and their role in the struggle for women's liberation. The phrase 'informed by a critical analysis of her position in society as a woman' highlights the need to place the woman writer in her political context.

Back in 1988, Virago had an opportunity to debate these issues publicly, occasioned by 'the case of the upstart vicar and the feminist publishing house', as Ros Coward dubbed it:

> For the literary establishment, the revelation that Rahila Khan's *Down the Road, Worlds Away* was in fact written by the Rev. Toby Forward was a glorious humiliation of political publishing… As far as the popular press was concerned, it was about the punishment of a bunch of intolerant harridans. Even a vicar who supported CND, the Labour Party, and took an active interest in multi-cultural education (usually a prime target to be hounded himself) was to be congratulated for pulling a fast one on the harpies.

Toby came out as a white middle-class vicar three weeks after the book was published, and Virago immediately withdrew it from sale. The simple fact that their policy was 'to publish the stories and thoughts of women who haven't had a voice in literature before', should have been firm enough ground from which to defend this decision. However, Virago was vulnerable on two grounds. First, they had no clear policy of *not* publishing work by men. Prior to publishing the vicar, they had already published (posthumously) H.G. Wells's *Ann Veronica*, George Gissing's *The Odd Women* and George Meredith's *Diana of the Crossways*. Nor has the vicar deterred them from publishing men who are not dead (yet): more recently, Sean French has edited two books on fatherhood, Richard Dalby has edited two books of ghost stories, and John Forrester has co-authored *Freud's Women* with Lisa Appignanesi.

Second, they were too easily drawn into the liberal snakepit of arguments about great art, imaginative experience and 'authentic' writing. They were thus caught in

the trap of having to uphold their literary judgement of the book, consistent with their commitment to publishing quality writing, while at the same time denouncing it in moral terms as a 'cruel hoax'. Traditional judgements of literary merit usually involve a recognition that a writer has succeeded in imaginatively representing experiences different from their own. Because Virago had adopted these aesthetic criteria, they were unable to answer the charge levelled at them by the literary establishment that they were being inconsistent when they disputed the ability or the right of a white male vicar to represent the lives of women in the Asian community.

Ros Coward comments that 'Many of the Asian writers to whom I spoke... felt that in some extremely complex ways the vicar's deception had been effective because of flaws and weaknesses in attitudes prevalent amongst publishers towards writers from ethnic minorities'. Yet Virago's main charge against him seemed to be merely that of 'deception', accompanied by much soul-searching about whether or not they were in part responsible for not detecting the fraud at an earlier stage. Ros Coward devotes some space to the question of whether the writing did contain clues to its author's race and gender. But actually Toby's imposture was a classic example of the ways in which white middle-class men, the guardians of the literary establishment, can exploit others' experiences with impunity. Of course a man who is part of the dominant culture has the political and cultural tools to appropriate the voices of oppressed groups. The case highlighted Virago's failure to preserve a space for 'the real woman' and the particular conditions of powerlessness from which she demands to speak. As women in the Asian community saw, Virago had no means of recognising 'the real thing'.

Virago appears to have gone through the 1980s clinging onto the fallacious belief that radicalism persists independent of context; that the project of representing women's ideas and women's lives remains politicized whatever the surrounding political climate. But writing cannot be separated from its conditions of production and reception. In the 1990s it is necessary for women's presses to reconnect with their political context, and to distinguish what they are doing from everyman's 'women's list'. If they are to remain viable as women's presses, then now more than ever, they need to differentiate their project from that of the mainstream — not in terms of content or quality but in terms of a materialist feminist politics of publishing. Only when they have dealt with the political paradox — women are selling well, but the women's movement has its back to the wall — only then will the women's presses have something to celebrate.

Note

1. Quotations from Virago directors are taken from a range of sources, including interviews, speeches, lectures and reports in the trade press.

References

Coward, Ros (1988), 'Looking for the real thing', *New Statesman*, 1 April.

28. Ignorance is Bliss when you're Just Seventeen

Stevi Jackson (1996)

On 6 February 1996 a bill was introduced into the House of Commons to print minimum age recommendations on the covers of teenage girls' magazines, a move which followed publicly aired concern about their sexually explicit content. A week earlier, BBC2 screened a documentary about five year old beauty queens in the Southern USA. The media were suddenly full of discussion about children and sexuality, or more specifically about girls and sexuality. As usual, public debate missed what feminists might see as the main issues, the perpetuation of compulsory heterosexuality and the construction of female sexuality in terms of objectification and pleasing men. Instead the focus was on the threat posed to childhood.

On the morning of February 6, Radio 4's regular phone-in focused on sex in teenage magazines, framed by the question 'whatever happened to childhood innocence?' 'Innocence' appears to be taken for granted as a defining feature of childhood, so that anything which threatens it is seen as a danger to childhood itself. Hence a recurrent theme in media discussions of both young women's magazines and child beauty queens was the idea of lost or stolen childhood. It is not just asexual innocence which is seen as threatened, but the supposed golden age of freedom from the pressures of adult life. Yet sexuality is nonetheless thought of as central to this age of innocence — as something such young children should know nothing about.

Where have we heard all this before? One arena where the concept of innocence has been deployed in the media is in coverage of child sexual abuse. Jenny Kitzinger argues that feminists should be critical of the way this concept is used to evoke public revulsion against sexual abuse. She points out that 'innocence' itself is eroticised as a sexual commodity and that the ideal of innocence is used to stigmatise the sexually knowing child, to make her a potentially legitimate victim. Moreover, in the name of protecting 'innocence', adults deprive children of access to sexual information which might help them avoid sexual abuse and exploitation.

In all this discussion of children and sex, it is rarely made explicit that gender is an issue: yet in both the case of the beauty pageants and the magazines the children

who are the objects of concern are *girls*. This makes a difference, since discourses on both childhood and sexuality which underpin these discussions are profoundly gendered. This neglect of gender has meant that the emphasis is on what is deemed extraordinary, the challenge to idealised models of childhood, rather than on what is depressingly and predictably ordinary — the cultural construction of sexualised femininity.

Like most women I know who watched the BBC documentary on child beauty queens, I was both fascinated and appalled. Part of what appalled me was what was being done to these children. The issue for me, though, was not that the discipline and sexualisation enforced on them was robbing of them of their childhoods — rather it seemed an extreme manifestation of the ways in which children in general and girls in particular are treated. Children are defined as dependants subject to parental authority and, within limits, parents have the power to rear them as they choose. Childhood is also remarkable for the degree of control exercised over the body by others. Children's appearance, deportment, posture and movement are regulated; they are touched, kissed and fussed over and more likely to be subject to physical punishment than any other category of person. This control of the body is more rigorously imposed on little girls, one facet of the intersection of gender with the more general powerlessness of children. The five year old beauty queens are young enough and small enough to be physically coerced. They are inexperienced enough not to know that any other mode of life is possible. Like all children, they are constrained to live their lives according to their parents' choices — they are forced to go along with what parents think best for them, whatever it is.

A degree of 'femininity' is being imposed on these children which might well seem excessive even by non-feminist standards. They are being taught very deliberately, rigorously and systematically that the only thing about them of value is their prettiness and their ability to carry off a carefully managed performance of stereotypical femininity. This merges with the reduction of children to objects owned by their parents. With little girls this has often lead to them being treated as dolls to be dressed up and displayed. One doting mother said of her daughter that, when dressed up and made up in her stage costume, she 'looks just like Barbie'.

The sexualisation of childhood is not new. Little girls have long been taught to cultivate prettiness and coquettishness, to get what they want by sexualising themselves. Beauty pageants can be seen as just a logical extension of this. For generations little girls have aspired to be 'May queens' or local carnival queens. The beauty contest is just a more commercialised and professionalised version. Even this is not a recent invention: beautiful baby contests are something I remember from my

childhood. I also recall that Pears soap sponsored a 'Miss Pears' competition, the winner of which then featured in advertisements. Judith Ennew suggests that such representations have distinct parallels with pornography. One example is a painting by Munier called 'Playmates', used by Pears Soap advertisements in 1903 (pre-dating Miss Pears) which features a scantily clad child in a distinctly sexual pose. She also places the famous photograph of Marilyn Monroe with her skirts blowing up around her next to a Oxo advertisement featuring a similar depiction of a small girl, suggesting that both represent the same fantasy (see pp 132-3). 'Sexuality' is further indicated by gestures, movements, a particular turn of the head, a knowing look or wink — all of which the competitors in the beauty pageants were being explicitly taught.

Being encouraged to sexualise themselves as objects without understanding the implications is a dangerous game for girls. Paradoxically the same parents who encourage their daughters to behave like this would, I'm sure, think it terrible for them to know about the realities of sex. It is this anxiety which underlies recent concern about teenage magazines. On the one hand these publications encourage aspects of femininity which are socially approved — interest in fashion, make-up and being attractive — while in another they appear to pose the threat of a more knowing and active female sexuality. It is the issue of sexual knowledge and how much of it should be available to young women which is the central issue at stake in the attempt to regulate teenage girls' reading.

Sex and the teenage girl

The Periodical (Protection of Children) Bill is a private member's bill introduced under the ten minute rule and, as such, is unlikely to become law. Even if there were a law requiring the printing of minimum reading ages on the covers of magazines, I cannot seeing this stopping young women from wanting to read them. The most popular magazine among boys aged 11-14 — *Viz* — does carry on its cover the message 'not for sale to children', but over a quarter of boys in this age group read it. I find this far more worrying than the magazines girls are reading, but boys' reading habits have not come under public scrutiny — a point I will return to later.

We might want to consider why a magazine called *Just Seventeen* is the most popular purchase among 11 to 14 year olds in the first place, or why *19* is read by girls in their mid-teens. Part of the appeal of these magazines is that they speak to those who are still classed as children, still lacking the rights of adulthood but who aspire to the maturity and status that young womanhood seems to offer them. More sensible commentators have pointed out that teenage interest in sexuality is nothing new. I entered my teens in the early 1960s when teenage magazines had lots of

romance and no explicit sexual content. In the stories a kiss was the culmination of every romantic encounter. I and my peers were desperate to know more but starved of likely sources. At the age of 11 or 12 we were reduced to reading out 'the dirty bits' from James Bond novels (it was that bad!). I recall great excitement when someone got hold of a copy of *Lady Chatterley's Lover*. At fourteen, continuing this communal reading practice, three friends and I were nearly expelled from school having been caught with *The Perfumed Garden*.

At least the magazines girls are reading today circulate in a public domain, where their content can be discussed and perhaps challenged, rather than furtively exchanged and whispered over in classrooms and playgrounds. Moreover, we cannot assume a direct link between the magazine's representations of sexuality and young women's sexual activities. The tendency to treat women as 'cultural dupes' brainwashed by whatever they are reading or seeing on television has been much criticised by feminist cultural theorists. Teenage girls are being depicted as cultural dupes by those seeking to restrict their access to magazines. The assumption is that, as children, they are peculiarly vulnerable to brainwashing, they do not know their own minds and therefore they are in danger of being corrupted. We need to credit young women with some ability to think for themselves.

On the other hand, the new emphasis on women and girls as active readers can go too far in denying that particular texts have any effectivity at all. What young people read about sexuality will not *make* them act in particular ways, but it is likely to inform the meanings they construct around their own sexuality. This is not grounds for barring them from reading about sex, but is grounds for being concerned about what sort of sex they are reading about.

The debate around the bill is framed in terms of whether access to explicit sexual information is a good or a bad thing — rarely is the quality of information discussed, other than in moral terms, and what counts as 'sex' is almost never questioned. The increased sexualisation of the magazines' content is seen in isolation, rather than as an aspect of the increased sexualisation of femininity in general. Changes in teenage girls' magazines parallel those in adult women's magazines and, in many respects, the boundaries between the two are blurring. There is now far more explicit sexual content in women's magazines in general and far less desexualised romance. Heterosexual love is itself becoming more sexualised, a trend discernible in Western culture as a whole since the early 20th century and visible in girls' magazines since the 1950s.

One feminist interpretation of this trend is that it is indicative of the increased eroticisation of women's subordination. Other feminists take a more optimistic view.

Angela McRobbie, for example, sees signs of progress in the newer magazines, a postmodern celebration of plurality. She argues that they represent a potential for less uniform, monolithic modes of femininity, for a more knowing and assertive female sexuality, for the exploration of alternatives to heterosexuality. In some ways the new magazines are an advance on earlier ones, but in many other ways I find it difficult to share McRobbie's optimism.

While writing this article I bought a selection of magazines over a period of about three weeks and asked friends and colleagues with teenage daughters what they read. The most popular ones are either music focused — although their real interest seems to be male stars as objects of female lust — or the fashion and relationships variety. It is the latter which have the most explicitly sexual content and it is these I have looked at most closely.

The magazines have certainly changed from those around in the 1960s and 1970s. Although the earlier magazines did include fashion, beauty tips, pin-ups, features on relationships and so on, their stock-in-trade was the comic strip romance. This has disappeared and the magazines now look much more like adult women's magazines of the *Cosmopolitan* variety. Even magazines for pre-teens now have a more grown-up look and share some content with teenage magazines. *Bunty*, for example, which I remember as being a comic book featuring stories about boarding schools, gymkhanas and ballet classes now has a more adult look. It still has some of the old favourites, but these sit alongside articles with lead-ins like: 'Which holiday hunk is the one for you?'

Once past this stage, the next step up is to magazines like *Just Seventeen*, the most popular of this genre among 11-14 year olds — read by 52% of them. There's also the fortnightly *Mizz* and somewhat glossier monthlies such as *Sugar* and *Bliss* (the latter carrying the message 'a girl's gotta have it' under the title). The monthlies may be intended for slightly older girls, but I know of twelve year olds who read them regularly. All, in any case, are aimed at girls still at school.

The barkers on the front of these magazines give an indication of what the fuss is about: 'Sex: should you tell mum or keep schtum'; 'I slept around, but I'm still a virgin'; 'Make him want you bad'; 'He slept with me for a bet'; 'Does sex change your life?'; 'I got pregnant on purpose'; 'Dribble over the sexiest footballer alive' and so on. There are also more serious sexual themes: 'Shock report: why 12 year olds are turning to prostitution'; 'Could I have AIDS: one girl's scary story'.

The sexual message is more explicit still in the magazines for older teenagers such as *19* and *More!*, the latter being (in)famous for its regular 'position of the fortnight' (with line drawings, full instructions and a 1 to 5 difficulty rating). *More!* is the most

adult of these magazines in other senses, in that it addresses its readers as young women with jobs living independently of their parents. The biggest clue to its target audience is that it is alone among these magazines in assuming that the objects of its readers' lust are men rather than boys. It is a tackier, more downmarket version of *Cosmopolitan*, with cheaper clothes in its fashion features and more of a tabloid journalism style. According to Angela McRobbie its 415,000 readers are aged on average between 15 and 17.

Once past the lurid headlines, the contents of these magazines are mixed and often contradictory. Problem page reassurance that all bodies are normal is contradicted by injunctions to improve, disguise or conceal bodily imperfections. Advice on saying no to sex and not rushing into it sits side by side with articles and quizzes which give the impression that the only important thing in life is to attract, keep and please your man. An article in *Bliss* about the joys of being without a boyfriend, which looks at first sight like a positive move, lists among the 'good things about being single' such items as being free to do what you want, to spend time with your mates, but also 'you can eye up any guy you want without feeling guilty'.

It is true that the tone of all this talk of boys, sex and looking good is, as Angela McRobbie says, often ironic and self mocking. Boys are not treated with any great reverence and often they are the butt of jokes. I'm not sure, however, how far this undermines the fairly conventional range of femininities represented in these magazines. Certainly the way readers are addressed implies a more knowing and active sexuality: girls are no longer expected to passively wait until Mr Right makes a move, they are expected to make it happen. Equality seems to be understood within the discourse of these magazines as behaving like men: girls can look at male bodies just as men have traditionally looked at female bodies. At the same time there is an acknowledgement of persistent difference as in '11 things you should NEVER say to boys' (*Sugar*); 'Dazed and confused: just 17 girly things lads will never understand' (*Just Seventeen*).

Moreover, the old idea that girls' sexuality is being attractive and alluring has by no means vanished. The boundaries of what is acceptable in this respect have shifted and behaviour once thought of as that of a 'slag' or 'tart' is now playfully endorsed. Here is the response to those who score highly on a sexiness quiz in *Mizz*:

Grrrrr! You little tiger! You have the secret of sex appeal all right, right down to wearing slinky black numbers to take the dog for a walk, and flirting with your Headmaster to get out of detention. Stop that wiggle when you walk — you'll do yourself an injury!

Yet alongside this are more serious articles about both sexuality and other aspects of life. The same issue of *Mizz* carries articles on teenage prostitution and on a girl coping with her mother's death. The more considered discussions of sexuality in both articles and problem pages are often constructive and informative. The readers of these magazines certainly know far more about coercive sex, sexual exploitation, rape and incest than previous generations and are better informed about avoiding pregnancy and sexually transmitted diseases. Girls also know more about their own bodies and how to derive pleasure from them. This is all to the good. So too, in my view, is the demystification of romantic notions that good sex is something which magically happens once you fall in love. However, this has its downside, in that the idea that sex has to be 'worked at' produces its own anxieties and is itself a form of social regulation.

Magazines read by younger teenagers cannot be accused of promoting early sexual experimentation. Generally the message is not to rush into early sex and to resist being pressured into it either by friends or boyfriends. Some carry regular explicit warnings on their problem pages on the illegality of under age sex: 'Be sure, be safe and remember sex under 16 is illegal' (*Just Seventeen*); 'It's cool to wait, sex under 16 is illegal' (*Bliss*). Some of the advice on sex is helpful and positive, the sorts of things young heterosexual women need to know but may not find out from other sources. Sex, however, is still defined in terms of the penetrative norm — 'having sex' means heterosexual coition — even though there are items on problem pages and elsewhere explaining clitoral orgasms and masturbation.

The magazines are relentlessly heterosexual. This is one of the points on which my reading of these magazines differs markedly from Angela McRobbie's. I did not find evidence of 'gay and lesbian sexualities [being] frequently invoked' or any great sign of a postmodern plurality of sexualities. While there is undoubtedly greater openness about lesbian and gay sexualities, in the magazines I read these issues remain marginalised. I only found four explicit discussions — all, significantly, on problem pages. The line taken is, on the whole, a liberal one which seeks to present a fairly positive view but without challenging the normality of heterosexuality.

The problem pages reveal that some boys, at least, read girls' magazines — assuming, that is, that the letters are genuine. It is now common for magazines to have 'agony uncles' as well as 'agony aunts', both to advise on boys' problems and to offer a male point of view on girls' dilemmas. Given that these magazines assume a community of young, heterosexual and primarily female readers and that they focus on heterosexual relationships, one obvious question is: what are the boys these girls relate to reading?

In all the public discussion of girls' magazines, there has been a silence around what boys are reading. In part this reflects the lack of magazines aimed at a young male market. Since there are still only a few adult 'men's magazines', aside from pornographic ones, it is not surprising that no-one has yet launched a publication aimed at teenage boys — particularly since boys seem to read less than girls. *Viz*, the most popular magazine among young teenage boys, is intended for adult men of a puerile disposition. Its appeal may be that it is a fairly easy progression from *The Beano* (which remains among the top five magazines for boys in the early teens). The other 'top five' publications for this age-group are *The Sun* and two computer game magazines. It would seem that if boys of this age are engaging with issues of sex and relationships at all, it is at the level of page 3 and 'the fat slags' — hardly promising for young heterosexual women in search of either true love or sensational sex. Most research on young people's access to sexual information suggests that pornography is boys' main source of 'knowledge' on sex.

In the early 1970s, while I was researching teenage girls' ideas about sexuality, I worked in a psychiatric unit for teenage boys aged 11-15. The boys all read pornography and the walls of the unit were covered in photographs of naked women — those with fully exposed genitals were strongly favoured. Some of the staff objected, but the psychiatrist in charge saw the consumption of pornography as a sign of 'healthy development' in the boys and a legitimate part of the therapeutic environment. Meanwhile the youth club in which I was conducting my research, which claimed to have liberal attitudes to sex, threw me out because I mentioned orgasms to the girls and let on that it was possible for girls to masturbate. While health and youth workers might no longer endorse such gross double standards, I suspect they have by no means vanished and that interest in pornography is still regarded as part of a normal 'healthy' development for boys, that it is not seen as a problem that this is their main means of learning about sex. Finally, I suspect that these double standards are what underpin the concern about explicit sex in teenage magazines.

Whatever reservations I have about the magazines girls are reading, however much I might object to their relentless endorsement of compulsory heterosexuality, I can't help feeling that girls are better served by these magazines than by those available in the past. The girls I was talking to in the early 1970s all read *Jackie*, thought of sex in terms of 'love' and were woefully ignorant about their own bodies, although many were sexually active. Readers of *Bliss*, *Mizz*, *Sugar* and the like are far better informed about safer sex and their own bodies and are constantly exhorted to assert their own sexual wants and needs — including saying no to sexual practices they don't want.

This knowledge does not, of course, translate easily into more egalitarian sexual relationships. All the evidence we have suggests that whatever girls may know in theory, in practice the power dynamics of heterosexual relationships still work against them. However, ignorance would only make girls more vulnerable. One of the problems girls have in negotiating sex with boys is finding a language in which to discuss sexuality and assert their own sexual desires. At least these magazines begin to provide them with such a language, speak to them in terms which make sense in terms of their everyday experience. The problem is not that girls are exposed to too much sex, or too explicit sex, but the limited, male oriented ways in which sexuality is discussed.

References

Ennew, Judith (1986), *The Sexual Exploitation of Children,* Cambridge: Polity.

Kitzinger, Jenny (1988) 'Defending innocence: ideologies of childhood', *Feminist Review* 28.

McRobbie, Angela (1996) 'More! New sexualities in girls' and womens' magazines', in James Curran et al. (eds.), *Cultural Studies and Communications.* London: Arnold.

29. Housewives' Choice? (2001)

Delilah Campbell

Betty Friedan's *The Feminine Mystique* has one of the most memorable openings in feminist non-fiction:

> The problem lay buried, unspoken, for many years in the minds of American women. It was a strange stirring, a sense of dissatisfaction, a yearning that women suffered in the middle of the twentieth century in the United States. Each suburban wife struggled with it alone. As she made the beds, shopped for groceries, matched slipcover material, ate peanut butter sandwiches with her children, chauffeured Cub Scouts and Brownies, lay beside her husband at night, she was afraid to ask even of herself the silent question: 'is this all?' (p.13).

Writing well before the advent of the Women's Liberation Movement (*The Feminine Mystique* was begun in the late 1950s and first published in 1963), Friedan analysed what she called 'the problem that has no name': the oppressive emptiness of the life led by educated, affluent suburban housewives. The economic dependence, spatial confinement, social isolation and mind-numbing triviality of the housewife's role became one of second-wave feminism's central targets, along with the unfair division of domestic labour that went with it. For middle-class women particularly, escaping from this role was often an important part of the struggle they engaged in when they took on board the feminist slogan, 'the personal is political'.

Women never did manage to shrug off their disproportionate responsibility for housework, but 'doing housework' is not the same as 'being a housewife'. Today, domesticity is no longer seen as women's natural vocation, and few women under the age of about 60 would label themselves 'housewives' (those who do not work outside the home are more likely to call themselves 'full-time mothers'). But if the housewife has been consigned to the dustbin of history, a new and suspiciously similar phenomenon has recently emerged from that vast recycling bin known as postmodern culture. Welcome — or not — to the 'domestic goddess'.

From housewife to goddess: the new domesticity

I take the phrase 'domestic goddess' from the title of Nigella Lawson's book *How to be a Domestic Goddess*. This is slightly unfair, because the title is clearly meant to be

ironic, and the book itself is basically just a collection of cake recipes. Nevertheless, the title works as irony because it alludes to a recognisable phenomenon, which also has some less ironic recent manifestations.

For example, among the surprise publishing successes of the year 2000 were several 'how-to' books about housework — about starching linen, cleaning windows, scrubbing floors, and generally rediscovering the things your grandmother knew about how to keep a well-ordered house. Another unexpected seller was a new edition of the bible of Victorian domesticity, [Mrs] Isabella Beeton's *Household Management*. Meanwhile, British television brought us documentary series on *The 1900 House* and then *The 1940s House*, in each of which a modern family returned to the domestic arrangements of the past — putting washing through a mangle, preparing meals without modern convenience foods or labour-saving equipment. For the women of the families, domesticity was visibly a fulltime job. And what was notable was their enthusiasm for it. The 1940s House's Mrs Hymer was forthright about the exhaustion it produced, but she also extolled the power of traditional domestic arrangements to bring families together around what really mattered.

In upmarket women's magazines, too, the joys of domesticity have been a popular theme of late. According to an article in *Red*, increasing numbers of women are resigning from their high-powered jobs after concluding that they and their families would be happier if they used their time and talents in the home. The women who were interviewed for the piece were, if not radical feminists, then certainly not doormats. They were self-aware, articulate, persuasive about the decisions they had made. True, in the parallel universe of magazine journalism, two of the writer's acquaintances can be presented as a social trend: how many women are really giving up paid work — or seriously wishing they could afford to — is difficult to say. But even if the answer is 'none', it does not seem insignificant that there is apparently so much interest in *reading* about it. This suggests that there may be, to paraphrase Betty Friedan, 'a strange stirring, a sense of dissatisfaction, a yearning that women suffer at the beginning of the 21st century'. But what women are apparently yearning for now is not an alternative to domesticity. It is more like a return to it.

I use the word 'return' advisedly, for even when it is not an explicit recreation of a bygone age, the new domesticity is strikingly old-fashioned. You can see this by comparing it to the domestic regime championed by popular writers during the 1970s and 1980s. Shirley Conran's *Superwoman*, for instance, remembered for its author's bracing remark that 'life's too short to stuff a mushroom', was all

about making domestic activities take *less* time and effort. It was realistic about domesticity being women's work, but it assumed their more important sources of satisfaction lay elsewhere. Today's domestic ideal, by contrast, is almost perversely time-consuming. Not only are there no short-cuts, you are meant to derive pleasure from what is by most contemporary standards an extraordinary excess of effort — ironing the duvet cover, taking rugs outside and beating them, cleaning windows with vinegar rather than a proprietary spray.

Betty Friedan makes exactly the same point about the 1950s, observing of American suburban housewives after World War II that

They baked their own bread, sewed their own and their children's clothes, kept their new washing machines and dryers running all day. They changed the sheets twice a week instead of once, took the rug-hooking class at adult education, and pitied their poor frustrated mothers, who had dreamt of having a career. They gloried in their role as women, and wrote proudly on the census blank: 'occupation: housewife' (p.16).

Contemporary domestic goddesses would not describe themselves, 'proudly' or otherwise, as 'housewives': but their project is very much about making domestic work an *occupation* again, rather than just a collection of tedious low-level chores.

In case anyone thinks I am accusing the women to whom this vision appeals of being brainless fembots, let me confess that I am not untouched by it myself. I was gripped by *The 1940s House*; I have taken to baking cakes when stressed, and have flipped through Nigella Lawson's book in shops to see if I might want to buy it when it comes out in paperback. Worst of all, I quite often fantasise about giving up the rat-race for a spell of fulltime domestic bliss. I imagine myself in a clean and aesthetically pleasing house, cooking wholesome and delicious food, surrounded by other people who I choose to be with and who appreciate my efforts (though I do draw the line at putting a husband into this picture). A few years ago, such a scenario would never have entered my mind. Why am I susceptible to it now? Is the first decade of the 21st century turning into a re-run of the 1950s? And are feminist insights from the mid-20th century worth applying to the conditions of the 21st?

The feminine mystique revisited

The Feminine Mystique is a liberal text, but you could not call it wishy-washy. It contains, for instance, an entire chapter denouncing Freud and his latter-day followers for their ridiculous patriarchal doctrine of 'penis envy', and two more dripping contempt for functionalist social scientists and those who applied their teachings in programmes of domestic education for girls. It also offers a critique of the media which anticipates later feminist scholarship. Friedan herself wrote for women's magazines: *The Feminine Mystique* was partly inspired by the extreme dissonance she perceived between what women were actually telling her, and the picture of domestic paradise she was expected to paint in her journalism.

Friedan shows that in the decade after the war, women's magazines became progressively more domesticated. Whereas the *Ladies' Home Journal* and its ilk during the 1930s and 40s had featured stories about 'new women' with careers and pilots' licenses, as well as reports on politics and science, by the mid-1950s

their pages were full of stories about housewives (or women looking for husbands so they could become housewives) and articles on domestic pursuits. Women whose contributions to magazine journalism had been valued because of their distinguished reputations in other fields were now forced to reinvent themselves as 'ordinary' wives and mothers, 'revelling in a comic world of children's pranks and eccentric washing machines and parents' nights at the PTA' (p.50).

This is uncomfortably close to some present-day realities. In the past few years, glossy magazines like *Cosmopolitan* and *She* have abandoned their previous image as reading matter for intelligent 'career women' and cultivated an altogether fluffier image. Newspapers are awash in 'lifestyle' features, whose writers once again get paid to chronicle the ups and downs of life at home — the breakdown of domestic appliances, the amusing dramas of getting three children ready for a family outing, the horror that is a teenage boy's bedroom.

But if there are echoes of the 1950s and 60s in contemporary popular culture, there are also some differences between then and now. Today women who embrace domesticity do so by choice rather than compulsion. Though Betty Friedan emphasises the voluntarism of post-war women's surrender to the domestic ideal, she also shows that educated middle-class women in the 50s did not have the alternative options available to their counterparts today. On the other hand they did face relentless pressure towards domesticity from all kinds of 'experts', from the media and from their peers. Today, by contrast, it is the decision *not* to take up a profession, or to leave it permanently when she marries or has children, that educated women have to justify.

Another difference is that the new domesticity is not, or at least is never presented as, an exclusively female preserve. Some of its prominent media representatives are gods rather than goddesses, like Nigel Slater and Jamie Oliver. Male journalists are also well represented among the authors of the many newspaper columns now devoted to chronicling the mundane details of domestic life. The existence of the 'domestic god' who does not just pontificate on domesticity (as male experts have done for two centuries) but is seen to embrace it fully and enthusiastically, suggests to me, not that domesticity has become genderless (structural inequalities still have a bearing here: since men usually earn more, if one member of a heterosexual couple is going to give up paid work it will often make financial sense for it to be the woman), but that the desire for domesticity has some purchase on both sexes. It can't be explained, that is, as a simple desire to return to traditional, 1950s-style gender roles or as a reaction against feminism. (After all, men doing domesticity is very much in the spirit of a certain sort of feminism.) Though I will suggest later that it is still a feminist issue, arguably the

rise of the new domesticity has less to do with gender *per se* than with a more general search for meaning in contemporary life: it is a reaction to, or against, current trends in both paid work and consumer culture.

Getting a life: the problem of work

Betty Friedan repeatedly opposes the confinement of the suburban housewife to the freedom of the woman allowed to pursue a career. Mainstream liberal feminism has always maintained something similar to this position: the keystone of women's equality is access to the world of work, especially to the middle-class professions, and the key feminist issues are therefore things like sex discrimination in employment, sexual harassment in the workplace, equal pay, and the 'glass ceiling'.

Indisputably these issues remain relevant; but the celebration of waged work as inherently liberating for women, and inherently less oppressive than domesticity, seems increasingly out of touch with the experience of many 'career women'. In the accounts of those who have 'downshifted' to part-time jobs or fulltime motherhood, there is, on the contrary, a consistent focus on the all-consuming, but at the same time unsatisfying nature of much contemporary work. And when paid work is experienced as oppressive rather than fulfilling, the domestic sphere, popularly conceived as 'the opposite' of work, starts to look less like a cage and more like the refuge whose idealisation Friedan deplored.

It has been calculated that workers today spend more hours working than any group of people in recorded human history except factory hands in the early, unregulated phase of the industrial revolution. This affects women particularly adversely, precisely because they continue to be responsible for most of the domestic labour that is needed to maintain their households. Women with jobs have to come home and work a 'second shift'. Add to this the fact that many professional women are in working environments which are particularly stressful — women are, for instance, over-represented in public sector occupations like nursing, education and social work where they must constantly try to compensate for a chronic lack of resources — and it becomes easy to see the attraction of jacking in the day-job.

For most women, however, that is a fantasy. For working-class women the 'choice' not to work for wages was always constrained by economic realities; now the same is true for middle-class women, since contemporary middle-class lifestyles can rarely be maintained on a single income. This is what gives resonance to contemporary buzzphrases like 'the work-life balance', in which 'life' essentially means home and family. The new domesticity gives the illusion of a 'balance' by encouraging women who cannot escape either waged work or domestic work to

redefine their relationship to the latter: instead of being merely a 'second shift' at work, it becomes more like a hobby, a creative activity offering the pleasure and satisfaction which today's stressful paid jobs often do not.

Saving our souls: the problem of consumerism

'The problem that has no name' emerged at the beginning of the great western post-war consumer boom. This is relevant to what could be seen as a major shortcoming of Friedan's book, its exclusive focus on white middle-class suburban women. In fact, though, part of her point was that 'the problem' affected these privileged women most severely. They were the beneficiaries of the new affluence and the labour-saving products which reduced the drudgery of housework. But consequently, the occupation to which their gender consigned them no longer occupied the time they had to spend on it, nor demanded any real skill. From the interviews Friedan quotes, it is evident that many women's malaise — continual sleepiness, inability to concentrate, depression — had its origins in a kind of pathological boredom. Old-style domestic work was composed of repetitive and often menial tasks, but it did not leave the housewife with so many empty hours or so much surplus physical and mental energy.

What was supposed to fill the time freed up by the end of domestic drudgery? According to a fairly standard sociological-historical account, the real job of the post-war housewife was to *consume* — to buy things, especially non-essential or luxury items. The post-war period marked a new and decisive stage in the long-term process whereby the household shifted from being the key site of production in the pre-industrial era, to being a site almost exclusively of consumption. This historical account provided the basis for a marxist (and marxist feminist) critique of the modern housewife's role. The housewife was performing a vital service to capitalism: as well as reproducing her husband's labour power by feeding, clothing and nurturing him, she was redistributing his earnings back into the capitalist's coffers by buying things she did not need, but was induced to want by consumerist culture.

The classic marxist view of domestic consumerism has been criticised on many grounds — as patronisingly sexist (it portrays women as dupes of capitalism), as puritanical (it does not acknowledge the pleasures of consumption) and as insufficiently attentive to the gendered power relations inside households. However, it seems pointless to digress into this argument, because just as we are almost all wage-workers now, so we are also all defined, to a greater or lesser extent, by our habits and practices of consumption. For members of modern societies, of all

classes and generations, and of both genders, buying goods and services is both a leisure activity and a form of self-expression. Few of us are so poor that we have no choices at all. And even fewer of us have the time or the skills to produce our own food, clothing and entertainment.

But the extent to which we are caught up in consumerism has generated a backlash. The radical end of this is the anti-corporate, 'No Logo' movement; the more mainstream expression of it involves not alternatives *to* consumption but alternative consumption practices, such as buying organic and fair-trade, or choosing 'green' household appliances. This accepts the general premise that consuming is a meaningful act, and uses it to express alternative meanings, such as 'I care about saving the planet/improving life for workers in the third world'.

The new domesticity is part of this trend. Among the meanings it expresses are 'I do not think it is more important to make money for my employer than to make life pleasant for my family'; 'in the past people had less money but a better sense of values'; and 'shopping, cleaning and cooking are more satisfying when they take time and effort and skill'. Whether engaged in actively or vicariously, by reading and watching the TV gods and goddesses, the new domesticity marks out a sort of alternative space for the expression of individuality and the affirmation of non-market values.

So where, you might ask, is the harm in that? If domestic goddesses no longer have to be financially dependent on or subservient to their husbands, if domesticity is not a calling but just a hobby, then why not just let people (women, and a few men) indulge their taste for ironing sheets and baking sponges?

On reflection, though, it is difficult to see domesticity as a hobby like any other, particularly for women. Most women are obliged to practise domesticity in some form or other; aspiring to the status of a domestic goddess is making a virtue of necessity. Until housework really is shared equally between women and men, until women do not have to work a 'second shift', it will be hard to see domestic goddesshood as an uncoerced choice.

Another problem with the new domesticity is the idealisation of *family* life that goes with it. Domestic goddesses are propagandists for the idea of the family as the only real haven in a heartless world. You no longer have to be either female or straight to buy into this, but you do have to gloss over some of the less pleasant aspects of family life (the abuse of women and children that goes on behind closed doors). You also have to be willing to abandon three decades of feminist effort to create meaningful relationships outside the family, and community beyond the home. A feminist approach to the 'work-life balance' would not just be about having

enough time to spend with your family, but would also take account of women's need and desire for friendship, for educational and cultural activities, for involvement in community groups and — not least — for political activism. These things too provide a space for the affirmation of non-market values; they benefit both the people who engage in them and society at large.

Finally, there is (still) the problem of domesticity itself — what it actually consists of. For 200 years, people (usually people who didn't have to do it themselves) have tried to invest the job of running a home with meaning, status and glamour. They have made it into a science, eulogised it as an art, represented it as a career and now they are selling it as a fulfilling leisure pursuit. But the unchanging reality of domestic labour is that it is boring, thankless, and as a full-time occupation, soul-destroying. No attempt to disguise that reality has ever succeeded for long.

References

Friedan, Betty (1973) *The Feminine Mystique,* Harmondsworth: Pelican.

30. It's life, Jim... but not as we know it (2001)

Carol Morley

I n 1994 the trade paper *Television Today* reported a new idea for a TV programme called *Divorce Me,* which would feature real life divorcing couples competing for the contents of their own home. The chief executive of the production company explained, 'We've had reality entertainment shows and reality crime shows. I think the new mood in entertainment will be for reality game shows'.

Reality television (RT) has become a significant part of the television schedules, claiming an authenticity that other TV genres can't match. To appear democratic, inclusive and representative, RT relies heavily on the inclusion of so called 'ordinary people' — those previously outside the TV world. But is RT authentic and democratic? Does it offer possibilities for challenging attitudes to gender, class, race and sexuality, or does it merely reinforce existing stereotypes?

I want to pose these questions in relation to two recently popular reality programmes, *Big Brother* and *Popstars.* I also want to ask how it is possible for us both to revile these shows and at the same time enjoy watching them.

Big Brother and the pseudo-world

The phenomenally successful RT show *Big Brother* is part fly-on-the-wall docusoap, part quiz show, part talent contest, part psychological investigative study; it also has an interactive element where the viewing audience can ring in and vote to evict one of the contestants every week. The reward for appearing is instant celebrity and, for the final survivor, a large sum of money. On the whole the show is tedious, in the sense that nothing of any great significance happens, but that does not mean *Big Brother* as a programme is not significant. If my own and my friends' responses, the TV ratings and press reactions are anything to go by, it is compulsive viewing.

Big Brother can be compared to soap opera, which has often been seen as a 'female' genre. By contrast with 'male' genres such as the western, which are oriented to action and show men conquering the big wide world, soap operas are dramas that unfold in a domestic space. Their multiple storylines emphasize areas that women are deemed to have authority over, such as family, personal

relationships and emotional problem-solving. These genres initially arose in order to locate men in relation to the outside world while keeping women inside in an attempt to disempower them. But research on female spectators has shown that women can gain enormous pleasure from seeing even limited representations of themselves.

One of the pleasures of soap opera is sharing the experience of it with other women. The discussions female spectators have around the plots and characters of soaps are a form of gossip, a culturally gendered activity which many women enjoy. *Big Brother* does some of the same work. In taking us inside the house, into domestic space, into the world of gossip, you could argue that it feminises its audience.

But it also could be argued that the show was constructed with masculine intent. *Big Brother* is premised on voyeurism, on our pleasure in watching the contestants without them seeing us. Constant internet access also offers the spectator a degree of power over what is seen. The cinema has been theorised as reproducing a 'male gaze', and *Big Brother* seems to reinforce this. Even with that post-modern ironic wink, the show is still called *Big Brother*—not just a reference to Orwell, but also a name which underlines the power of patriarchy.

'Real' people?

The spectators of television now have a chance to appear on it, but they are still chosen by TV professionals. They are selected not only on their ability to bring along a realistic model of the everyday world, but also on their ability to play the TV game: it is a prerequisite that they conform to the needs of the programme makers.

The five female and five male *Big Brother* contestants arrived on the show[1] through a rigorous audition process: they had competed with thousands of others to appear. Definable characters emerged that we could follow, just like the characters in soap operas. While their diversity didn't stretch to age or size, we had a black woman (Mel), a black man (Darren), a lesbian (Anna) and a cross-section across class. The programmes were heavily edited in order to achieve a semblance of drama. The hours of footage that were generated from constant surveillance by many cameras all over the house had to emerge as palatable chunks, with a narrative structure, that could find their place in the television schedules. In observing the rules of narrative and character development, stereotypes inevitably arose.

Anna, who survived ten weeks to become the runner-up, revealed at the start of the show that she was a lesbian, and also an ex-novice nun. Her sexuality was discussed by the group, and later by the male contestants, who thought it was unfortunate that Anna wasn't 'available' to them. The group saw her sexuality as an

area of intrigue but nobody appeared to view it as threatening. Two of the women voiced their positions as bi-curious, but were still very much interested in men. Craig, the ultimate winner, asked Anna what it was like to share a bedroom with four other women, and did she fancy any of them? Anna didn't reply. She had a long-term relationship so was unlikely to show an interest in any of the female contestants while her girlfriend was watching. (It is interesting that the programme makers selected her knowing this.) While sexual tension appeared to brew in the house between the male and female contestants, Anna was seen as doubly non-threatening because she was not going to compete with the other women for male attention. By contrast, the exclusion of male homosexuality seemed very deliberate, as though the presence of a gay man would have been a threat to the other male contestants, who frequently underlined their heterosexual status.

When contestant 'Nasty' Nick was ousted midway through the series for breaking the rules of the game, a replacement was brought in from the outside world. As Claire arrived in the house, we saw a shot of Mel's reaction, which was widely interpreted by viewers and in the press as a look of jealousy. After her part in the show was over, Mel explained that what she really felt at that moment was paranoia, because Claire had watched them all on TV. This 'look of jealousy' is indicative of how Mel was constructed as overtly sexual and flirtatious. She appeared to bond with the male contestants but was wary and competitive with the female contestants. Overall, Mel was continually being presented as devious and manipulative when it came to men. There is a strong racist stereotype at work here. As in the case of Mel B from the Spice Girls, who was dubbed 'Scary Spice', Big Brother Mel, who is also of mixed race, was presented as embodying a threatening 'otherness'.

In all the countries where a version of *Big Brother* exists, the final winner has so far always been a white heterosexual male[2]. Why hasn't a woman won? Anna almost won, probably because she came across as such an unthreatening presence. All the rest of the women were represented as problematic. Nicola, who wore a skimpy bikini almost always, was seen by the male contestants as argumentative and volatile. Sada, author of a book entitled *The Babe's Bible,* was presented as duplicitous, one moment giving a lecture on how she would never kill a fly, the next moment shown swatting an insect between her palms with glee. She was the only woman in the house to have a boyfriend, so was therefore perceived as unavailable by the lad contestants (who spent time speculating about which woman they fancied most). Sada was the first person to be evicted from the house. Caroline was also deemed argumentative and a troublemaker, while Mel was seen as flirtatious and manipulative.

Before Craig won *Big Brother*, it was leaked to the press that he was going to donate the prize money to a family friend, a young woman with Down's syndrome who needed a heart operation. While undoubtedly a charitable act, this had the air of the male saviour and hero about it—further compounded when Craig left the house and walked through the crowds flexing his muscles to waiting photographers. It seemed that unreconstructed masculinity had won the day.

Popstars

Building on the new desire for celebrity, confession and the real, *Popstars* can be seen as the ultimate in reality programming. The premise of the show was the formation of a band from mass auditions: five finalists would be launched into celebrity, given a recording contract and awarded £100,000 each if their first single reached number one. The TV series followed the competing contestants' heartaches and struggles; we were privy to their intimate confessions. When we were down to the last ten contestants, we were taken into their homes and introduced to their families. We seemed to be offered everything that lay behind the scenes.

We witnessed, for instance, the anxieties of 18-year old Suzanne, who doubted she would ever make it into the final band, though ultimately she did. Along the way she exhibited signs of self-loathing. She compared herself with the other women competing, and found herself not as thin or as pretty. When so much meaning

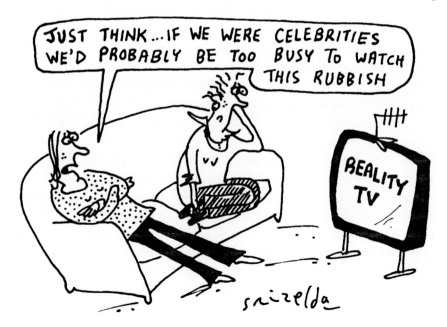

is placed upon the way women look, and thinness is equated with some kind of success, it isn't surprising that she focused on her body, her appearance. Back in the 1970s, the TV talent show *Opportunity Knocks* launched the child star Lena Zavaroni, whose rise to fame, subsequent battle with eating disorders, and early tragic death, have all been well documented. Her eating disorders appear to have been tightly interwoven with her rise to celebrity. In *Popstars*, another young woman who clearly had a very powerful singing voice and impressive dancing style remarked that she would never make it to the final round because she wasn't thin. She was right. Yet the show's emphasis on Suzanne's insecurities seemed to be reinforcing a representation of women as neurotic and narcissistic.

After Kym was selected to be in the band, we learnt that she had hidden from the programme makers the fact that she was the mother of two young children. She defended her omission to judge Nigel, saying that it would have prevented her being chosen. It had always held her back in the past and had often been the reason she has not landed a job. Nigel chastised her; he spoke of his disappointment in her and assured her that her status as a mother would in no way have prevented her from being picked. The words rang hollow: just as one woman was not selected because she wasn't thin, so it is clear that Kym's status as a single mother would have raised a number of issues for the judges. They would have discussed the criticism the programme might receive for taking a mother away from her children. They would have discussed her desirability to fans if they were to find out she had two children. They would have talked about the ramifications of a single mother being a role model for younger fans. Her commitment to the band would also have been questioned (this has since played out in Kym's ranking at the betting shops as odds-on favourite to be the first band-member to leave).

Kym's decision to withhold information about herself reinforces the point that people seeking celebrity status and the material rewards that accompany it will do all they can to fit in. Before they are even at the point of having 'made it', the female wannabes are already conforming to a stereotypical image of women: they reveal flesh, they wear high heels, they are thin (weaker and taking up less room), all for the sake of appearing sexually available to men.

Last week in a restaurant, I caught a glimpse of Emma Bunton, a.k.a. 'Baby Spice'. I noticed she was scanning the room to catch the discreet glances, to make sure that everyone in the restaurant recognised her. I was reminded of another celebrity-spotting some months before. I was going into a clothes shop when the woman in front of me tripped and turned around in embarrassment. It was Mel from *Big Brother*. I kept her in my sightline while I circled the shop; she was looking

to see who was looking at her. Her status depended on people knowing who she was. She had performed her television role, and here she was seeking her reward— recognition. Mel, famous for being on a reality TV show, famous for being famous. The self-consciousness that goes with celebrity status is just a logical extension of what it is to be a woman, constantly objectified and constantly surrounded by unobtainable images of who we are supposed to be.

The contestants on *Big Brother* and *Popstars* are freely participating in the shows, but not without manipulation from a variety of sources. They are constructed and marketed, and at the end of the day their purpose is to make a profit for those who manufacture them. The contestants are so desperate to be celebrities that they will do almost anything, and the female participants do appear to be more vulnerable. We only have to look at the myriad female stars that are becoming thinner and thinner, their earning power growing in inverse proportion to their diminishing bodies. I worry about Suzanne from *Popstars*: will she get too thin? I worry about the contestant from *Big Brother* described in a recent article (written by a man) as 'opening her legs, showing all, desperate to cling onto any celebrity status she'd got left'.

Watching TV: getting what we want or making do with what we get?

Reality television claims to be a testimony to our 'real' lives, and the way we want to live our lives. In fact, though, reality shows are not democratic, and they reproduce prevailing stereotypes all too easily. So what accounts for the pleasure we find in them?

As women, we have a history of interacting with TV and film genres that may not have our interests at heart, and of celebrating the images of women they present, from the *femmes fatales* of *film noir* to the prisoners in Cell Block H. Anna from *Big Brother* may not have had much of a voice in the show, but she became, arguably, a lesbian icon: the London lesbian hang-out Candy Bar urged patrons to 'vote to keep Anna in *Big Brother*', and built a night around her final appearance. Lacking more varied and complex representations, it seems we are prepared to make the most of what we get.

Notes

1. This piece discusses the first UK series of *Big Brother*, which was broadcast in 2000.

2. It is no longer true that all *Big Brother* winners have been male, heterosexual and white. Of the nine UK series broadcast to date, straight white men have won four, but winners have also included one gay man, one black man, two white women and a contestant who was revealed to be a male-to-female transsexual [Eds.]

Notes on Contributors

Dena Attar wrote regularly for *T&S* in the 1980s and early 1990s, and also contributed to its 2002 special issue 'Feminist perspectives after September 11'. She is a Senior Lecturer and staff tutor at the Open University.

Rosemary Auchmuty is professor of law at the University of Reading. Formerly Associate Director of the AHRC Centre for Law, Gender and Sexuality, she still writes about radical feminism, lesbian history, and girls' fiction – as well as feminist approaches to law.

Deborah Cameron began writing for *T&S* in 1984, and continued for another 17 years, during which time the editorial collective took the hint and invited her to join. As an academic she specializes in the study of language and culture, with a particular focus on gender and sexual politics. She has taught at universities in the UK, US and Sweden, and is now professor of language and communication at Oxford University.

Delilah Campbell is a freelance cultural critic who contributed several pieces to *T&S* in its second decade.

Christine Delphy is a sociologist, writer and journalist with a long history of involvement in French feminist politics. In 1977 she and Simone de Beauvoir founded the feminist journal *Questions féministes*, later to become *Nouvelles questions féministes*, which partly inspired *T&S*. She is Directrice de recherche émérite at the Centre national de la recherche scientifique (CNRS) in Paris.

Jacky Fleming is well known for her feminist cartoons, which appeared regularly in *T&S*.

Liz Frazer teaches politics at New College, Oxford.

Janis Goodman has worked as a feminist cartoonist for over 30 years. She has produced strip cartoons for the *New Statesman*, *Yorkshire on Sunday, Everywoman* and *Mailout.* She also works for Leeds Animation Workshop and as an etcher.

Grizelda is a professional cartoonist whose work appears in *The Independent, The New Statesman* and *Private Eye*.

Rachel Hasted worked for many years as a curator in social history museums, specializing in the representation of diversity in British history. Since 2006 she has been Head of Social Inclusion and Diversity Policy at English Heritage.

Cath Jackson gave many of the best years of her life to drawing cartoons for a range of publications, not least *Trouble & Strife*, which inspired what she considers to be some of her best work. Chief among her creations are Vera the Visible Lesbian, published in the London magazine *City Limits*, and Nurse Nightshade, who haunted the pages of the *Nursing Times*. Cath hung up her pen in the mid-1990s and has since only produced cartoons when either foolishly in love or beguiled by flattery. When not drawing cartoons for *T&S* she contributed to the magazine as a writer, designer and editorial collective member.

Stevi Jackson is Professor of Women's Studies at The University of York and was a member of the *T&S* Collective during the 1990s. She has published widely on gender and sexuality.

Celia Jenkins is a feminist sociologist of education who currently lectures at the University of Westminster in Sociology and Women's Studies. She was involved with the feminist group Women Against the Prostitution of Women.

Susanne Kappeler was a member of the *T&S* collective in the late 1980s. She has written extensively on questions of representation, pornography and violence, and was active in the Campaign Against Pornography. She taught for a number of years in universities in Europe and North Africa, and now runs an animal refuge in Switzerland.

Liz Kelly became the longest-serving member of the *T&S* collective, and regularly contributed pieces to the magazine. She holds the Roddick Chair of violence against women and is director of the Child and Woman Abuse Studies Unit at London Metropolitan University.

Diana Leonard has been active in the women's movement since the early 1970s. She has been based for many years at the Institute of Education, teaching and researching on gender and schooling, and women in higher education. In the early 1980s she was seconded to the Open University to work on its first women's studies course.

Sarah Maguire is a long-standing feminist and human rights lawyer and activist, working in conflict-affected areas across the globe.

Angela Martin is a freelance cartoonist and artist who contributed extensively to *T&S*.

Monica McWilliams was centrally involved in the formation of the Northern Ireland Women's Coalition, and was one of its two representatives at the talks which led to the Good Friday agreement. She is now Chief Commissioner for Human Rights in Northern Ireland.

Lilian Mohin is a writer, editor and publisher, and a founding director of Onlywomen Press, the independent lesbian feminist publishing house.

Carol Morley is an independent filmmaker whose films explore female experience and cross the boundaries between fact and fiction. She has on ongoing interest in television culture, and undertook some of the earliest research on reality TV.

Julia Parnaby is an information professional in the voluntary sector and lives in London.

Sigrid Rausing is a publisher, anthropologist and philanthropist. The Sigrid Rausing Trust, which she founded in 1995, funds projects and organizations working for social justice, women's and minority rights.

Joan Scanlon was a member of the *T&S* collective for eleven years. Before the advent of computerized production methods her workplace, London Contemporary Dance School, with its large mock-Tudor library tables, provided a useful if somewhat incongruous location for pasting up the magazine. She now runs a gardening business in London, and chairs the board of Clean Break Theatre Company.

Sara Scott, a former *T&S* collective member and regular contributor, began her career in educational broadcasting, and went on to become a researcher specializing in issues of sexual violence and mental health. In 2006 she and Di McNeish set up their own company, DMSS Research & Consultancy.

Purna Sen specializes in the areas of gender, human rights, development and violence against women. She has worked at the London School of Economics and for Amnesty International, and is now Head of Human Rights at the Commonwealth Secretariat.

Judy Stevens is an exhibiting printmaker and illustrator whose work appears regularly in books, advertising and newspapers. She regularly contributed to T&S—uniquely, her work was included in both the first issue and the very last—and for a time she was also a member of the editorial collective.

Julia Swindells lives by the river in Cambridge, England, and remains addicted to co-authorship of a political kind, her most recent feminist project being the editing of five volumes of eighteenth-century women's theatrical memoirs with Sue McPherson.

Ruth Swirsky teaches at the University of Westminster, where she is struggling to keep Women's Studies alive.

Ruth Wallsgrove was a founding member of the *Trouble & Strife* collective. She also worked on *Spare Rib* and had a close association with *off our backs* in the US. She now sells trains (full-sized ones) and founded Transition Sydney in 2008.

Members of the T&S Editorial Collective, 1983–2002
Lisa Adkins, Lynn Alderson, Dianne Butterworth, Debbie Cameron, Margot Farnham, Marian Foley, Jalna Hanmer, Mandana Hendessi, Cath Jackson, Stevi Jackson, Susanne Kappeler, Liz Kelly, Sophie Laws, Diana Leonard, Agnes Quashi, Jill Radford, Sheila Saunders, Joan Scanlon, Sara Scott, Judy Stevens, Ruth Wallsgrove.

Index